Adobe After Effects

2024 Release

Classroom in a Book®

The official training workbook from Adobe

Brie Gyncild & Lisa Fridsma

Adobe After Effects Classroom in a Book 2024 Release

Cover Illustration: Pes Motion Studio, behance.net/peslab

ISBN-13: 978-0-13-831648-8

ISBN-10: 0-13-831648-1

1 2023

WHERE ARE THE LESSON FILES?

Purchase of this Classroom in a Book in any format gives you access to the lesson files you'll need to complete the exercises in the book.

1 Go to peachpit.com/AfterEffectsCIB2024.

2 Sign in or create a new account.

3 Click Submit.

● **Note:** If you encounter problems registering your product or accessing the lesson files or web edition, go to peachpit.com/support for assistance.

4 Answer the questions as proof of purchase.

5 The lesson files can be accessed through the Registered Products tab on your Account page.

6 Click the Access Bonus Content link below the title of your product to proceed to the download page. Click the lesson file links to download them to your computer.

● **Note:** If you purchased a digital product directly from peachpit.com, your product will already be registered. Look for the Access Bonus Content link on the Registered Products tab in your account.

CONTENTS

GETTING STARTED

Adobe After Effects provides a comprehensive set of 2D and 3D tools for compositing, animation, and effects that motion graphics professionals, visual effects artists, web designers, and film and video professionals need. After Effects is widely used for digital post-production of film, video, DVDs, and the web. You can composite layers in various ways, apply and combine sophisticated visual and audio effects, and animate both objects and effects.

About Classroom in a Book

Adobe After Effects Classroom in a Book 2024 Release is part of the official training series for Adobe graphics and publishing software, developed with the support of Adobe product experts. The lessons are designed to let you learn at your own pace. If you're new to Adobe After Effects, you'll learn the fundamental concepts and features you'll need to master the program. And if you've been using Adobe After Effects for a while, you'll find that Classroom in a Book teaches many advanced features, including tips and techniques for using the latest version.

Although each lesson provides step-by-step instructions for creating a specific project, there's room for exploration and experimentation. You can follow the book from start to finish, or do only the lessons that match your interests and needs. Each lesson concludes with a review section summarizing what you've covered.

Prerequisites

Before beginning to use *Adobe After Effects Classroom in a Book 2024 Release*, make sure that your system is set up correctly and that you've installed the required software and hardware. You should have a working knowledge of your computer and operating system. You should know how to use the mouse and standard menus and commands, and also how to open, save, and close files. If you need to review these techniques, see the printed or online documentation included with your Microsoft® Windows® or Apple® macOS® software.

To complete the lessons in this book, you'll need to have Adobe After Effects, Adobe Bridge, and Adobe Media Encoder installed. Additional optional exercises require Adobe Premiere Pro, Adobe Audition, and Adobe Character Animator. The exercises in this book are based on After Effects 24.

Installing After Effects, Bridge, and Media Encoder

Adobe After Effects is not included with the book; you must purchase it separately as part of an Adobe Creative Cloud subscription. For system requirements and complete instructions on installing the software, visit https://helpx.adobe.com/after-effects/system-requirements.html. Note that After Effects requires a 64-bit operating system. To view QuickTime movies on macOS, you must also have Apple QuickTime 7.6.6 or later installed on your system.

Some of the lessons in this book use Adobe Bridge or Adobe Media Encoder. After Effects, Bridge, and Media Encoder use separate installers. You must install these applications from Adobe Creative Cloud (adobe.com) onto your hard disk. Follow the onscreen instructions.

Activating fonts

Several lessons use specific fonts that may not be installed on your system. You can activate the fonts using Adobe Fonts or choose a different font on your system with similar characteristics. If you choose a different font, your projects won't look exactly like the ones shown in the book.

Adobe Fonts licenses are included in Creative Cloud subscriptions.

To activate fonts within After Effects, choose File > Fonts From Adobe, or click the Creative Cloud icon next to Add Adobe Fonts in the Font menu in the Character panel. Then, find the font in Adobe Fonts in your browser, and activate the font.

Optimizing performance

Creating movies is memory-intensive work for a desktop computer. After Effects 2024 requires a minimum of 16GB of RAM. The more RAM that is available to After Effects, the faster the application will work for you. For information about optimizing memory, cache, and other settings for After Effects, see "Improve performance" in After Effects Help.

Restoring default preferences

The preferences files control the way the After Effects user interface appears on your screen. The instructions in this book assume that you see the default interface when they describe the appearance of tools, options, windows, panels, and so forth. Therefore, it's a good idea to restore the default preferences, especially if you are new to After Effects.

Each time you quit After Effects, the panel positions and certain command settings are recorded in the preferences files. To restore the original default settings, press Ctrl+Alt+Shift (Windows) or Command+Option+Shift (macOS) while starting After Effects. Then, choose Reset Preferences in the Startup Repair Options dialog box. (After Effects creates new preferences files if they don't already exist the next time you start the program.)

Restoring the default preferences can be especially helpful if someone has already customized After Effects on your computer. If your copy of After Effects hasn't been used yet, these files won't exist, so this procedure is unnecessary.

Important: If you want to save the current settings, you can rename a preferences file instead of deleting it. When you are ready to restore those settings, change the name back, and make sure that the file is located in the correct preferences folder.

1 Locate the After Effects preferences folder on your computer:

- **For Windows:** .../Users/*<user name>*/AppData/Roaming/Adobe/ AfterEffects/24.0

- **For macOS:** .../Users/*<user name>*/Library/Preferences/Adobe/ After Effects/24.0

2 Rename any preferences files you want to preserve, and then restart After Effects.

● **Note:** In macOS, the user library folder is hidden by default. To see it, in the Finder, choose Go > Go To Folder. In the Go To Folder dialog box, type **~/Library**, and then click Go.

Online content

Your purchase of this Classroom in a Book includes the following online materials:

Lesson files

To work through the projects in this book, you will need to download the lesson files from peachpit.com. You can download the files for individual lessons or it may be possible to download them all in a single file.

Web Edition

The Web Edition is an online interactive version of the book providing an enhanced learning experience. Your Web Edition can be accessed from any device with a connection to the Internet, and it contains:

- The complete text of the book
- Hours of instructional video keyed to the text
- Interactive quizzes

Accessing the lesson files and Web Edition

● **Note:** If you encounter problems registering your product or accessing the lesson files or Web Edition, go to peachpit.com/support for assistance.

You must register your product on peachpit.com in order to access the online content:

1 Go to peachpit.com/AfterEffectsCIB2024.

2 Sign in or create a new account.

3 Click Submit.

4 Answer the questions as proof of purchase.

5 You can access the lesson files from the Registered Products tab on your Account page: Click the Access Bonus Content link below the title of your product to proceed to the download page. Click the lesson file links to download them to your computer.

You can access the Web Edition from the Digital Purchases tab on your Account page. Click the Launch link to access the product.

● **Note:** If you purchased a digital product directly from www.peachpit.com, your product will already be registered. Look for the Access Bonus Content link on the Registered Products tab in your account.

Organizing the lesson files

The files are compressed into ZIP archives to speed download time and protect the contents from damage during transfer. You must uncompress (or "unzip") the files to restore them to their original size and format before you use them with the book. Modern macOS and Windows systems are set up to open ZIP archives by simply double-clicking.

● **Note:** If for any reason you need to download fresh copies of the lesson files, you can download them from your account again at any time.

1 On your hard drive, create a new folder in a convenient location, and name it **Lessons**, following the standard procedure for your operating system:

 - In Windows, right-click, and choose New > Folder. Then enter the new name for your folder.

 - In macOS, in the Finder, choose File > New Folder. Type the new name, and drag the folder to the location you want to use.

2 Drag the unzipped Lessons folder (which contains folders named Lesson01, Lesson02, and so on) that you downloaded onto your hard drive to your new Lessons folder. When you begin each lesson, navigate to the folder with that lesson number to access all the assets you need to complete the lesson.

About copying the sample movies and projects

You will create and render one or more movies in some lessons in this book. The files in the Sample_Movie folders are examples that you can use to see the end results of each lesson and to compare them with your own results.

The files in the End_Project_File folders are samples of the completed project for each lesson. Use these files for reference if you want to compare your work in progress with the project files used to generate the sample movies.

These sample movies and end-project files vary in size from relatively small to quite large, so you can either download them all now if you have ample storage space, or download just the files for each lesson as needed, and then delete them when you finish that lesson.

How to use these lessons

Each lesson in this book provides step-by-step instructions for creating one or more specific elements of a real-world project. The lessons build on each other in terms of concepts and skills, so the best way to learn from this book is to proceed through the lessons in sequential order. In this book, some techniques and processes are explained and described in detail only the first few times you perform them.

Many aspects of the After Effects application can be controlled by multiple techniques, such as a menu command, a button, dragging, and a keyboard shortcut. Only one or two of the methods are described in any given procedure, so that you can learn different ways of working even when the task is one you've done before.

The organization of the lessons is also design-oriented rather than feature-oriented. That means, for example, that you'll work with layers and effects on real-world design projects over several lessons, rather than in just one lesson.

Additional resources

Adobe After Effects Classroom in a Book 2024 Release is not meant to replace documentation that comes with the program or to be a comprehensive reference for every feature. Only the commands and options used in the lessons are explained in this book.

Tutorials within After Effects can help you get started: In After Effects, choose Window > Learn. The Learn panel opens with a series of tutorials.

For comprehensive information about program features and tutorials, refer to these resources:

- **Adobe After Effects Learn & Support:** helpx.adobe.com/support/after-effects.html is where you can find and browse tutorials, help, and support on www.adobe.com.

- **After Effects tutorials:** helpx.adobe.com/after-effects/tutorials.html lists online tutorials for beginner and experienced users. You can go there directly from After Effects by choosing Help > After Effects Online Tutorials.

- **After Effects Forums:** community.adobe.com lets you tap into peer-to-peer discussions, and questions as well as answers about After Effects.

- **Adobe Creative Cloud Discover tab:** creativecloud.adobe.com/cc/discover offers thoughtful articles on design and design issues, a gallery showcasing the work of top-notch designers, tutorials, and more.

- **Resources for educators:** www.adobe.com/education and edex.adobe.com offer a treasure trove of information for instructors who teach classes on Adobe software. Find solutions for education at all levels, including free curricula that use an integrated approach to teaching Adobe software and can be used to prepare for the Adobe Certified Associate exams.

Also check out these useful links:

- **Adobe Exchange:** exchange.adobe.com is a central resource for finding tools, services, extensions, code samples, and more to supplement and extend your Adobe products.

- **Adobe After Effects product home page:** www.adobe.com/products/aftereffects

Adobe Authorized Training Centers

Adobe Authorized Training Centers offer instructor-led courses and training on Adobe products. Visit https://learning.adobe.com/partner-finder.html to access a directory of AATCs.

1 GETTING TO KNOW THE WORKFLOW

Lesson overview

In this lesson, you'll learn how to do the following:

- Create a project and import footage.
- Create compositions and arrange layers.
- Navigate the Adobe After Effects interface.
- Use the Project, Composition, and Timeline panels.
- Transform layer properties.
- Use the Properties panel.
- Apply basic effects.
- Create keyframes.
- Preview your work.
- Customize the workspace.
- Adjust preferences related to the user interface.
- Find additional resources for using After Effects.

 This lesson will take about an hour to complete. If you haven't already done so, download the project files for this lesson from peachpit.com/ AfterEffectsCIB2024, following the instructions in the Getting Started section under "Accessing the lesson files and Web Edition."

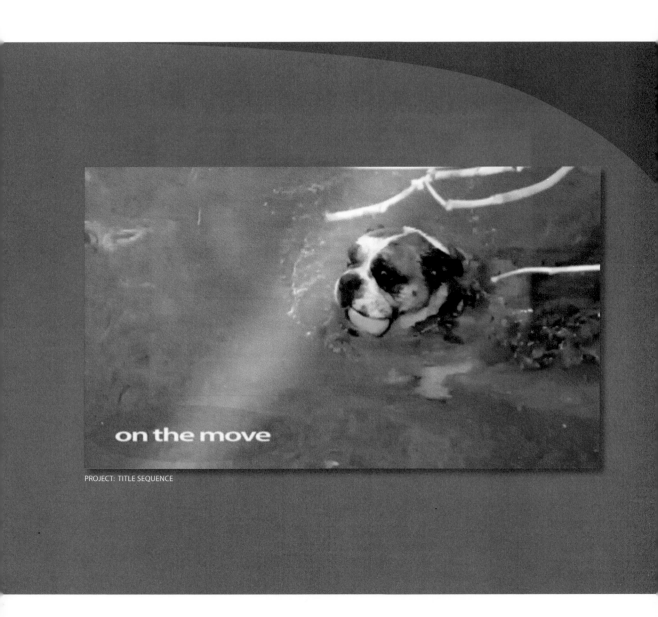

PROJECT: TITLE SEQUENCE

on the move

Whether you use After Effects to animate a simple video title sequence or to create complex special effects, you generally follow the same basic workflow. The After Effects interface facilitates your work and adapts to each stage of production.

About the After Effects work area

After Effects offers a flexible, customizable work area. The main window of the program is called the *application window*. Panels are organized in this window in an arrangement called a *workspace*. The default workspace contains stacked panels as well as panels that stand alone, as shown below.

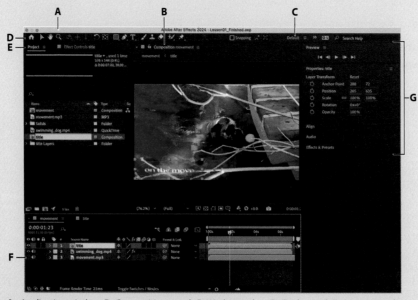

A. *Application window* **B.** *Composition panel* **C.** *Workspace bar* **D.** *Tools panel* **E.** *Project panel*
F. *Timeline panel* **G.** *Stacked panels*

You customize a workspace by dragging the panels into the configuration that best suits your working style. You can drag panels to new locations, change the order of stacked panels, move panels into or out of a group, place panels alongside each other, stack panels, and undock a panel so that it floats in a new window above the application window. As you rearrange panels, the other panels resize automatically to fit the window.

When you drag a panel by its tab to relocate it, the area where you can drop it—called a *drop zone*—becomes highlighted. The drop zone determines where and how the panel is inserted into the workspace. Dragging a panel to a drop zone either docks it, groups it, or stacks it.

If you drop a panel along the edge of another panel, group, or window, it will dock next to the existing group, resizing all groups to accommodate the new panel.

If you drop a panel in the middle of another panel or group, or along the tab area of a panel, it will be added to the existing group and be placed at the top of the stack. Grouping a panel does not resize other groups.

You can also open a panel in a floating window. To do so, select the panel, and then choose Undock Panel or Undock Frame from the panel menu. Or, drag the panel or group outside the application window.

Getting started

A basic After Effects workflow follows six steps: importing and organizing footage, creating compositions and arranging layers, adding effects, animating elements, previewing your work, and rendering and outputting the final composition so that it can be viewed by others. In this lesson, you will create a simple animated video using this workflow, and along the way, you'll learn your way around the After Effects interface.

First, you'll preview the final movie to see what you'll create in this lesson.

1 Make sure the following files are in the Lessons/Lesson01 folder on your hard disk, or download them from peachpit.com now:

 • In the Assets folder: movement.mp3, swimming_dog.mp4, title.psd

 • In the Sample_Movie folder: Lesson01.mp4

2 Open and play the Lesson01.mp4 sample movie in Windows Movies & TV or QuickTime Player to see what you will create in this lesson. When you are done, close Windows Movies & TV or QuickTime Player. You may delete the sample movies from your hard disk if you have limited storage space.

Creating a project and importing footage

When you begin each lesson of this book, it's a good idea to restore the default preferences for After Effects so that your experience matches the descriptions and images in the book. (For more information, see "Restoring default preferences" on page 3.) You can do this with a simple keyboard shortcut.

1 Start After Effects, and then immediately hold down Ctrl+Alt+Shift (Windows) or Command+Option+Shift (macOS) to restore default preferences settings. In the Startup Repair Options dialog box, click Reset Preferences.

The Home window opens. It provides easy access to your recent After Effects projects, as well as to tutorials and more information about After Effects.

2 Click New Project in the Home window.

▶ **Tip:** Restoring default preferences can be tricky in Windows, especially if you're working on a fast system. Press the keys after you double-click the application icon but before After Effects begins to list the files it's activating. Alternatively, you can choose Edit > Sync Settings > Clear Settings, and then restart the application.

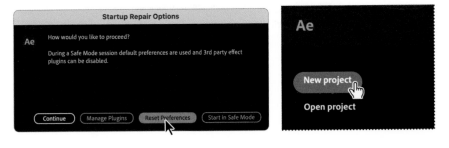

After Effects displays an empty, untitled project.

Tip: To quickly
maximize a panel,
double-click the panel
tab. To return it to its
original size, double-
click the tab again.

An After Effects project is a single file that stores references to all the footage
you use in that project. It also contains *compositions*, which are the individual
containers used to combine footage, apply effects, and, ultimately, drive the output.

When you begin a project, often the first thing you'll do is add footage to it.

Note: If the
files aren't next to
each other, Control-
click (Windows) or
Command-click
(macOS) to select them.
Do not select
the title.psd file.

3 Choose File > Import > File.

4 Navigate to the Assets folder in your Lessons/Lesson01 folder. Shift-click to select
 the movement.mp3 and swimming_dog.mp4 files. Then click Import or Open.

A *footage item* is the basic unit in an After Effects project. You can import many types of footage items, including moving-image files, still-image files, still-image sequences, audio files, layered files from Adobe Photoshop and Adobe Illustrator, other After Effects projects, and projects created in Adobe Premiere® Pro. You can import footage items at any time.

Because one of the footage items for this project is a multilayer Photoshop file, you'll import it separately as a composition.

5 Double-click in the lower area of the Project panel to open the Import File dialog box.

► **Tip:** You can also choose File > Import > Multiple Files to select files located in different folders or drag and drop files from Explorer or the Finder. You can use Adobe Bridge to search for, manage, preview, and import footage.

6 Navigate to the Lesson01/Assets folder again, and select the title.psd file. Choose Composition from the Import As menu. (In macOS, you may need to click Options to see the Import As menu.) Then click Import or Open.

After Effects opens an additional dialog box that displays options for the file you are importing.

7 In the title.psd dialog box, choose Composition from the Import Kind menu to import the layered Photoshop file as a composition. Select Editable Layer Styles in the Layer Options area, and then click OK.

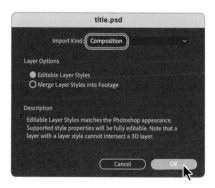

The footage items appear in the Project panel.

8 In the Project panel, click to select different footage items. Notice that a thumbnail preview appears at the top of the Project panel. You can also see the file type and size, as well as other information about each item, in the Project panel columns.

title ▾	
	576 x 144 (0.91)
	Δ 0;00;29;29, 29.97 …

Name	▲	Type	
movement.mp3	■	MP3	
swimming_dog.mp4	■	ImporterXDCAMEX	
title	□	Composition	
title Layers	■	Folder	

swimming_dog.mp4 ▾	
	1280 x 720 (1.00)
	Δ 0:00:07:00, 30.00 fps
	Millions of Colors
	avc1
	48.000 kHz / 32 bit U / Stereo

Name	▲	Type	S
movement.mp3	■	MP3	
swimming_dog.mp4	■	ImporterXDCAMEX	
title	□	Composition	
title Layers	■	Folder	

When you import files, After Effects doesn't copy the video and audio data itself into your project. Instead, each footage item in the Project panel contains a reference link to the source files. When After Effects needs to retrieve image or audio data, it reads it from the source file. This keeps the project file small and allows you to update source files in another application without modifying the project.

> **Tip:** You can locate missing fonts or effects the same way. Choose File > Dependencies, and then choose Find Missing Fonts or Find Missing Effects. Or just type **Missing Fonts** or **Missing Effects** into the Search box in the Project panel.

If you move a file or if After Effects can't access its location, it will report that the file is missing. To identify missing files, choose File > Dependencies > Find Missing Footage. You can also type **Missing Footage** into the Search box in the Project panel to look for the missing assets.

To save time and minimize the size and complexity of a project, you'll usually import a footage item once even if you're using it multiple times in a composition. However, you may sometimes need to import a source file more than once, such as if you want to use it at two different frame rates.

After you've imported footage, it's a good time to save the project.

9 Choose File > Save. In the Save As dialog box, navigate to the Lessons/
 Lesson01/Finished_Project folder. Name the project **Lesson01_Finished.aep**,
 and then click Save.

Creating a composition and arranging layers

The next step of the workflow is to create a composition. You create all animation,
layering, and effects in a composition. An After Effects composition has both spatial
dimensions and a temporal dimension (time).

Compositions include one or more layers, arranged in the Composition panel
and in the Timeline panel. Any item that you add to a composition—such as a
still image, moving-image file, audio file, light layer, camera layer, or even another
composition—becomes a new layer. Simple projects may include only one composi-
tion, while elaborate projects may include several compositions to organize large
amounts of footage or intricate effects sequences.

To create a composition, you'll drag the footage items into the Timeline panel,
and After Effects will create layers for them.

1 In the Project panel, Shift-click
 to select the movement.mp3,
 swimming_dog.mp4, and title assets.
 Don't select the title Layers folder.

2 Drag the selected footage items
 into the Timeline panel. The New
 Composition From Selection dialog
 box appears.

> **Tip:** To create
> a composition from
> footage as you import
> it, select Create
> Composition in the
> Import File dialog box.

After Effects bases the dimensions of the new composition on the selected footage. In this example, all of the footage is sized identically, so you'll accept the default settings for the composition.

3 Select swimming_dog.mp4 in the Use Dimensions From menu, and then click OK to create the new composition.

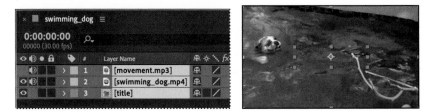

The footage items appear as layers in the Timeline panel, and After Effects displays the composition, named swimming_dog, in the Composition panel.

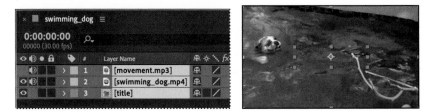

When you add a footage item to a composition, that footage becomes the source for a new layer. A composition can have any number of layers, and you can also include a composition as a layer in another composition, which is called *nesting*.

Some of the assets are longer than others, but you want them all to continue only as long as the swimming dog is on the screen. You'll change the length of the entire composition to 7:00 to match the dog clip.

4 Choose Composition > Composition Settings.

5 In the Composition Settings dialog box, rename the composition **movement**, type **7:00** for the Duration, and then click OK.

The Timeline panel displays the same duration for each of the layers.

In this composition, there are three footage items, and therefore three layers in the Timeline panel. Depending on the order in which the elements were selected when you imported them, your layer stack may differ from the one shown on the previous page. The layers need to be in a specific order as you add effects and animations, however, so you'll rearrange them now.

About layers

Layers are the components you use to build a composition. Any item that you add to a composition—such as a still image, moving-image file, audio file, light layer, camera layer, or even another composition—becomes a new layer. Without layers, a composition consists only of an empty frame.

Using layers, you can work with specific footage items in a composition without affecting any other footage. For example, you can move, rotate, and draw masks for one layer without disturbing any other layers in the composition, or you can use the same footage in more than one layer and use it differently in each instance. In general, the layer order in the Timeline panel corresponds to the stacking order in the Composition panel.

▶ **Tip:** To deselect all layers, click a blank area of the Timeline panel or press F2.

6 Click an empty area of the Timeline panel to deselect the layers, and then drag the title layer to the top of the layer stack, if it is not already there. Drag the movement.mp3 layer to the bottom of the layer stack.

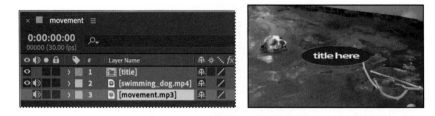

7 Choose File > Save to save your project so far.

Adding effects and modifying layer properties

● **Note:** This exercise is just the tip of the iceberg. You will learn more about effects and animation presets in Lesson 2, "Creating a Basic Animation Using Effects and Presets," and throughout the rest of this book.

Now that your composition is set up, you can start having fun—applying effects, making transformations, and adding animation. You can add any combination of effects and modify any of a layer's properties, such as size, placement, or opacity. Using effects, you can alter a layer's appearance or sound, and even generate visual elements from scratch. The easiest way to start is to apply any of the hundreds of effects included with After Effects.

Changing Transform properties

The title is currently in the center of the screen, obscuring the dog and distracting from the action. You'll move it to the lower left corner, where it will remain visible but not in the way.

1 Select the title layer (layer 1) in the Timeline panel. Notice that layer handles appear around the layer in the Composition panel.

2 Click the arrow to the left of the layer number to expand the layer, and then
 expand the layer's Transform properties: Anchor Point, Position, Scale, Rotation,
 and Opacity. Notice that the same properties appear in the Properties panel.

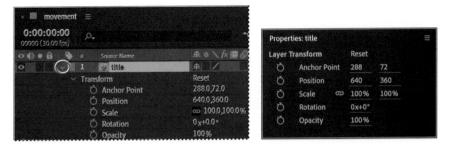

3 If you can't see the properties, scroll down the Timeline panel using the scroll
 bar at the right side of the panel. Better yet, select the title layer name again,
 and press P.

This keyboard shortcut displays only the Position property, which is the only property
you want to change for this exercise. You'll change the Position property to move the
title layer to the lower left corner.

4 Change the coordinates for the Position property to **265, 635**. Or use the
 Selection tool to drag the title to the lower left corner of the screen.

5 Press P to hide the Position property, or click the arrow to the left of the layer
 number to hide all properties.

Adding an effect to correct color

After Effects includes several effects to correct or modify color in your projects.
You'll use the Auto Contrast effect to adjust the overall contrast in the clip and
intensify the color of the water.

Note: If you double-click a layer in the Timeline panel, After Effects opens the layer in the Layer panel. To return to the Composition panel, click the Composition tab.

1 Select the swimming_dog.mp4 layer in the Timeline panel.

2 In the Effects & Presets panel (in the panel stack at the right side of the application window), type **contrast** in the search box.

After Effects searches for effects and presets that contain the letters you type, and displays the results interactively. Before you have finished typing, the Auto Contrast effect—located in the Color Correction category—appears in the panel.

3 Drag the Auto Contrast effect onto the swimming_dog layer in the Timeline panel.

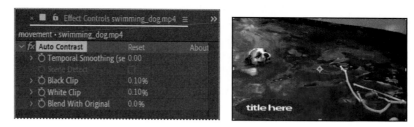

After Effects applies the effect and opens the Effect Controls panel in the upper left area of the workspace.

The contrast intensifies colors a little more than you need. You'll customize the settings to reduce the effect.

4 In the Effect Controls panel, click the number next to Blend With Original, type **20%**, and press Enter or Return to accept the new value.

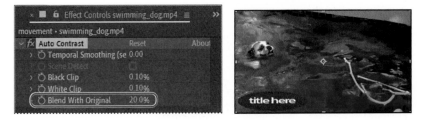

Adding a stylistic effect

After Effects also includes many stylistic effects. You'll add a beam of light to the clip to add an artistic touch. You'll change the settings of this effect to modify the angle and intensity of the light.

1 Click the *x* in the search box in the Effects & Presets panel to clear it, and then locate the CC Light Sweep effect by doing one of the following:

 • Type **CC Light** in the search box.

 • Click the arrow next to Generate to expand the category in alphabetical order.

2 Drag the CC Light Sweep effect in the Generate category onto the swimming_dog layer name in the Timeline panel. After Effects adds the CC Light Sweep settings to the Effect Controls panel under the Auto Contrast effect.

3 In the Effect Controls panel, click the arrow next to the Auto Contrast effect to hide those settings so that you can see the CC Light Sweep settings more easily.

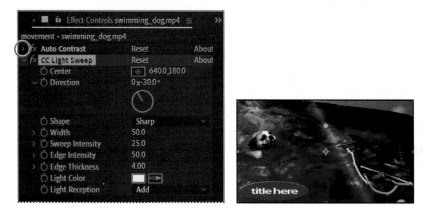

First, you'll change the angle of the light.

4 For Direction, type **37°**.

5 From the Shape menu, choose Smooth to widen and soften the light beam.

6 For Width, type **68** to widen the beam a bit more.

7 Change the Sweep Intensity value to **20** to make the beam a little more subtle.

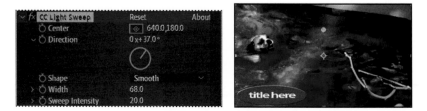

8 Choose File > Save to save your work so far.

Animating the composition

So far, you've started a project, created a composition, imported footage, and applied some effects. It all looks great, but how about some movement? You've applied only static effects.

In After Effects, you can change any combination of a layer's properties over time using conventional keyframing, expressions, or keyframe assistants. You'll explore many of these methods throughout the lessons of this book. For this project, you'll apply an animation preset to introduce the title to the screen, and you'll animate the title's color over time.

Preparing the text composition

In this exercise, you'll work with a separate composition—the one you imported from a layered Photoshop file.

1 Select the Project tab to display the Project panel, and then double-click the title composition to open it as a separate composition in its own Timeline panel.

● **Note:** If the Project tab isn't visible, choose Window > Project to open the Project panel.

This composition is the layered Photoshop file you imported. Two layers—Title Here and Ellipse 1—appear in the Timeline panel. The Title Here layer contains place-holder text that was created in Photoshop.

At the top of the Composition panel is the Composition Navigator bar, which displays the relationship between the main composition (movement) and the current composition (title), which is nested within the main composition.

You can nest multiple compositions within each other; the Composition Navigator bar displays the entire composition path. Arrows between the composition names indicate the direction in which information flows.

Before you can replace the text, you need to make the layer editable.

About the Tools panel

As soon as you create a composition, the tools in the Tools panel in the upper left corner of the After Effects application window become available. After Effects includes tools that enable you to modify elements of your composition. Some of these tools—the Selection tool and the Hand tool, for example—will be familiar to you if you use other Adobe applications, such as Photoshop. Others will be new.

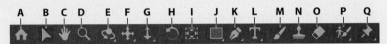

A. Home **B.** Selection **C.** Hand **D.** Zoom **E.** Orbit Camera **F.** Pan Camera **G.** Dolly Camera **H.** Rotation **I.** Pan Behind **J.** Mask and Shape tools **K.** Pen tools **L.** Type tools **M.** Brush **N.** Clone Stamp **O.** Eraser **P.** Roto Brush and Refine Edge tools **Q.** Puppet tools

When you hover the pointer over any button in the Tools panel, a tool tip identifies the tool and its keyboard shortcut. A small triangle in the lower right corner of the button indicates that one or more additional tools are hidden behind it. Click and hold the button to display the hidden tools, and then select the tool you want to use.

● **Note:** If you see a warning about missing fonts or layer dependencies, click OK. If Adobe Fonts opens, activate the missing font.

2 Select the Title Here layer (layer 1) in the Timeline panel, and then choose Layer > Create > Convert To Editable Text.

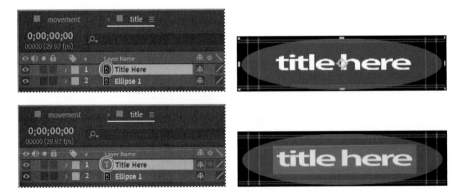

A T icon appears next to the layer name in the Timeline panel, indicating that it is now an editable text layer. The layer is also selected in the Composition panel, ready for you to edit.

The blue lines at the top, bottom, and sides of the Composition panel indicate title-safe and action-safe zones. Television sets enlarge a video image and allow some portion of its outer edges to be cut off by the edge of the screen. This is known as *overscan*. The amount of overscan is not consistent between television sets, so you should keep important parts of a video image, such as action or titles, within

margins called *safe zones*. Keep your text inside the inner blue guides to ensure that it is in the title-safe zone, and keep important scene elements inside the outer blue guides to ensure that they are in the action-safe zone.

Editing text

You'll start by replacing the placeholder text with real text. Then you'll format it to fit the space better.

1 Select the Horizontal Type tool (T) in the Tools panel, and drag over the placeholder text in the Composition panel to select it. Then type **on the move**.

● **Note:** After Effects offers robust character and paragraph formatting controls, but the default settings—whatever typeface appears when you type—should be fine for this project. You'll learn more about type in Lesson 3, "Animating Text."

2 Select the text again. Then, in the Text section of the Properties panel (on the right side of the screen), change the text size to **100 px** and the tracking to **–50**.

Animating text with animation presets

Now that the text is formatted, you can apply an animation preset. You'll use the Fade Up Words preset, so the words will appear in order over time.

1 Select the Title Here layer in the Timeline panel again, and make sure you're at the first frame of the animation by doing one of the following:

- Drag the current-time indicator all the way to the left of the time ruler, to 0:00.

- Press the Home key on your keyboard.

2 In the Effects & Presets panel, type **fade up words** in the search box.

3 Select the Fade Up Words effect in the Animate In category, and drag it onto the *on the move* text in the Composition panel.

After Effects adds the effect. Because it's a simple effect, there are no settings in the Effect Controls panel.

4 Manually preview the effect by dragging the current-time indicator from 0:00 to 1:00. The words fade in, so that they are all onscreen by 1:00.

About timecode and duration

The primary concept related to time is *duration*, or length. Each footage item, layer, and composition in a project has its own duration, which is reflected in the beginning and ending times displayed in the time rulers in the Composition, Layer, and Timeline panels.

The way you view and specify time in After Effects depends on the display style, or unit of measure, that you use to describe time. By default, After Effects displays time in Society of Motion Picture and Television Engineers (SMPTE) timecode: hours, minutes, seconds, and frames. Note that the figures are separated by semicolons in the After Effects interface, representing drop-frame timecode (which adjusts for the real-time frame rate), but this book uses a colon to represent non-drop-frame timecode.

To learn when and how to change to another system of time display, such as frames, or feet and frames of film, see After Effects Help.

About the Timeline panel

Use the Timeline panel to animate layer properties and set In and Out points for a layer. (In and Out points are the points at which a layer begins and ends in the composition.) Many of the Timeline panel controls are organized in columns of related functions. By default, the Timeline panel contains a number of columns and controls, as shown here:

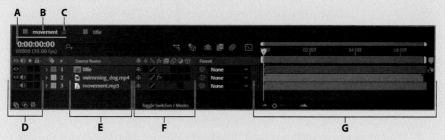

A. Current time **B.** Composition name **C.** Timeline panel menu **D.** Audio/Video Switches column
E. Source Name/Layer Name column **F.** Layer switches **G.** Time graph/Graph Editor area

Understanding the time graph

The time graph portion of the Timeline panel (the right side) contains a time ruler, markers to indicate specific times, and duration bars for the layers in your composition.

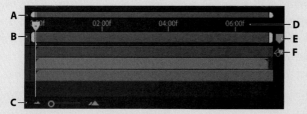

A. Time navigator start and end brackets
B. Work area start and end brackets
C. Time zoom slider
D. Time ruler
E. Composition marker bin
F. Composition button

Before delving too deeply into animation, it will help to understand at least some of these controls. The duration of a composition, a layer, or a footage item is represented visually in the time graph. On the time ruler, the current-time indicator marks the frame you are viewing or editing, and the frame appears in the Composition panel.

The work area start and end brackets indicate the part of the composition that will be rendered for previews or final output. When you work on a composition, you may want to render only a portion of it by specifying a segment of the composition time ruler as a work area.

A composition's current time appears in the upper left corner of the Timeline panel. To move to a different time, drag the current-time indicator in the time ruler—or click the current-time field in the Timeline panel or Composition panel, type a new time, and press Enter or Return, or click OK.

For more information about the Timeline panel, see After Effects Help.

Animating effects using keyframes

You'll add an effect to the type layer, but this time, you'll animate its settings using keyframes.

1 Go to the beginning of the time ruler by doing one of the following:

 • Drag the current-time indicator to the left in the time ruler so that it's positioned at 0:00.

 • Click the Current Time field in the Timeline panel or Composition panel, and type **00**. If you clicked in the Current Time field in the Composition panel, click OK to close the Go To Time dialog box.

2 Type **channel blur** in the search box in the Effects & Presets panel.

3 Drag the Channel Blur effect onto the Title Here layer in the Timeline panel.

After Effects adds the Channel Blur effect to the layer and displays its settings in the Effect Controls panel. The Channel Blur effect individually blurs the red, green, blue, and alpha channels in a layer. It will create an interesting look for the title.

4 In the Effect Controls panel, set the Red Blurriness, Green Blurriness, Blue Blurriness, and Alpha Blurriness values to **50**.

5 Click the stopwatch icon (⏱) next to each of the settings you changed to create initial keyframes. The text will be blurred as it first appears.

Keyframes are used to create and control animation, effects, audio properties, and many other kinds of changes that occur over time. A keyframe marks the point in time where you specify a value, such as spatial position, opacity, or audio volume. Values between keyframes are *interpolated*. When you use keyframes to create a change over time, you must use at least two keyframes—one for the state at the beginning of the change, and one for the state at the end of the change.

6 From the Blur Dimensions menu, choose Vertical.

7 Go to 1:00 in the timeline.

8 Change the values to the following:

- Red Blurriness: **0**

- Green Blurriness: **0**

- Blue Blurriness: **0**

- Alpha Blurriness: **0**

9 Manually preview the effect by moving the current-time indicator from 0 to 1:00.

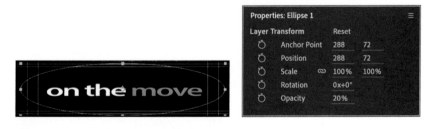

Changing the opacity of the background

The title looks good, but the ellipse is too bright. You'll change its opacity so that the water in the video shows through.

1 In the Timeline panel, select the Ellipse 1 layer.

2 In the Properties panel, change the Opacity value to **20%**.

▶ **Tip:** You can change Opacity values in the Properties panel or the Timeline panel. In the Timeline panel, the keyboard shortcut for the Opacity property is T: think of it as *transparency*.

▶ **Tip:** To see how the title appears over the water, click the movement tab in the Timeline panel.

Using the Properties panel

The Properties panel provides quick access to properties for the selected layer. It displays Transform properties for all layers, and additional properties for text or shape layers. You can also animate essential properties in a nested composition in the Properties panel.

To reveal a property in the Timeline panel, double-click its name in the Properties panel.

You can animate many properties using either the Timeline panel or the Properties panel, depending on your preferences and workflow. Throughout the book, we use the Properties panel when it's more efficient to do so.

Previewing your work

You're probably eager to see the results of your work. You can preview your composition using the Preview panel, which is in the stacked panels on the right side of the application window in the default workspace. To preview your composition, click the Play/Stop button in the Preview panel, or press the spacebar on your keyboard.

1 In the title Timeline panel, hide all layer properties, and deselect all layers.

2 Make sure that the Video switch () is selected for the layers that you want to preview—in this case, the Title Here and Ellipse 1 layers.

3 Press the Home key to go to the beginning of the time ruler.

4 Do one of the following:

- Click the Play/Stop button (▶) in the Preview panel.
- Press the spacebar.

▶**Tip:** Verify that the work area brackets include all the frames you want to preview.

5 To stop the preview, do one of the following:

- Click the Play/Stop button in the Preview panel.
- Press the spacebar.

You've previewed a simple animation, so it probably played back in real time.

When you press the spacebar or click the Play/Stop button, After Effects caches the composition and allocates enough RAM to play the preview (with audio) as fast as the system allows, up to the frame rate of the composition. The number of frames played depends on the amount of RAM available to the application.

In the Timeline panel, the preview plays either the span of time you specify as the work area or from the beginning of the time ruler. In the Layer and Footage panels, the preview plays only untrimmed footage. Before you preview, check which frames are designated as the work area.

Now you'll preview the entire composition—the animated text plus graphic effects.

6 Click the movement tab in the Timeline panel to bring it forward.

7 Make sure that the Video switch (👁) is turned on for all of the layers in the composition except the audio layer, and press F2 to deselect all layers.

8 Drag the current-time indicator to the beginning of the time ruler, or press the Home key.

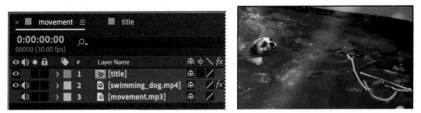

9 To start the preview, click the Play/Stop button (▶) in the Preview panel, or press the spacebar.

▶ **Tip:** To toggle whether After Effects renders and caches frames when idle, choose Composition > Preview > Cache Frames When Idle. To customize how this feature works, change settings in the Previews panel of the After Effects Preferences dialog box.

A green progress bar indicates which frames are cached to RAM. When all of the frames in the work area are cached, the preview plays back in real time. By default, After Effects caches frames when it's not actively performing other actions. This can save you time and provide more accurate previews more quickly. However, if After Effects hasn't cached all the included frames yet, the playback may be slower and the audio may drag the first time you preview the movie.

The more detail and precision you want to preview, the more RAM is required. You can control the amount of detail shown by changing the resolution, magnification, and preview quality of your composition. You can also limit the number of layers previewed by turning off the Video switch for certain layers, or limit the number of frames previewed by adjusting the composition's work area.

10 Press the spacebar to stop the preview.

11 Choose File > Save to save your project.

Optimizing performance in After Effects

How you configure After Effects and your computer determines how quickly After Effects renders projects. Complex compositions can require a large amount of memory to render, and the rendered movies can take a large amount of disk space to store. Search for "Improve Performance" in After Effects Help for tips that can help you configure your system, After Effects preferences, and your projects for better performance.

By default, After Effects enables GPU acceleration for effects, layer animations, and other features that can take advantage of the performance enhancements. Adobe recommends enabling GPU acceleration. However, if you receive an error or know that your system's GPU is not compatible with After Effects, you can disable GPU acceleration for a project: Choose File > Project Settings, and then choose Mercury Software Only on the Video Rendering And Effects tab.

▶ **Tip:** See the status of GPU acceleration quickly. The rocket icon at the bottom of the Project panel is dimmed when GPU acceleration is disabled.

Rendering and exporting your composition

When you're finished with your masterpiece—as you are now—you can render and export it at the quality settings you choose, and create movies in the formats that you specify. You will learn about exporting compositions in subsequent lessons, especially in Lesson 15, "Rendering and Outputting."

Customizing workspaces

In the course of this project, you may have resized or repositioned some panels or opened new ones. As you modify a workspace, After Effects saves those modifications, so the next time you open the project, the most recent version of a workspace is used. However, you can choose to restore the original workspace at any time by choosing Window > Workspace > Reset "Default" To Saved Layout.

Alternatively, if you find yourself frequently using panels that aren't part of the Default workspace, or if you like to resize or group panels for different types of projects, you can save time by customizing the workspace to suit your needs. You can save any workspace configuration, or use any of the preset workspaces that come with After Effects. These predefined workspaces are suitable for different types of workflows, such as animation or effects work.

Using predefined workspaces

Take a minute to explore the predefined workspaces in After Effects.

1 If you closed the Lesson01_Finished.aep project, open it—or any other project—to explore the workspaces.

2 Click Animation in the Workspace bar, which is next to the Tools panel. Click the double arrows (**»**) to see workspaces that don't fit in the Workspace bar.

After Effects opens the panels that you would commonly use for animation tasks, including Motion Sketch, Wiggler, and Smoother. You can also change workspaces using the Workspace menu.

3 Choose Window > Workspace > Motion Tracking.

Different panels open. The Info, Preview, Tracker, and Content-Aware Fill panels give you easy access to tools and controls commonly used when tracking motion.

Saving a custom workspace

You can save any workspace, at any time, as a custom workspace. Once saved, new and edited workspaces appear in the Window > Workspace submenu and in the Workspace bar at the top of the application window. If a project with a custom workspace is opened on a system other than the one on which it was created, After Effects looks for a workspace with a matching name. If After Effects finds a match (and the monitor configuration matches), it uses that workspace; if it can't find a match (or the monitor configuration doesn't match), it opens the project using the current local workspace.

1 Close a panel by choosing Close Panel from its panel menu.

2 Choose Window > Effects & Presets to open another panel.

The Effects & Presets panel is added to the panel stack.

3 Choose Window > Workspace > Save As New Workspace. Enter a name for the workspace, and click OK to save it, or click Cancel if you don't want to save it.

4 Click Default in the Workspace bar to restore the original panels.

Controlling the brightness of the user interface

You can brighten or darken the After Effects user interface. Changing the brightness preference affects panels, windows, and dialog boxes.

1 Choose Edit > Settings > Appearance (Windows) or After Effects > Settings > Appearance (macOS).

2 Drag the Brightness slider to the left or right, and notice how the screen changes.

Note: By default, the After Effects user interface is dark. We've used a lighter interface for the images in this book so that text in the interface will be visible in print. If you use the default UI brightness, your panels and dialog boxes will appear darker than ours.

3 Click OK to save the new brightness setting or Cancel to leave your preferences unchanged. You can click Default to restore the default brightness setting.

4 Choose File > Close Project to close the file without saving any changes.

Collaborating in After Effects

You can work with others remotely using features in After Effects designed to enable collaboration. To create a shared project, choose File > New > New Team Project, and then invite others to work in a project whose media is saved to a shared location such as Creative Cloud or Dropbox. Frame.io, included with Creative Cloud, makes it easier to share content for review and approval without leaving your composition. To learn about collaboration features, see After Effects Help.

Finding resources for using After Effects

After Effects includes interactive tutorials in the application itself. To access them, select Learn in the Workspace bar. An overview of the interface and essential features is available in the Learn panel, as are several interactive tutorials.

The Home window that appears when you open the application provides quick access to the tutorials in the Learn panel as well as more advanced tutorials online. Additionally, it provides links to other information to help you get the most out of After Effects. You can return to the Home window at any time by clicking the Home icon in the Tools panel.

For complete and up-to-date information about using After Effects panels, tools, and other application features, visit the Adobe website. To search for information in After Effects Help and support documents, as well as on other websites relevant to After Effects users, simply enter a search term in the Search Help box in the upper right corner of the application window. You can narrow the results to view only Adobe Help and support documents.

For additional resources, such as tips and techniques and the latest product information, check out the After Effects Help And Support page at helpx.adobe.com/after-effects.html.

Congratulations! You've finished Lesson 1. Now that you're acquainted with the After Effects workspace, you can continue to Lesson 2 to learn how to create and animate compositions using effects and preset animations, or you can proceed to another lesson in this book.

Review questions

1 What are the basic components of the After Effects workflow?

2 What is a composition?

3 How can you find missing footage?

4 How can you preview your work in After Effects?

5 How can you customize an After Effects workspace?

Review answers

1 Most After Effects workflows include these steps: importing and organizing footage, creating compositions and arranging layers, adding effects, animating elements, previewing your work, and rendering and exporting the final composition.

2 A composition is where you create all animation, layering, and effects. An After Effects composition has both spatial and temporal (time) dimensions. Compositions include one or more layers—video, audio, still images—arranged in the Composition panel and in the Timeline panel. Simple projects may include only one composition, while elaborate projects may include several compositions to organize large amounts of footage or intricate effects sequences.

3 To locate missing footage, choose File > Dependencies > Find Missing Footage. Or type **Missing Footage** into the Search field in the Project panel.

4 You can manually preview your work in After Effects by moving the current-time indicator, or you can press the spacebar or click the Play/Stop button in the Preview panel to preview your composition from the current-time indicator to the end of the composition. After Effects allocates enough RAM to play the preview (with audio) as fast as the system allows, up to the frame rate of the composition.

5 You can customize an After Effects workspace by dragging the panels into the configuration that best suits your working style. You can drag panels to new locations, move panels into or out of groups, place panels alongside each other, stack panels, and undock a panel so that it floats above the application window. As you rearrange panels, the other panels resize automatically to fit the application window. You can save custom workspaces by choosing Window > Workspace > Save As New Workspace.

2 CREATING A BASIC ANIMATION USING EFFECTS AND PRESETS

Lesson overview

In this lesson, you'll learn how to do the following:

- Work with the layers of an imported Adobe Illustrator file.
- Use guides to position objects.
- Apply drop-shadow and emboss effects.
- Apply a text animation preset.
- Precompose layers.
- Apply a dissolve transition effect.
- Adjust the transparency of a layer.
- Render an animation for broadcast use.

 This lesson will take about an hour to complete. If you haven't already done so, download the project files for this lesson from peachpit.com/ AfterEffectsCIB2024, following the instructions in the Getting Started section under "Accessing the lesson files and Web Edition."

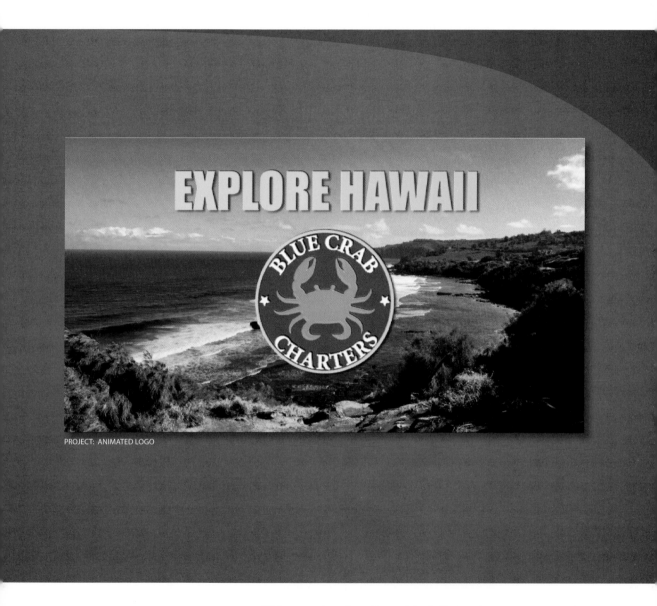

PROJECT: ANIMATED LOGO

Hit the ground running with a variety of effects and animation presets in After Effects. You can use them to create great-looking animations quickly and easily.

Getting started

In this lesson, you will become more familiar with the Adobe After Effects project workflow. You'll learn new ways to accomplish basic tasks as you create a simple identification graphic for the introduction to a video presentation called "Explore Hawaii" for the fictional Blue Crab Charter Services. You will animate the title and logo so that they fade to become a watermark in the lower right corner of the screen during the presentation. Then you'll export the introduction for broadcast output.

First, take a look at the final project files to see what you'll be doing.

1 Make sure the following files are in the Lessons/Lesson02 folder on your hard disk, or download them from peachpit.com now:

 • In the Assets folder: BlueCrabLogo.ai, MauiCoast.jpg

 • In the Sample_Movie folder: Lesson02.mp4

2 Open and play the Lesson02.mp4 sample movie in Windows Movies & TV or QuickTime Player to see what you will create in this lesson. When you are done, close Windows Movies & TV or QuickTime Player. You may delete the sample movie from your hard disk if you have limited storage space.

Before you begin the lesson, you'll restore the default application settings for After Effects. See "Restoring default preferences" on page 3 for more information.

3 Start After Effects, and then immediately hold down Ctrl+Alt+Shift (Windows) or Command+Option+Shift (macOS) to restore default preferences settings. In the Startup Repair Options dialog box, click Reset Preferences.

4 In the Home window, click New Project.

After Effects opens to display a blank, untitled project.

5 Choose File > Save As > Save As.

6 In the Save As dialog box, navigate to the Lessons/Lesson02/ Finished_Project folder.

7 Name the project **Lesson02_Finished.aep**, and then click Save.

Creating a new composition

Following the workflow you learned in Lesson 1, you need to import footage and create a new composition. After you've created a composition, you'll add your footage item to it.

Importing a background image

You'll import the background image first.

1 Choose File > Import > File, and navigate to the Assets folder in your Lessons/Lesson02 folder.

2 Select the MauiCoast.jpg file, and click Import or Open.

Creating an empty composition

First, you'll create the composition itself, without any layers.

1 Create a new composition by doing one of the following:

- Click the Create A New Composition button (▣) at the bottom of the Project panel.

- Click the New Composition button in the Composition panel.

- Choose Composition > New Composition.

- Press Ctrl+N (Windows) or Command+N (macOS).

2 In the Composition Settings dialog box, do the following:

- Name the composition **Explore Hawaii**.

- Choose HD • 1920x1080 • 29.97 fps from the Preset pop-up menu. This preset automatically sets the width, height, pixel aspect ratio, and frame rate for a high-definition video.

- In the Duration field, type **300** to specify 3 seconds, and then click OK.

After Effects displays an empty composition named Explore Hawaii in the Composition panel and in the Timeline panel. Now, you'll add the background.

3 Drag the MauiCoast.jpg footage item from the Project panel to the Timeline panel to add it to the Explore Hawaii composition.

Tip: The keyboard shortcut for fitting a layer to a composition is Ctrl+Alt+F (Windows) or Command+Option+F (macOS).

4 With the MauiCoast layer selected in the Timeline panel, choose Layer > Transform > Fit To Comp to scale the background image to the dimensions of the composition.

Importing the foreground element

Your background is now in place. The foreground object you'll use is a layered vector graphic that was created in Illustrator.

1 Choose File > Import > File.

2 In the Import File dialog box, select the BlueCrabLogo.ai file in the Lessons/ Lesson02/Assets folder. (It's named BlueCrabLogo if file extensions are hidden.)

3 Choose Composition from the Import As menu. (In macOS, you may need to click Options to display the Import As menu.) Then click Import or Open.

The Illustrator file is added to the Project panel as a composition named BlueCrabLogo. A folder named BlueCrabLogo Layers also appears. This folder contains the three individual layers of the Illustrator file. Click the arrow to open the folder and see its contents if you like.

4 Drag the BlueCrabLogo composition file from the Project panel into the Timeline panel above the MauiCoast layer.

You should now see both the background image and the logo in the Composition panel and in the Timeline panel.

5 Choose File > Save to save your work so far.

Working with imported Illustrator layers

The BlueCrabLogo graphic was created in Illustrator; your job in After Effects is to add text and animate it. To work with the layers of the Illustrator file independently of the background footage, you'll open the BlueCrabLogo composition in its own Timeline and Composition panels.

1 Double-click the BlueCrabLogo composition in the Project panel.

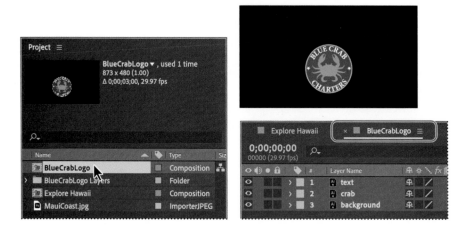

The composition opens in its own Timeline and Composition panels.

2 Select the Horizontal Type tool (T) in the Tools panel, and click in the Composition panel.

3 Type **EXPLORE HAWAII**, all capital letters, and then select all of the text you just entered. Notice that the generic Text 1 layer name in the Timeline panel changes to EXPLORE HAWAII, the text you typed.

● **Note:** You could also make these changes in the Character panel. To open it, choose Window > Character.

4 In the Text section of the Properties panel, select a sans serif typeface such as Impact, and change the font size to **80** pixels.

5 Click the eyedropper (🖊) next to Fill in the Properties panel, and click the outer border on the logo to select the yellow color.

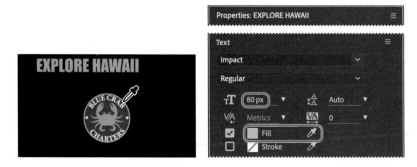

After Effects applies it to the text you typed. Leave all other options in the Text section of the panel at their defaults.

You'll position the text you just typed using a guide.

6 Select the Selection tool (▶) in the Tools panel.

7 Choose View > Show Rulers, and then drag a guide from the top ruler into the Composition panel.

8 Right-click or Control-click the guide, click Edit Position, type **120** in the Edit Value dialog box, and click OK. The guide moves to the position you specified.

▶ **Tip:** You can also choose View > Show Grid to make the nonprinting grid visible to help you position objects. Choose View > Show Grid again to hide the grid later.

9 Drag the text so that it is centered over the image, snapping its bottom edge to the guide.

10 Drag another guide from the top ruler, right-click or Control-click it, click Edit Position, type **150** in the Edit Value dialog box, and click OK.

11 In the Timeline panel, select the background layer, and then Shift-select the text layer to select all three logo layers. Align the top of the logo with the lower guide.

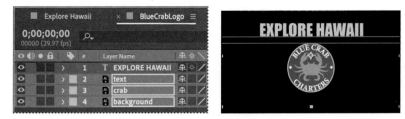

12 Choose View > Show Rulers, and then choose View > Show Guides, to hide the ruler and the guides.

13 Choose File > Save to save your work.

Applying effects to a layer

Now you'll return to the main composition, Explore Hawaii, and apply an effect to the BlueCrabLogo layer. This will apply the effect to all of the layers nested in the BlueCrabLogo composition.

1 Click the Explore Hawaii tab in the Timeline panel, and then select the BlueCrabLogo layer.

2 In the Properties panel, change the scale to **250%**.

The effect you create next will be applied only to the logo elements, not to the background image.

3 With the layer still selected, choose Effect > Perspective > Drop Shadow.

A soft-edged shadow appears behind the nested layers of the BlueCrabLogo layer—the logo graphic and the words *Explore Hawaii*—in the Composition panel. You can customize the effect using the Effect Controls panel.

4 Choose Window > Effect Controls if the Effect Controls panel isn't already open. In the Effect Controls panel, make sure that the drop shadow's Distance is **5,** and increase its Softness to **4**. You can set each value by clicking the field and typing the number or by dragging the blue value.

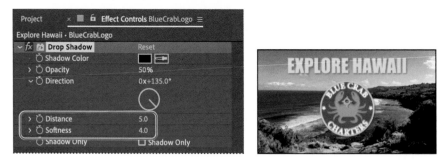

The drop shadow is nice, but the logo will stand out even more if you apply an emboss effect. You can use either the Effect menu or the Effects & Presets panel to locate and apply effects.

5　Click the Effects & Presets tab to open the panel. Then click the arrow next to Stylize to expand the category.

6　With the BlueCrabLogo layer selected in the Timeline panel, drag the Color Emboss effect into the Composition panel.

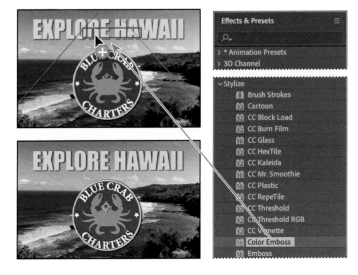

The Color Emboss effect sharpens the edges of objects in the layer without suppressing the original colors. The Effect Controls panel displays the Color Emboss effect and its settings below the Drop Shadow effect.

7　Choose File > Save to save your work.

Applying and controlling effects

You can apply or remove an effect at any time. Once you've applied effects to a layer, you can temporarily turn off one or all of the effects in the layer to concentrate on another aspect of your composition. Effects that are turned off do not appear in the Composition panel, and typically aren't included when the layer is previewed or rendered.

By default, when you apply an effect to a layer, the effect is active for the duration of the layer. However, you can make an effect start and stop at specific times, or make the effect more or less intense over time. You'll learn more about creating animation using keyframes and expressions in Lesson 5, "Animating a Multimedia Presentation," and Lesson 6, "Animating Layers."

You can apply and edit effects on adjustment layers just as you do with other layers. Note, however, that when you apply an effect to an adjustment layer, the effect is applied to all layers below it in the Timeline panel.

Effects can also be saved, browsed, and applied as animation presets.

Applying an animation preset

You've positioned the type and applied some effects to it. It's time to add some animation! You will learn several ways to animate text in Lesson 3; for now, you'll use a simple animation preset that will fade the words *Explore Hawaii* onto the screen next to the logo. You'll need to work in the BlueCrabLogo composition so that you can apply the animation to only the EXPLORE HAWAII text layer.

1 Click the BlueCrabLogo tab in the Timeline panel, and select the EXPLORE HAWAII layer.

2 Move the current-time indicator to 1:05, which is the point at which you want the text to start fading in.

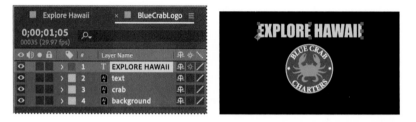

3 In the Effects & Presets panel, choose Animation Presets > Text > Animate In.

4 Drag the Fade Up Words animation preset onto the EXPLORE HAWAII layer in the Timeline panel or over the words *Explore Hawaii* in the Composition panel. Don't worry about the text disappearing— you're looking at the first frame of the animation, before the words have started to appear.

5 Click a blank area of the Timeline panel to deselect the EXPLORE HAWAII layer, and then drag the current-time indicator to 2:10 to manually preview the text animation. The text appears, one word at a time, until the words *Explore Hawaii* are fully onscreen at 2:10.

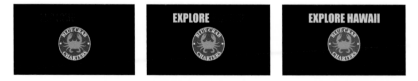

Precomposing layers for a new animation

The presentation graphic is coming along nicely, and you're probably eager to preview the complete animation. Before you do, however, you'll add a dissolve to all of the logo elements except the words *Explore Hawaii*. To do this, you need to precompose the other three layers of the BlueCrabLogo composition: text, crab, and background.

Precomposing is a way to nest layers within a composition. Precomposing moves the layers to a new composition, which takes the place of the selected layers. When you want to change the order in which layer components are rendered, precomposing is a quick way to create intermediate levels of nesting in an existing hierarchy.

1 Shift-click to select the text, crab, and background layers in the BlueCrabLogo Timeline panel.

2 Choose Layer > Pre-compose.

3 In the Pre-compose dialog box, name the new composition **Dissolve_logo**. Make sure the Move All Attributes Into The New Composition option is selected. Then click OK.

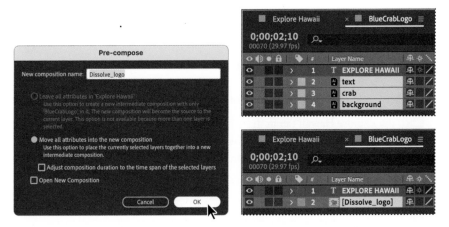

The three layers are replaced in the BlueCrabLogo Timeline panel with a single layer, Dissolve_logo. This new, precomposed layer contains the three layers that you selected in step 1. You can apply the dissolve effect to it without affecting the EXPLORE HAWAII text layer and its Fade Up Words animation.

4 Make sure the Dissolve_logo layer is selected in the Timeline panel, and press the Home key or drag the current-time indicator to 0:00.

Tip: To locate the Dissolve – Vapor preset quickly, type **vap** in the search box in the Effects & Presets panel.

5 In the Effects & Presets panel, choose Animation Presets > Transitions – Dissolves, and then drag the Dissolve – Vapor animation preset onto the Dissolve_logo layer in the Timeline panel or onto the Composition panel.

The Dissolve – Vapor animation preset includes three components—a master dissolve, a box blur, and a solid composite, all of which appear in the Effect Controls panel. The default settings are fine for this project.

6 Choose File > Save.

Previewing the effects

It's time to preview all of the effects together.

1 Click the Explore Hawaii tab in the Timeline panel to switch to the main composition. Press the Home key or drag the current-time indicator to make sure you're at the beginning of the time ruler.

2 Make sure the Video switch (⊕) is selected for both layers in the Explore Hawaii Timeline panel.

3 Click the Play button (▶) in the Preview panel, or press the spacebar, to watch the preview. Press the spacebar to stop playback at any time.

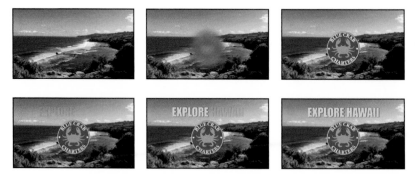

Adding transparency

The logo should appear semitransparently in the corner of the frame during the presentation. You'll reduce the opacity of the logo, scale it, and shift its position so that it can be used this way.

1 Still in the Explore Hawaii Timeline panel, go to 2:10.

2 Select the BlueCrabLogo layer in the Timeline panel.

3 In the Properties panel, click the stopwatch icon (⏱) next to Opacity to set a keyframe at this point in time. By default, the Opacity is 100%—fully opaque.

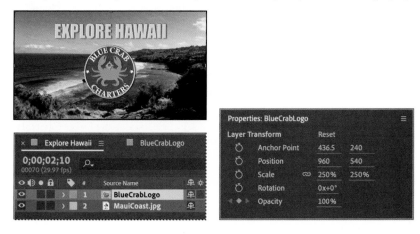

4 Press the End key or drag the current-time indicator to go to the end of the time ruler (2:29), and change the Opacity to **40%**. After Effects adds a keyframe.

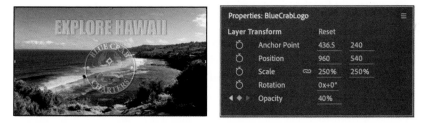

The logo appears, the words *Explore Hawaii* show up, and it all fades to 40% opacity.

5 Go to 2:10, and click the stopwatch icons (⏱) to set initial keyframes for both the Position and Scale properties.

6 Go to 2:25, and change the Scale to **60**% and the Position to **1700, 935**.

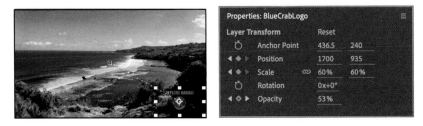

7 Click the Play button (▶) in the Preview panel, press the spacebar, or press 0 on your numeric keypad to preview your composition.

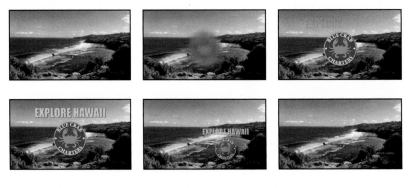

8 Press the spacebar to stop playback when you're done.

9 Choose File > Save to save your project.

Rendering the composition

● **Note:** For more about output formats and rendering, see Lesson 15, "Rendering and Outputting."

You're ready to prepare your presentation intro for output. When you create output, the layers of a composition and each layer's masks, effects, and properties are rendered frame by frame into one or more output files or, in the case of an image sequence, into a series of consecutive files.

Making a movie from your final composition can take a few minutes or many hours, depending on the composition's frame size, quality, complexity, and compression method. When you place your composition in the Render Queue, it becomes a render item that uses the render settings assigned to it.

● **Note:** For output to final-delivery formats, you can also use Adobe Media Encoder. You'll learn about Adobe Media Encoder in Lesson 15, "Rendering and Outputting."

After Effects provides a variety of formats and compression types for rendering output; the format you choose depends on the medium from which you'll play your final output or on the requirements of your hardware, such as a video-editing system.

You'll render and export the composition so that it can be broadcast on television.

1 Click the Project tab to bring the Project panel forward. If the Project tab is not visible, choose Window > Project.

2 Do one of the following to add the composition to the Render Queue:

- Select the Explore Hawaii composition in the Project panel, and choose Composition > Add To Render Queue. The Render Queue panel opens automatically.

- Choose Window > Render Queue to open the Render Queue panel, and then drag the Explore Hawaii composition from the Project panel onto the Render Queue panel.

3 Click the arrow to expand the Render Settings options. By default, After Effects renders compositions with Best Quality and Full Resolution. The default settings are fine for this project.

4 Click the arrow to expand the Output Module options. By default, After Effects uses the H.264 – Match Render Settings – 15Mbps setting to encode the rendered composition into a movie file.

5 Click the blue words next to the Output To menu.

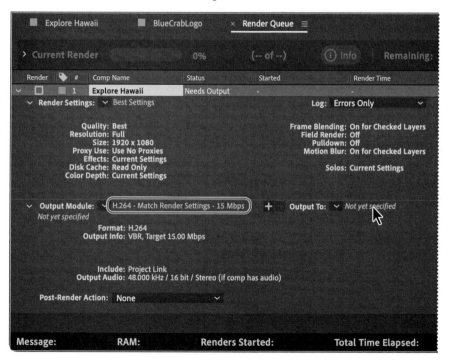

6 In the Output Movie To dialog box, accept the default movie name (Explore Hawaii), select the Lessons/Lesson02/Finished_Project folder for the location, and then click Save.

7 Back in the Render Queue panel, click the Render button.

After Effects displays a progress bar in the Render Queue panel as it encodes the file, and issues an audio alert when all items in the Render Queue have been rendered and encoded.

8 If you want to see your final product, double-click the Explore Hawaii.mp4 file in the Lessons/Lesson02/Finished_Project folder to open it in Windows Media Player or QuickTime, and then play the file.

9 Save and close the project file, and then quit After Effects.

Congratulations. You've created a presentation intro suitable for broadcast.

Review questions

1 What is *precomposing*?

2 How do you customize an effect?

3 How do you modify the transparency of a layer in a composition?

Review answers

1 *Precomposing* is a way to nest layers within a composition. Precomposing moves the layers to a new composition, which takes the place of the selected layers. When you want to change the order in which layer components are rendered, precomposing is a quick way to create intermediate levels of nesting in an existing hierarchy.

2 After you apply an effect to a layer in a composition, you can customize its properties in the Effect Controls panel. This panel opens automatically when you apply the effect, or you can open it at any time by selecting the layer with the effect and choosing Window > Effect Controls.

3 To modify the transparency of a layer, reduce its opacity. Select the layer in the Timeline panel, and then change the Opacity value in the Properties panel. Or, in the Timeline panel, press T to reveal to reveal the layer's Opacity property, and change it there.

3 ANIMATING TEXT

Lesson overview

In this lesson, you'll learn how to do the following:

- Create and animate text layers.
- Stylize text using the Character, Paragraph, and Properties panels.
- Apply and customize text animation presets.
- Preview animation presets in Adobe Bridge.
- Install fonts using Adobe Fonts.
- Animate text using keyframes.
- Edit and animate imported Adobe Photoshop text.
- Use a text animator group to animate selected characters on a layer.

 This lesson will take about 90 minutes to complete. If you haven't already done so, download the project files for this lesson from peachpit.com/AfterEffectsCIB2024, following the instructions in the Getting Started section under "Accessing the lesson files and Web Edition."

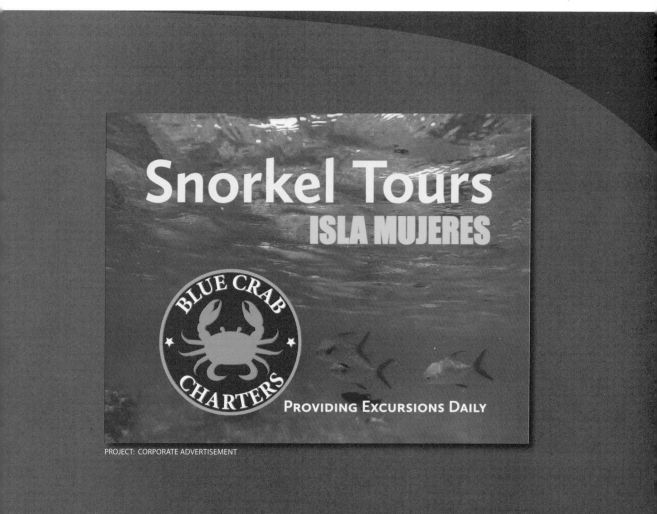

Your type doesn't need to sit still while your audience is reading it. In this lesson, you'll learn several ways to animate type in After Effects, including timesaving methods unique to text layers.

Getting started

Adobe After Effects offers many ways to animate text. You can animate text layers by manually creating keyframes in the Timeline panel, using animation presets, or using expressions. You can even animate individual characters or words in a text layer. In this lesson, you'll employ several different animation techniques, including some that are unique to text, while you design a promotion for snorkeling tours from the fictional Blue Crab Charters company. You'll also take advantage of Adobe Fonts to install a font for use in your project.

As in other projects, you'll begin by previewing the movie you're creating, and then you'll open After Effects.

1 Make sure the following files are in the Lessons/Lesson03 folder on your hard disk, or download them from peachpit.com now:

 • In the Assets folder: BlueCrabLogo.psd, FishSwim.mov, LOCATION.psd

 • In the Sample_Movie folder: Lesson03.mp4

2 Open and play the Lesson03.mp4 sample movie in Windows Movies & TV or QuickTime Player to see what you will create in this lesson. When you are done, close Windows Movies & TV or QuickTime Player. You may delete the sample movie from your hard disk if you have limited storage space.

As you start the application, restore the default settings for After Effects. See "Restoring default preferences" on page 3.

3 Start After Effects, and then immediately hold down Ctrl+Alt+Shift (Windows) or Command+Option+Shift (macOS) to restore default preferences settings. In the Startup Repair Options dialog box, click Reset Preferences.

4 Click New Project in the Home window.

After Effects opens to display a blank, untitled project.

5 Choose File > Save As > Save As, and navigate to the Lessons/Lesson03/Finished_Project folder.

6 Name the project **Lesson03_Finished.aep**, and then click Save.

Creating the composition

First, you'll import footage and create the composition.

1 Click the New Composition From Footage button in the Composition panel to create a new composition.

2 Navigate to the Lessons/Lesson03/Assets folder on your hard disk, select FishSwim.mov, and then click Import or Open.

After Effects can import several file formats, including Adobe Photoshop and Adobe Illustrator files as well as QuickTime and AVI movies. This makes After Effects an incredibly powerful application for compositing and motion graphics work.

3 Choose File > Save.

You're ready to add the title text to the composition.

About text layers

In After Effects, you can add text with flexibility and precision. The Tools, Character, and Paragraph panels contain a wide range of text controls; some of these are also available in the Properties panel. You can create and edit horizontal or vertical text directly on the screen in the Composition panel, and quickly change the font, style, size, and color of the text. You can apply changes to individual characters and set formatting options for entire paragraphs, including alignment, justification, and word-wrapping. In addition to all of these style features, After Effects provides tools for easily animating specific characters and properties, such as text opacity and hue.

After Effects uses two types of text: point text and paragraph text. Use *point text* to enter a single word or line of characters; use *paragraph text* to enter and format text as one or more paragraphs.

In many ways, text layers are just like any other layers in After Effects. You can apply effects and expressions to text layers, animate them, designate them as 3D layers, and edit the 3D text while viewing it from multiple angles. As with layers imported from Illustrator, text layers are continuously rasterized, so when you scale the layer or resize the text, it retains crisp, resolution-independent edges. The two main differences between text layers and other layers are that you cannot open a text layer in its own Layer panel and you can animate the text in a text layer using special text-animator properties and selectors.

Installing a font using Adobe Fonts

Hundreds of fonts are available through Adobe Fonts, which is included with an Adobe Creative Cloud membership. You'll use Adobe Fonts to install a font that will work well for the title text. When you install an Adobe Fonts font on your system, it's available in any application.

1 Choose File > Add Fonts From Adobe.

After Effects opens the Adobe Fonts page in your default browser.

2 Make sure you're signed in to Creative Cloud. If not, click Sign In at the top of the screen, and then enter your Adobe ID.

3 Type **Snorkel Tours** in the sample text field. If you don't see all the text, move the slider to change the text size.

Using your own text as the sample text lets you get a feel for how a font will work in your project.

You can browse fonts on the Adobe Fonts website, but because there are so many, it's often more efficient to filter them or to search for a specific font. You'll filter fonts to see those that meet your requirements.

4 Choose Name from the Sort menu in the upper right corner. Then, on the left side of the page, hide the Tags area, and select Sans Serif in the Classification area. In the Properties area, select the buttons for medium weight, medium width, medium x-height, low contrast, and standard capitalization.

Adobe Fonts displays several fonts that meet the requirements you specified.

5 Browse a few pages' worth of fonts to see what's available. Calluna Sans, which is probably on the third page, will work nicely.

6 Click Calluna Sans.

Adobe Fonts displays an image with the font in context and sample text for all the fonts in the selected family as well as additional information about the font.

● **Note:** Depending on your system and your Internet connection, it may take a few minutes for Adobe Fonts to activate your fonts.

7 Click Add Font next to the Regular and Bold versions of the font.

The selected fonts are automatically added to your system and are then available in any application, including After Effects. After you've activated your fonts, you can close Adobe Fonts and your browser.

Creating and formatting point text

When you enter point text in After Effects, each line of text is independent—the length of a line increases or decreases as you edit the text, but it doesn't wrap to the next line. The text you enter appears in a new text layer. The small line through the I-beam marks the position of the text baseline.

1 In the Tools panel, select the Horizontal Type tool (T).

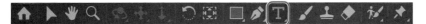

2 Click anywhere in the Composition panel, and type **Snorkel Tours**. Then exit text-editing mode by pressing Enter on the numeric keypad or selecting the layer name in the Timeline panel. The text layer is selected in the Composition panel.

● **Note:** If you press Enter or Return on the regular keyboard instead of on the numeric keypad, you'll begin a new paragraph.

Formatting character attributes

You can edit character attributes in the Character panel or the Properties panel. If text is highlighted, changes you make affect only the highlighted text. If no text is highlighted, changes you make affect the selected text layers and the text layers' selected Source Text keyframes, if any exist. To create defaults for the next text entry, make changes in the Character panel when no text is highlighted and no text layers are selected. By default, the Properties panel displays character options when you select a text layer.

▶ **Tip:** To open the Character panel, choose Window > Character. To open the Paragraph panel, choose Window > Paragraph.

After Effects displays sample text for each font. You can filter fonts to display only fonts from Adobe or favorites you've marked.

1 Select the Snorkel Tours text layer in the Timeline panel.

2 In the Properties panel, choose Calluna Sans Bold from the Font Family menu.

3 Set the Font Size to **90** pixels, and make sure no stroke is selected.

4 Leave all other options at their default settings.

▶ **Tip:** To select a font quickly, begin typing its name in the Font Family box. The Font Family menu jumps to the first font on your system that matches the letters you've typed. If a type layer is selected, the text in the Composition panel is formatted with the newly selected font.

Formatting paragraph attributes

Use the Paragraph section of the Properties panel to set options that apply to an entire paragraph, such as alignment, indentation, and leading. For point text, each line is a separate paragraph. You can set formatting options for a single paragraph, multiple paragraphs, or all paragraphs in a text layer. You just need to make one adjustment for this composition's title text.

● **Note:** Your screen may look different, depending on where you started typing.

1 In the Paragraph section of the Properties panel, click the Center Text button. This aligns horizontal text to the center of the layer, not to the center of the composition.

2 Leave all other options at their default settings.

Positioning the type

To precisely position layers, such as the text layer you're working on now, you can display rulers, guides, and grids in the Composition panel. These visual reference tools don't appear in the final rendered movie.

1 Make sure the Snorkel Tours text layer is selected in the Timeline panel.

2 Choose Layer > Transform > Fit To Comp Width. This scales the layer to fit to the width of the composition.

Now you can position the text layer using a grid.

3 Choose View > Show Grid and then View > Snap To Grid.

4 Using the Selection tool (▶), drag the text up in the Composition panel until the text is in the top quarter of the composition, centered in the surface of the water. Press Shift after you start dragging to constrain the movement and help you position the text.

5 When the layer is in position, choose View > Show Grid again to hide the grid.

This project isn't destined for broadcast TV, so it's okay that the title extends beyond the title-safe and action-safe areas of the composition at the beginning of the animation.

6 Choose File > Save to save your project.

Animating with scale keyframes

The text layer was scaled to nearly 250% when you applied the Fit To Comp Width command to it earlier in this lesson. Now, you'll animate the layer's scale so that the type gradually shrinks down to 200%.

1 In the Timeline panel, move the current-time indicator to 3:00.

2 Select the Snorkel Tours text layer.

3 In the Properties panel, click the stopwatch icon (Ⓞ) next to the Scale property to add a keyframe at the current time (3:00).

4 Move the current-time indicator to 5:00.

5 Reduce the layer's Scale values to **200, 200%**. After Effects adds a new Scale keyframe at the current time.

Previewing a range of frames

Now, you'll preview the animation. Although the composition is 13 seconds long, you need to preview only the first five seconds, since that is where the text animation occurs.

1 Move the current-time indicator to 5:10, and press N to set the end of the work area. The scale animation ends shortly before 5:10.

2 Press the spacebar to preview the animation from 0:00 to 5:10. The movie title scales to a smaller size.

3 Press the spacebar to stop playback after you've viewed the animation.

Adding Easy Ease

The beginning and end of the scale animation are rather abrupt. In nature, nothing comes to an absolute stop. Instead, objects ease into and out of starting and stopping points. You'll apply Easy Ease to make the animation smoother.

1 In the Timeline panel, right-click (Windows) or Control-click (macOS) the Scale keyframe at 3:00, and choose Keyframe Assistant > Easy Ease Out. The keyframe becomes a left-pointing icon.

2 Right-click (Windows) or Control-click (macOS) the Scale keyframe at 5:00, and choose Keyframe Assistant > Easy Ease In. The keyframe becomes a right-pointing icon.

3 Watch another preview. Press the spacebar to stop it when you're done.

4 Hide the Scale property in the Timeline panel, and then choose File > Save.

Using a text animation preset

Currently, the title appears when the video begins. You'll animate the title to make its arrival more interesting. The easiest way to do that is to use one of the many animation presets that come with After Effects. After applying an animation preset, you can customize it and save it to use again in other projects.

1 Press the Home key or go to 0:00 to make sure the current-time indicator is at the beginning of the time ruler.

After Effects applies animation presets from the current time.

2 Select the Snorkel Tours text layer.

Browsing animation presets

Note: If Bridge isn't installed, you'll be prompted to install it when you choose Browse Presets. For more information, see page 2.

You already applied an animation preset using the Effects & Presets panel in Lesson 2, "Creating a Basic Animation Using Effects and Presets." But what if you're not sure which animation preset you want to use? To help you choose the right animation preset for your projects, you can preview presets in Adobe Bridge.

1 Choose Animation > Browse Presets. Adobe Bridge opens, displaying the contents of the After Effects Presets folder. Click Yes if prompted to enable the After Effects extension in Bridge.

2 In the Content panel, double-click the Text folder, and then the Organic folder.

3 Click to select the first preset, Autumn. Adobe Bridge plays a sample of the animation in the Preview panel.

4 Select a few other presets, and watch them in the Preview panel.

Note: If a generic ffx image appears instead of the preview, reset Bridge preferences: Press Ctrl+Alt+Shift (Windows) or Command+Option+Shift (macOS) while you restart Bridge.

5 Preview the Ripple preset, and then right-click (Windows) or Control-click (macOS) the thumbnail, and choose Place In Adobe After Effects.

6 Return to After Effects, but leave Adobe Bridge open in the background.

After Effects applies the preset to the selected layer, which is the Snorkel Tours layer, but the layer no longer appears in the composition. This is because at 0:00, the first frame of the animation, the letters haven't yet rippled into the scene.

About Adobe Bridge

Adobe Bridge is a powerful, flexible tool for organizing, browsing, and locating the assets you need to create content for print, web, television, DVD, film, and mobile devices. Adobe Bridge keeps native Adobe files (such as PSD and PDF files) as well as non-Adobe files available for easy access. You can drag assets into your layouts, projects, and compositions as needed; preview your assets; and even add metadata (file information) to assets to make files easier to locate.

In this lesson, you're opening Adobe Bridge from within After Effects, but you can also open Adobe Bridge directly. To do so, choose Adobe Bridge from the Start menu (Windows) or double-click the Adobe Bridge icon in the Applications/ Adobe Bridge folder (macOS).

The Content panel in Adobe Bridge updates interactively. For example, when you select the Assets folder in the Folders panel, thumbnail previews of the folder's contents appear in the Content panel. Adobe Bridge displays previews of image files such as those in PSD, TIFF, and JPEG formats, as well as Illustrator vector files, multipage Adobe PDF files, QuickTime movie files, and more.

You may need to install Adobe Bridge separately from Creative Cloud. If Bridge is not installed, you'll be prompted to install it when you choose Animation > Browse Presets.

Customizing an animation preset

After you apply an animation preset to a layer, all of its properties and keyframes are listed in the Timeline panel. You'll use those properties to customize the preset.

1 Press the spacebar to watch a preview of the animation. The letters flip into place, and then the entire title scales down to 200%. Press the spacebar again to stop the preview.

The letters appear to ripple into the background. It looks great—but you'll customize the preset to change the order in which the letters appear.

2 Select the Snorkel Tours text layer in the Timeline panel, and then expand the layer's properties. Navigate to the Text > Animator - Ripple 1 (Skew) > Selector Offset > Advanced properties.

3 Click Off next to Randomize Order to toggle it to On.

The Randomize Order property changes the order in which letters appear on the screen as they ripple into place.

4 Drag the current-time indicator from 0:00 to 3:00 to manually preview the animation you edited.

5 Hide the layer's properties.

6 Press the End key to move the current-time indicator to the end of the time ruler, and then press N to set the end bracket of the work area.

7 Press the Home key or go to 0:00 to return the current-time indicator to the beginning of the time ruler.

8 Choose File > Save to save your project.

Animating imported Photoshop text

When you just need to add a few words of text to a unique project, it works well to type directly into After Effects. But in the real world, you may need to ensure brand and style consistency among multiple projects. Fortunately, you can import text from Photoshop or Illustrator. You can preserve text layers, edit them, and animate them in After Effects.

Importing text

Some of the remaining text for this composition is in a layered Photoshop file, which you'll import now.

1 Double-click an empty area in the Project panel to open the Import File dialog box.

2 Select the LOCATION.psd file in the Lessons/Lesson03/Assets folder. Choose Composition – Retain Layer Sizes from the Import As menu. (In macOS, you may need to click Options to see the Import As menu.) Then click Import or Open.

3 In the LOCATION.psd dialog box, select Editable Layer Styles, and click OK.

After Effects can import Photoshop layer styles, retaining the appearance of the layers you're importing. The imported file is added as a composition to the Project panel; its layers are added in a separate folder.

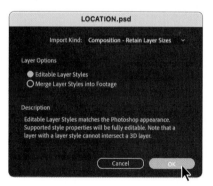

4 Drag the LOCATION composition from the Project panel into the Timeline panel, placing it at the top of the layer stack.

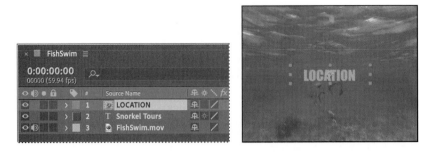

Because you imported the LOCATION.psd file as a composition with layers intact, you can work on it in its own Timeline panel, editing and animating its layers independently.

Editing imported text

The text you imported isn't currently editable in After Effects. You'll change that so that you can control the type and apply animations. The LOCATION.psd file is a boilerplate template for the location of company tours. You'll edit the text and add a stroke to help it stand out for this promotion.

1 Double-click the LOCATION composition in the Project panel to open it in its own Timeline panel.

2 Select the LOCATION layer in the Timeline panel, and choose Layer > Create > Convert To Editable Text. (Click OK if you see a warning about missing fonts.)

Now the text layer can be edited, so you can customize the tour location.

3 Double-click the LOCATION layer in the Timeline panel to select the text
 and automatically switch to the Horizontal Type tool (T).

4 Type **ISLA MUJERES**.

5 Switch to the Selection tool (▶) to exit text-editing mode.

6 In the Text section of the Properties dialog box, click the Stroke color box to
 open it. Select a teal blue color (we used R=70, G=92, B=101), and click OK.
 Leave all other settings as they are.

Note: The layer
name does not change
in the Timeline panel
when you change the
text in the layer. This
is because the original
layer name was created
in Photoshop. To
change a layer's name,
select it in the Timeline
panel, press Enter or
Return, type the new
name, and press Enter
or Return again.

7 Choose File > Save to save your work so far.

Animating text to appear over time

You want the letters of the location—*ISLA MUJERES*—to flow organically onto
the screen under the activity title. The easiest way to do this is to use another text
animation preset.

1 Go to 5:00 in the timeline. At that point, the title has finished scaling to its
 final size.

2 Select the LOCATION layer in the Timeline panel.

3 Press Ctrl+Alt+Shift+O (Windows) or Command+Option+Shift+O (macOS)
 to jump to Adobe Bridge.

4 Navigate to the Presets/Text/Animate In folder.

5 Select the Raining Characters In animation preset, and watch it in the Preview
 panel. This effect works well to reveal the text gradually.

6 Right-click or Control-click the Raining Characters In preset, and choose Place In Adobe After Effects 2024 to apply it to the LOCATION layer, and then return to After Effects.

● **Note:** The Raining Characters In preset changes the color of the text, which is fine for this project.

7 With the LOCATION layer selected in the Timeline panel, press UU to see the properties modified by the animation preset. You should see two keyframes for Range Selector 1 Offset: one at 5:00 and one at 7:15.

The U key, sometimes referred to as the *Überkey*, is a valuable keyboard shortcut that reveals all the animated properties of a layer. Press it once to see the animated properties; press it twice to view all modified properties.

You have a lot of animation to fit into this composition, so you'll speed up the effect.

▶ **Tip:** Press the Shift key while you move the keyframe to ensure it moves to the current time.

8 Go to 6:00, and then drag the second Range Selector 1 Offset keyframe to 6:00.

9 Select the LOCATION layer, and press U to hide the modified properties.

10 Select the FishSwim tab in the Timeline panel to make that timeline active, and then go to 6:00, if you're not there already.

11 Use the Selection tool (▶) to move the LOCATION layer so that *ISLA MUJERES* is right-aligned with and just below *Snorkel Tours*.

12 Deselect all layers. Drag the current-time indicator across the time ruler from 4:00 to 6:00 to see the letters fall into place. Then save your work so far.

Animating type tracking

Next, you'll add the company name and then animate its appearance using a text animation tracking preset. By animating tracking, you can make words seem to expand outward as they appear onscreen from a central point.

Applying a tracking preset

First you'll create the text, and then you'll add a tracking preset.

1 Select the Horizontal Type tool (T), and then type **BLUE CRAB CHARTERS**.

2 Select the BLUE CRAB CHARTERS layer. In the Properties panel, choose Times New Roman Bold from the Font Family menu, choose **48 px** from the Font Size menu, set the Fill to white, and deselect Stroke. In the Paragraph section of the panel, make sure Center Text is selected.

3 Go to 7:10.

4 Use the Selection tool (▶) to move the BLUE CRAB CHARTERS layer down to the lower third of the screen, aligned with *Snorkel Tours*, as in the image below.

5 Open the Effects & Presets panel. Then type Increase Tracking in the search box, and double-click the preset to apply it to the BLUE CRAB CHARTERS layer.

6 Drag the current-time indicator across the time ruler between 7:10 and 9:10 to manually preview the tracking animation.

Customizing the tracking animation preset

The text expands, but you want the letters to be so close initially that they're nearly on top of each other, and then to expand to a reasonable, readable distance apart. The animation should also occur more quickly. You'll adjust the Tracking Amount to achieve both goals.

1 Select the BLUE CRAB CHARTERS layer in the Timeline panel, and press UU to reveal the properties that were modified.

2 Go to 7:10.

3 Under Animator 1, change the Tracking Amount to −**5** so that the letters are squeezed together.

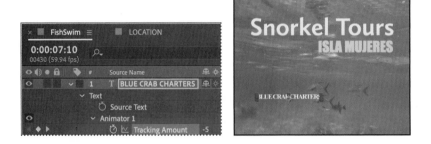

4 Click the Go To Next Keyframe arrow (▶) for the Tracking Amount property, and then change the value to **0**.

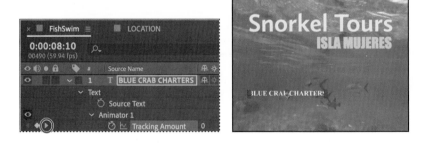

5 Drag the current-time indicator across the time ruler between 7:10 and 8:10. The letters expand, and stop animating at the last keyframe.

6 Hide the properties for all layers.

Animating text opacity

You'll take the animation of the company name a little further by having it fade onscreen as the letters expand. To do this, you'll animate the layer's Opacity property.

1 Make sure the BLUE CRAB CHARTERS layer is selected.

2 Go to 7:10. In the Properties panel, set the Opacity to **0%**. Then click the stopwatch icon (⏱) to set an Opacity keyframe.

3 Go to 7:20, and set the Opacity to **100%**. After Effects adds a second keyframe.

Now the letters of the company name will fade in as they expand onscreen.

4 Drag the current-time indicator across the time ruler between 7:10 and 8:10 to see the letters of the company fade in as they spread out.

5 Right-click (Windows) or Control-click (macOS) the ending Opacity keyframe, and choose Keyframe Assistant > Easy Ease In.

6 Choose File > Save.

Animating an image to replace text

You've used several animation presets to change the way text appears onscreen. Now you'll use one to make text disappear. You'll import a logo, and animate it to swoop in and appear to erase the *BLUE CRAB CHARTERS* text, replacing it.

Animating an imported image

First you'll import the logo and animate its position.

1 Click the Project tab to bring the Project panel forward, and then double-click an empty area in the Project panel to open the Import File dialog box.

2 Select the BlueCrabLogo.psd file in the Lessons/Lesson03/Assets folder. Choose Composition – Retain Layer Sizes from the Import As menu. (In macOS, you may need to click Options to see the Import As menu.) Then click Import or Open.

3 In the BlueCrabLogo.psd dialog box, select Editable Layer Styles, and click OK.

4 Drag the BlueCrabLogo composition into the Timeline panel, placing it at the top of the layer stack.

The logo is centered on the screen, but you want it to enter from the left and move down to replace *Blue Crab Charters*. You'll animate the layer's Position and Scale properties to do that.

5 Move the current-time indicator to 10:00.

6 With the BlueCrabLogo layer selected, change the Position values to **–810, 122**, and the Scale to **25%** in the Properties panel. Then click the stopwatch icon (⏱) next to each of those properties to create initial keyframes.

7 Go to 11:00, and change the Position to **377, 663**, and the Scale to **85%**. After Effects creates keyframes for the properties.

The logo moves into position, but you want it to swoop in, rather than moving in a straight line. You'll add some intermediate Position keyframes.

8 Go to 10:15, and change the Position to **139, 633**.

9 Go to 10:30, and change the Position to **675, 633**.

10 Go to 10:00, and press the spacebar to preview the animation. Press the spacebar again to stop the preview, and then hide all layer properties.

Applying an animation preset

The logo swoops in. Now you'll apply an animation preset to make it appear that the logo is erasing the text as it arrives.

1 Go to 10:10, and select the BLUE CRAB CHARTERS layer.

2 In the Effects & Presets panel, search for Fade Out By Character.

3 Double-click the Fade Out By Character preset to apply it to the layer.

4 With the BLUE CRAB CHARTERS layer selected, press U to see its animated properties.

5 Go to 10:12.

6 Move the first Range Selector 1: Start keyframe to 10:12.

7 Go to 10:29, and move the second Range Selector 1: Start keyframe to 10:29.

8 Press the spacebar to preview your project, and then press the spacebar again
 to stop the preview.

9 Press U to hide the layer properties, and save your work.

Using a text animator group

Text animator groups let you animate individual letters within a block of text
in a layer. You'll use a text animator group to draw attention to *BLUE CRAB
CHARTERS*, animating only the characters in the middle word without affecting
the tracking and opacity animation of the other characters in the layer.

1 In the Timeline panel, go to 9:10.

2 Expand the BLUE CRAB CHARTERS layer to see its Text property group name.

3 Select the BLUE CRAB CHARTERS layer, and make sure only the layer name
 is selected.

4 Next to the Text property group name, click the Animate pop-up menu, and
 choose Skew.

After Effects adds a property group named Animator 3 to the layer's Text properties.

5 Select Animator 3, press Enter
 or Return, and rename it **Skew
 Animator**. Then press Enter or
 Return again to accept the new
 name.

Now you're ready to define the range of letters that you want to skew.

6 Expand the Skew Animator's Range Selector 1 properties.

Each animator group includes a default range selector. Range selectors constrain the animation to particular letters in the text layer. You can add selectors to an animator group, or apply multiple animator properties to the same range selector.

7 While watching the Composition panel, drag the Skew Animator's Range Selector 1 Start value up (to the right) until the left selector indicator (⋈) is just before the *C* in *CRAB*.

8 Drag the Skew Animator's Range Selector 1 End value down (to the left) until its indicator (⋈) is just after the B in *CRAB* in the Composition panel.

Now, any properties that you animate with the Skew Animator will affect only the characters that you selected.

About text animator groups

A text animator group includes one or more *selectors* and one or more *animator properties*. A selector is like a mask—it specifies which characters or section of a text layer you want an animator property to affect. Using a selector, you can define a percentage of the text, specific characters in the text, or a specific range of text.

Using a combination of animator properties and selectors, you can create complex text animations that would otherwise require painstaking keyframing. Most text animations require you to animate only the selector values, not the property values. Consequently, text animators use a small number of keyframes even for complex animations.

For more information about text animator groups, see After Effects Help.

Skewing the range of text

Now, you'll make that middle word shake and shimmy by setting Skew keyframes.

1 Drag the Skew Animator's Skew value left and right, and notice that only the selected word sways. The other words in the line of text remain steady.

2 Set the Skew Animator's Skew value to **0**.

3 Go to 9:15, and click the stopwatch icon (⏱) for Skew to add a keyframe to the property.

4 Go to 9:18, and set the Skew value to **50**. After Effects adds a keyframe.

5 Go to 9:25, and change the Skew value to **−50**. After Effects adds another keyframe.

6 Go to 10:00, and change the Skew value to **0** to set the final keyframe.

7 Click the Skew property name to select all of the Skew keyframes. Then choose Animation > Keyframe Assistant > Easy Ease to add an Easy Ease to all keyframes.

8 Hide the properties for the BLUE CRAB CHARTERS layer in the Timeline panel.

9 Press Home, or go to 0:00, and then preview the entire composition.

▶ **Tip:** To quickly remove all text animators from a text layer, select the layer in the Timeline panel, and choose Animation > Remove All Text Animators. To remove only one animator, select its name in the Timeline panel, and press Delete.

10 Press the spacebar to stop playback, and then choose File > Save to save your work.

Animating a layer's position

You've used several text animation presets to dazzle your audience. For a simpler effect, you can animate the Transform properties for a text layer, just as you can any other layer.

Currently, the company logo appears onscreen, but there's no context for it. You'll add the words *Providing Excursions Daily*, animating them so that they move into position as the company name is appearing onscreen.

1 In the FishSwim Timeline panel, go to 11:30.

At this point, all the other text is onscreen, so you can position the "Providing Excursions Daily" line accurately.

2 Select the Horizontal Type tool (T).

▶ **Tip:** To make sure no layers are selected, click an empty area in the Timeline panel, press F2, or choose Edit > Deselect All.

3 Make sure no layers are selected, and then click in the Composition panel. Make sure you're clicking in an area that doesn't overlap an existing text layer.

4 Type **Providing Excursions Daily**.

5 Select the text you just typed. Then, in the Properties panel, choose Calluna Sans Bold from the Font Family menu. Set the Font Size to **48 px**.

6 Make sure the Fill Color box is set to white.

7 Click More to see additional options. Then select Small Caps. Leave all other options at their default settings.

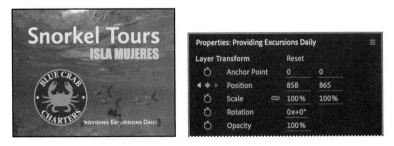

8 Select the Selection tool (▶), and then drag the Providing Excursions Daily layer so that the text is aligned with the bottom of the logo and the right edge of *Snorkel Tours*.

9 In the Properties panel, click the stopwatch icon (⏱) next to the Position property to create an initial keyframe for the layer.

10 Go to 11:00, the point where the logo has replaced the company name.

11 Drag the Providing Excursions Daily layer off the right edge of the composition. Press the Shift key as you drag to create a straight path.

12 Preview the animation, and then hide all layer properties.

It's simple, but effective. The text moves in from the right side and stops in its final position beside the logo.

Adding motion blur

Motion blur is the blur that occurs as an object moves. You'll apply motion blur to finesse the composition and make the movement look more natural.

1 In the Timeline panel, click the Motion Blur switch (⊘) for each layer *except* the FishSwim and LOCATION layers.

Now you'll apply motion blur to the layer in the LOCATION composition.

2 Switch to the LOCATION Timeline panel, and enable motion blur for the layer.

3 Switch back to the FishSwim Timeline panel, and select the Motion Blur switch for the LOCATION layer.

After Effects automatically enables motion blur for the composition when you enable it for any layer.

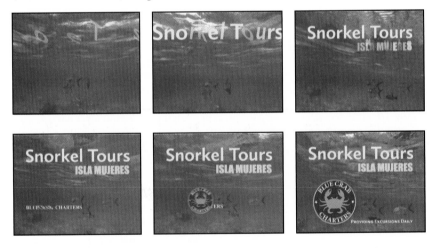

4 Preview the entire, completed animation.

5 Choose File > Save.

Give yourself a pat on the back. You just completed some hard-core text animations. If you'd like to export the composition as a movie file, see Lesson 15, "Rendering and Outputting," for instructions.

Review questions

1 What are some similarities and differences between text layers and other types of layers in After Effects?

2 How can you preview a text animation preset?

3 What are text animator groups?

Review answers

1 In many ways, a text layer is just like any other layer in After Effects. You can apply effects and expressions to text layers, animate them, designate them as 3D layers, and edit 3D text while viewing it in multiple views. However, they differ from most layers in that you can't open text layers in their own Layer panels. Text layers consist entirely of vector graphics, so when you scale the layer or resize the text, it retains crisp, resolution-independent edges. You can animate the text in a text layer using special text animator properties and selectors.

2 You can preview text animation presets in Adobe Bridge by choosing Animation > Browse Presets. Adobe Bridge opens and displays the contents of the After Effects Presets folder. Navigate to folders containing categories of text animation presets, such as Blurs or Paths, and watch samples in the Preview panel.

3 Text animator groups enable you to animate the properties of individual characters in a text layer over time. Text animator groups contain one or more *selectors*, which are like masks: They let you specify which characters or section of a text layer you want an animator property to affect. Using a selector, you can define a percentage of the text, specific characters in the text, or a specific range of text.

4

WORKING WITH SHAPE LAYERS

Lesson overview

In this lesson, you'll learn how to do the following:

- Create custom shapes.

- Customize a shape's fill and stroke.

- Use path operations to transform shapes.

- Animate shapes.

- Taper strokes in shapes.

- Snap layers into alignment.

- Use the Create Nulls From Paths panel.

 This lesson will take about an hour to complete. If you haven't already done so, download the project files for this lesson from peachpit.com/AfterEffectsCIB2024, following the instructions in the Getting Started section under "Accessing the lesson files and Web Edition."

PROJECT: ANIMATED ILLUSTRATION

Shape layers make it easy to create expressive
backgrounds and intriguing results. You can animate
shapes, apply animation presets, and connect them to
other shapes to intensify their impact.

Getting started

Shape layers are created automatically when you draw a shape with any of the drawing tools. You can customize and transform an individual shape or its entire layer to create interesting results. In this lesson, you will use shape layers to create a whimsical animation.

First, you'll preview the final movie and set up the project.

1 Make sure the following files are in the Lessons/Lesson04 folder on your hard disk, or download them from peachpit.com now:

 • In the Assets folder: Background.mov

 • In the Sample_Movie folder: Lesson04.mp4

2 Open and play the Lesson04.mp4 sample movie in Windows Movies & TV or QuickTime Player to see what you will create in this lesson. When you are done, close Windows Movies & TV or QuickTime Player. You may delete the sample movie from your hard disk if you have limited storage space.

As you start After Effects, restore the default application settings. See "Restoring default preferences" on page 3.

3 Start After Effects, and then immediately hold down Ctrl+Alt+Shift (Windows) or Command+Option+Shift (macOS) to restore default preferences settings. In the Startup Repair Options dialog box, click Reset Preferences.

4 Click New Project in the Home window.

After Effects opens to display a blank, untitled project.

5 Choose File > Save As > Save As, and then navigate to the Lessons/Lesson04/ Finished_Project folder.

6 Name the project **Lesson04_Finished.aep**, and then click Save.

Creating the composition

Next, you'll import the background movie and create the composition.

1 Click New Composition From Footage in the Composition panel.

2 Navigate to the Lessons/Lesson04/Assets folder on your hard disk, select the Background.mov file, and then click Import or Open.

After Effects adds the Background.mov file to the Project panel. It creates a composition based on the Background.mov file and opens the new composition in both the Timeline and Composition panels.

3 Press the spacebar to preview the background movie. In the scene, night turns to day as the sky lightens and the colors brighten. Press the spacebar again to stop playback.

Adding a shape layer

After Effects includes five shape tools: Rectangle, Rounded Rectangle, Ellipse, Polygon, and Star. When you draw a shape directly in the Composition panel, After Effects adds a new shape layer to the composition. You can apply stroke and fill settings to a shape, modify its path, and apply animation presets. Shape attributes are represented in the Timeline panel; many are also in the Properties panel. You can animate each setting over time.

The same drawing tools can create both shapes and masks. Masks are applied to layers to hide or reveal areas or as input into effects; shapes have their own layers. When you select a drawing tool, you can specify whether the tool draws a shape or a mask.

Drawing a shape

You'll begin by drawing a star.

1 Press the Home key or move the current-time indicator to the beginning of the time ruler.

2 Press F2 or click an empty area in the Timeline panel to make sure no layers are selected.

If you draw a shape when a layer is selected, the shape becomes a mask for that layer; the cursor displays a masked box (🖑▫) as you start to draw. If you draw a shape when no layer is selected, After Effects creates a shape layer; the cursor displays a star (🖑★) as you start to draw.

3 Choose Edit > Settings > General (Windows) or After Effects > Settings > General (macOS). Select Center Anchor Point In New Shape Layers, and click OK.

The anchor point is the reference point After Effects uses when it changes a layer's position, scale, or rotation. By default, a shape layer's anchor point is at the center of the composition. Selecting Center Anchor Point In New Shape Layers positions the anchor point in the center of the first shape you draw on a layer.

4 Select the Star tool (⭐), hidden behind the Rectangle tool (■) in the Tools panel.

5 Drag a small star in the sky.

The shape appears in the Composition panel, and After Effects adds a shape layer named Shape Layer 1 to the Timeline panel.

6 Select the Shape Layer 1 layer name, press Enter or Return, change the layer name to **Star 1**, and press Enter or Return to accept the change.

Applying a fill and stroke

You can change the color of a shape by modifying its Fill settings in the Tools panel. Clicking the word *Fill* opens the Fill Options dialog box, where you can select the kind of fill, its blending mode, and its opacity. Clicking the Fill Color box opens the Adobe Color Picker if the fill is solid or the Gradient Editor if the fill is a gradient.

Similarly, you can change the color and width of the stroke of a shape by modifying its Stroke settings in the Tools panel. Click the word *Stroke* to open the Stroke Options dialog box; click the Stroke Color box to select a color.

1 Select the Star 1 layer in the Timeline panel.

2 Click the Fill Color box to open the Shape Fill Color dialog box.

3 Change the color to a bright yellow (we used R=215, G=234, B=23), and click OK.

4 Click the Stroke Color box, change the stroke color to an even brighter yellow color (we used R=252, G=245, B=3), and then click OK.

5 Make sure the Stroke Width value is **2 px**.

6 Choose File > Save to save your work so far.

Creating a self-animating shape

Wiggle Paths is a path operation that turns a smooth shape into a series of jagged peaks and valleys. You'll use it to make the star shimmer a little. Because the operation is self-animating, you need to change only a few properties for the entire shape to move on its own.

1 Expand the Star 1 layer in the Timeline panel, if it isn't already expanded, and choose Wiggle Paths from the Add pop-up menu.

2 Press the spacebar to play the movie so you can see the effect. Press the spacebar again to stop playback.

The star's edge is too jagged. You'll change the settings for a subtler effect.

3 Expand Wiggle Paths 1. Then change the Size to **2.0** and the Detail to **3.0**.

4 Change Wiggles/Second to **5.0**.

5 Click the Motion Blur switch (●) for the layer.

When you enable Motion Blur for a layer, After Effects enables it for the entire composition, so that you can apply Motion Blur to any additional layers.

6 Hide the layer properties.

7 Press the spacebar to preview the star's effect; press it again to stop playback.

The star shouldn't be visible during the daytime, so you'll animate its Opacity value.

8 Press the Home key or move the current-time indicator to the beginning of the time ruler.

9 Select the Star 1 layer in the Timeline panel.

10 In the Layer Transform section of the Properties panel, click the stopwatch icon (●) for Opacity to create an initial keyframe at 100%.

11 Go to 2:15, and change the Opacity value to **0%**.

Duplicating a shape

The sky should have more than one star, and they should all shimmer. You'll duplicate the star you created multiple times so that each of the new layers has the same properties as the original. Then you'll adjust each star's position and rotation separately. Finally, you'll animate the offset paths to accentuate the twinkling effect.

1 Press the Home key or move the current-time indicator to the beginning of the time ruler.

2 Select the Star 1 layer in the Timeline panel.

3 Choose Edit > Duplicate.

After Effects adds a Star 2 layer at the top of the layer stack. It is identical to the Star 1 layer, including its position.

4 Press Ctrl+D (Windows) or Command+D (macOS) five times to create five additional star layers.

5 Select the Selection tool (▶) in the Tools panel, and press F2 to deselect all layers in the Timeline panel.

Adjusting the position, scale, and rotation of each shape

The stars you created are all on top of each other. You'll customize the position, scale, and angle of rotation for each.

1 Using the Selection tool, drag each star to a different position in the sky.

2 Select the Star 1 layer, and then adjust its Rotation and Scale values in the Properties panel.

3 Adjust the Rotation and Scale values for each of the other layers to create variation among the stars. You can also use the Selection tool to adjust the stars' positions.

4 Press the spacebar to preview the animation. The stars twinkle and fade as night turns to day. Press the spacebar again to stop the playback.

Animating concentric shapes

You'll enhance the twinkling effect by animating the stroke for each star.

1 Press the Home key or move the current-time indicator to the beginning of the time ruler.

2 Expand the properties for the Star 7 layer, and then choose Offset Paths from the Add menu.

The selected star expands in the Composition panel; its stroke has been repeated multiple times.

3 Expand the Offset Paths 1 properties in the Timeline panel.

4 Reduce the Amount to **4,** and increase Copies to **2.**

The Amount value determines how much the shape expands; positive values expand the stroke outward, and negative values send it inward. Increase the number of Copies to add repetition.

5 Click the stopwatch icon (⏱) next to the Amount and Copies properties to create initial keyframes.

6 Go to 0:10, and change the Copies to **3.** Then, go to 1:00, and change the Amount to **1** and the Copies to **1.**

7 Repeat steps 2–6 for each of the other stars, varying the timing and settings so that they expand and contract at different times.

8 Hide the properties for all layers. Then select the Star 1 layer and Shift-select the Star 7 layer to select all the star layers.

9 Choose Layer > Pre-compose, name the new composition **Starscape**, and click OK.

After Effects creates a new composition named Starscape that contains the seven star shapes; the new composition replaces the layers in the Background composition. You can continue to edit the star layers by opening the Starscape composition, but precomposing the layers keeps the Timeline panel organized.

10 Choose File > Save to save your work so far.

Creating custom shapes with the Pen tool

You can use the five shape tools to create a wide variety of shapes. However, the real power in using shape layers is that you can draw any shape and manipulate it in a myriad of ways.

You'll use the Pen tool to draw a shape that resembles the base of a flowerpot. You'll also animate its color so that the flowerpot is dark at the beginning of the scene, but gets lighter as the sky lightens.

1 Make sure no layers are selected in the Timeline panel, and then go to 1:10.

2 Select the Pen tool (✐) in the Tools panel.

3 In the Composition panel, click an initial vertex, and add three more to draw a shape that resembles the base of a flowerpot, as in the illustration. Click again in the initial vertex to close the shape.

When you create the first vertex, After Effects automatically adds a shape layer—Shape Layer 1—to the Timeline panel.

4 Select Shape Layer 1, press Enter or Return, and change the layer's name to **Base of Flowerpot**. Press Enter or Return to accept the new name.

5 With the Base of Flowerpot layer selected, click the Fill Color box in the Properties panel, and select a dark brown color (we used R=62, G=40, B=22).

6 Choose None from the menu next to Stroke Color in the Properties panel.

7 In the Properties panel, select Shape 1 in the Layer Contents section.

8 Click the stopwatch icon next to the Fill Color property to create an initial keyframe.

9 Go to 4:01, click the Fill Color box, and change the fill color to a lighter brown. (We used R=153, G=102, B=59.) Then click OK.

10 Hide all layer properties in the Timeline panel. Press F2 or click an empty area in the Timeline panel to deselect all layers.

Positioning layers with snapping

Now you'll create the rim of the flowerpot and position it atop the base using the snapping feature in After Effects.

Creating a shape with rounded corners

You'll use the Rounded Rectangle tool to create the rim of the flowerpot.

1 Go to 1:10.

2 Select the Rounded Rectangle tool (■), hidden behind the Star tool (★) in the Tools panel.

3 In the Composition panel, drag a shape a little wider than the top of the flowerpot. Draw the shape a little bit above the base of the pot.

4 Select Shape Layer 1, press Enter or Return, and change the layer's name to **Rim of Flowerpot**. Press Enter or Return to accept the new name.

5 Select the Rim of Flowerpot layer.

6 If the rim matches the base, skip to step 7. Otherwise, click the eyedropper next to the Fill Color property in the Properties panel, and then click the base of the flowerpot in the Composition panel to sample the color.

7 Click the stopwatch icon (⊙) next to the Fill Color property to create an initial keyframe.

8 Go to 4:01, and use the eyedropper to change the fill color to match the lighter brown in the flowerpot base.

9 Hide all layer properties. Press F2 or click an empty area in the Timeline panel to deselect all layers.

Snapping layers into position

The flowerpot layers currently have no relationship to each other in the composition. You'll use the Snapping option in After Effects to quickly align the layers. When the Snapping option is enabled, the layer feature that is closest to your pointer when you click becomes the snapping feature. As you drag the layer near other layers, features on other layers are highlighted, showing you where the snapping feature would snap if you released the mouse button.

Note: You can snap two shape layers together, but not two shapes within a single layer. Also, a layer must be visible to snap to it. 2D layers can snap to 2D layers, and 3D layers can snap to 3D layers.

1 Select the Selection tool (▶) in the Tools panel.

2 Select Snapping in the options section of the Tools panel, if it's not already selected.

▶ **Tip:** If the Snapping option isn't selected, you can temporarily enable it: Click a layer and start dragging, and then press Ctrl (Windows) or Command (macOS) as you drag the layer.

3 Select the Rim of Flowerpot layer in the Timeline panel.

When you select a layer in the Composition panel, After Effects displays the layer handles and anchor point. You can use any of these points as the snapping feature for a layer.

4 Click near the bottom of the rim, and drag it near the upper edge of the Base of Flowerpot layer until it snaps into place. Be careful not to drag the corner itself, or you'll resize the layer.

As you drag the layer, a box appears around the handle you selected, indicating that it is the snapping feature.

5 Use the Selection tool to adjust the size of the rim or base of the flowerpot if you need to.

6 Deselect all layers, and choose File > Save to save your work.

Animating a shape

You can animate the Position, Opacity, and other Transform properties of shape layers just as you animate them in other layers. But shape layers provide additional opportunities for animation, including fills, strokes, paths, and path operations.

You'll create another star, and then use the Pucker & Bloat path operation to transform it into a flower as it falls toward the flowerpot and changes color.

Animating a path operation

Path operations are similar to effects. They modify a shape's path while preserving the original path. Path operations are live, so you can modify or remove them at any time. You used the Wiggle Paths path operation and Offset Paths earlier. Now you'll apply a Pucker & Bloat path operation.

Pucker & Bloat pulls the vertices of a path outward while curving the segments inward (puckering), or pulls the vertices inward while curving the segments outward (bloating). You can animate the degree of pucker or bloat over time.

1 Press the Home key or move the current-time indicator to the beginning of the time ruler.

2 Select the Star tool (★), hidden behind the Rounded Rectangle tool (⬤) in the Tools panel, and draw another star in the upper right area of the sky.

After Effects adds a Shape Layer 1 layer to the Timeline panel.

3 Click the Fill Color box, and change the fill color to the same bright yellow you used for the other stars. (We used R=215, G=234, B=23.) Then click OK.

4 Click the Stroke Color box, change the stroke color to a red color (we used R=159, G=38, B=24), and then click OK.

After Effects automatically changes the stroke options from None to Solid Color when you change the stroke color.

5 Select the Shape Layer 1 layer, press Enter or Return, change its name to **Falling Star**, and press Enter or Return again.

6 In the Timeline panel, choose Pucker & Bloat from the Add pop-up menu in the Falling Star layer.

7 Expand the Pucker & Bloat 1 properties in the Timeline panel.

8 Change the Amount to **0**, and click the stopwatch icon (⏱) to create an initial keyframe.

9 Go to 4:01, and change the amount to **139**.

The star shape becomes a flower. After Effects creates a keyframe.

Animating position and scale

The star becomes a flower, but it should be falling as it changes. You'll animate its position and scale now.

1 Press the Home key or move the current-time indicator to the beginning of the time ruler.

2 Select the Falling Star layer in the Timeline panel. In the Properties panel, click the stopwatch icon (⏱) next to the Position and Scale properties to create initial keyframes at their current values.

3 Go to 4:20. Select the Selection tool. Then move the star to the center of the screen, hovering above the flowerpot between the tree and the house, so that it's in its final position. (You may need to deselect Snapping in the Tools panel to position the flower where you want it.) At this point, the star has become a flower, but it hasn't changed size.

After Effects creates a Position keyframe.

4 Go to 4:01. Increase the Scale value so that the flower is about the width of the flowerpot. The value you use depends on the original size of the star and on the width of the flowerpot.

5 Press the spacebar to preview the animation. The star falls as it becomes a flower, but its trajectory is straight. You want it to fall in a slight arc. Press the spacebar again to stop playback.

6 Go to 2:20, and adjust the star's position up, so that its path becomes a gentler arc.

7 Press the spacebar to preview the star's path again, and then press the spacebar to stop playback. If you want to change the path, you can add Position keyframes at other points in the time ruler.

8 Hide the properties for the Falling Star layer.

Animating fill color

Currently, the star remains yellow with a red stroke as it becomes a flower. You'll animate its fill color so that the final flower is red.

1 Press the Home key or move the current-time indicator to the beginning of the time ruler.

2 Select the Falling Star layer, and then click the stopwatch icon (Ö) next to the Fill Color property in the Properties panel to create an initial keyframe.

3 Go to 4:01, and change the fill color to a red color. (We used R=192, G=49, B=33.)

4 Hide all layer properties. Press F2 or click an empty area in the Timeline panel to deselect all layers.

5 Press the spacebar to preview your animation. Press the spacebar again to stop playback. Then, choose File > Save to save your work so far.

Animating using parenting

When you parent one layer to another, the child layer adopts the attributes of the parent layer. You'll draw a stem and leaves to meet the falling star. You can simply parent the leaves and stem to ensure they move together.

Drawing tapered strokes with the Pen tool

First you'll draw the stem. It will have a slightly thicker stroke than the flower, but no fill, and its tapered end will rise to meet the flower.

1 Go to 4:20, when the flower is in its final position.

2 Select the Pen tool in the Tools panel.

3 Click the word *Fill* to open the Fill Options dialog box, and then select the None option, and click OK.

4 Click the Stroke Color box in the Tools panel, change the stroke color to green (we used R=44, G=73, B=62), and click OK. Change the Stroke Width to **10 px**.

5 Click just below the rim of the flowerpot to create an initial vertex, and then click at the center of the flower. Before releasing the mouse, drag the Bezier handle to create a subtle curve in the stem.

6 Select the Shape Layer 1 layer, press Enter or Return, change its name to **Stem**, and press Enter or Return again.

7 In the Timeline panel, move the Stem layer below the Base of Flowerpot layer so it's inside the pot, not outside of it.

8 Expand the Stem layer properties, and then expand Contents > Shape 1 > Stroke 1 > Taper. Change the End Length to **83%**.

The Length values determine how quickly the stroke tapers. Start Length tapers the stroke at its starting point; End Length tapers the stroke's end point. Width determines how much the stroke tapers, and Ease determines how sharp the tapered end is.

9 With the Stem layer selected, click the stopwatch icon (🕓) next to the Position property in the Properties panel to create an initial keyframe at its final position.

10 Go to 3:00, and press Alt+[(Windows) or Option+[(macOS) to set the In point of the layer to the current time.

Tip: If you haven't already deselected the Snapping option, you may need to deselect it now in order to position the stem where you want it.

11 Select the Selection tool (▶) in the Tools panel, and drag the stem down so that it is completely below the top of the flowerpot. Press Shift as you drag to move it straight down.

The stem will begin to emerge from the pot at 3:00.

12 Hide the properties for the Stem layer.

Drawing curved shapes

Now you'll draw leaves with a fill but no stroke, using Bezier handles to round them.

1 Go to 4:20, when the flower is in its final position.

2 Press F2 or click an empty area of the Timeline panel to deselect all layers. Then select the Pen tool in the Tools panel, click the Fill Color box, select a color that is similar to the green stroke color (we used R=45, G=74, B=63), and click OK. Click the word *Stroke*, select None in the Stroke Options dialog box, and click OK.

3 Click an initial vertex for the leaf near the base of the stem, and then click another for the other end of the leaf. Before you release the mouse, drag the Bezier handle to create a curved leaf.

4 Press F2 to deselect the layer, and then repeat step 3 to draw another leaf at the base of the other side of the stem.

5 Select Shape Layer 1, press Return or Enter, rename it **Leaf 1**, and then press Return or Enter. Then rename Shape Layer 2 **Leaf 2**.

Parenting layers

You'll parent the leaves to the stem so they'll emerge with it.

1 Move the Leaf 1 and Leaf 2 layers beneath the Base of Flowerpot layer and above the Stem layer in the Timeline panel so that the leaves will be behind the flowerpot as they rise.

2 Hide all layer properties, and deselect all layers.

3 Drag the pick whip (⊚) from the Leaf 1 layer to the Stem layer, and then drag the pick whip from the Leaf 2 layer to the Stem layer.

The Leaf 1 and Leaf 2 layers will move in relationship to the Stem layer.

The layers aren't needed until the stem begins to emerge at 3:00, so you'll set their In point to match the stem's.

4 Go to 3:00. Select the Leaf 1 layer and Shift-select the Leaf 2 layer. Then press Alt+[(Windows) or Option+[(macOS) to set the In point for both of the layers.

Note: Depending on how you drew your leaves, they may protrude from the flower pot. You'll have a chance to address that later, if necessary.

About parent and child layers

Parenting assigns one layer's transformations to another layer, called a *child layer*. Creating a parenting relationship between layers synchronizes the changes in the parent layer with the corresponding transformation values of the child layers, except opacity. For example, if a parent layer moves 5 pixels to the right of its starting position, then the child layer also moves 5 pixels to the right of its starting position. A layer can have only one parent, but a layer can be a parent to any number of 2D or 3D layers within the same composition. Parenting layers is useful for creating complex animations, such as linking the movements of a marionette or depicting the orbits of planets in the solar system.

For more information on parent and child layers, see After Effects Help.

Using nulls to connect points

You've learned that parenting connects one layer to another. Sometimes you want to connect *a single point* to another layer—for example, the top of the stem in your animation to the flower itself. The Create Nulls From Paths panel lets you do just that. A null object is an invisible layer that has all the same properties as other layers so that it can serve as a parent to any layer. The Create Nulls From Paths panel creates null objects based on specific points, which you can then parent to other layers without having to write complex expressions.

● **Note:** The Create Nulls From Paths panel works only with masks or with Bezier shapes (shapes drawn with the Pen tool). To convert a shape drawn with a shape tool to a Bezier path, expand the shape layer contents, right-click the path (e.g., Rectangle 1), and choose Convert To Bezier Path.

There are three options in the Create Nulls From Paths panel: Points Follow Nulls creates nulls that *control* the position of the path points; Nulls Follow Points creates nulls that *are controlled by* the positions of the path points; and Trace Path creates a single null with its position linked to the coordinates of the path.

You'll create a null for the point at the top of the stem, and then you'll join that null to the flower so the two remain connected even as the flower moves.

1 Go to 4:20 so you can see the stem and leaves well.

2 Choose Window > Create Nulls From Paths.jsx.

3 Expand the Stem layer in the Timeline panel, and then expand Contents > Shape 1 > Path 1.

4 Select Path.

You must select a path in the Timeline panel in order to create a null using the options in the Create Nulls From Paths panel.

5 Click Points Follow Nulls in the Create Nulls From Paths panel.

After Effects creates two nulls, corresponding to the two points on the stem path. The null objects appear in gold in the Composition panel, and as layers named Stem: Path 1 [1.1.0] and Stem: Path 1 [1.1.1] in the Timeline panel. You only need the null for the top point.

6 Select the null that corresponds to the bottom point of the stem, and delete it.

7 In the Timeline panel, drag the pick whip (⊙) from the Stem: Path 1 [1.1.1] layer to the Falling Star layer.

● **Note:** After you create the nulls, you can close the Create Nulls From Paths panel, or you can leave it open.

8 Move the current-time indicator across the time ruler to see how the stem connects to the flower.

You'll animate the flower subtly, and the stem will move with it.

9 Go to 4:28, and use the Selection tool to move the flower a bit to the right as if it had been moved by the wind.

10 Select the Falling Star layer. Go to 4:20, and click the stopwatch icon (Ⓣ) next to the Rotation property in the Properties panel to create an initial keyframe at its original rotation. Go to 4:28, and change the rotation to **30°**.

11 Choose File > Save to save your work.

Previewing the composition

You've created several shape layers using shape tools and the Pen tool, animated them, and used null objects to parent them. It's time to see how it all comes together.

1 Hide all layer properties, and then press F2 to deselect all layers.

2 Press the Home key or move the current-time indicator to the beginning of the time ruler.

3 Press the spacebar to preview your animation. Press the spacebar again to stop playback.

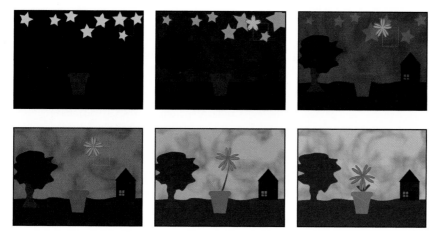

4 Make any adjustments you need to make. For example, if the leaves protrude from the flowerpot as they rise with the stem, use the Selection tool to adjust their position or rotation, or animate the leaves' opacity so that they are visible only as they emerge from the pot.

5 Choose File > Save to save the final project.

▶ **Tip:** To rotate a leaf from its tip, use the Pan Behind tool to move its anchor point to the tip.

Animating layers to match audio

You can time animation to match the beat of an audio file. First you need to create keyframes from the amplitude of the audio (which determines loudness), and then sync the animation to those values.

- To create keyframes from audio amplitude, right-click or Control-click the audio layer in the Timeline panel, and choose Keyframe Assistant > Convert Audio To Keyframes. After Effects adds the Audio Amplitude layer. The new layer is a null object layer, meaning it has no size or shape and won't appear in a final render. After Effects creates keyframes that specify the amplitude of the audio file in each frame of the layer.

- To sync an animated property with the audio amplitude, select the Audio Amplitude layer, and press E to display the effects properties for the layer. Expand the channel you want to use. Then Alt-click (Windows) or Option-click (macOS) the stopwatch icon for the property whose animation you want to sync with to add an expression; with the expression selected in the time ruler, click the pick whip icon (⊚) on the Expression:[property name] line, and drag it to the Slider property name in the Audio Amplitude layer. When you release the mouse, the pick whip snaps, and the expression in the shape layer time ruler now means that the property values for the layer will depend on the Slider values of the Audio Amplitude layer.

Review questions

1 What is a shape layer, and how do you create one?

2 How can you create multiple copies of a layer, including all of its properties?

3 How can you snap one layer to another?

4 What does the Pucker & Bloat path operation do?

Review answers

1 A shape layer is simply a layer that contains a vector graphic called a shape. To create a shape layer, draw a shape directly in the Composition panel, using any of the drawing tools or the Pen tool.

2 To duplicate a layer, select it, and choose Edit > Duplicate or press Ctrl+D (Windows) or Command+D (macOS). All of the original layer's properties, keyframes, and other attributes are included in the new layer.

3 To snap one layer to another in the Composition panel, select Snapping in the options section of the Tools panel. Then click next to the handle or point you want to use as a snapping feature, and drag the layer close to the point to which you want to align it. After Effects highlights the points to which it will align when you release the mouse button.

4 Pucker & Bloat pulls the vertices of a path outward while curving the segments inward (puckering), or pulls the vertices inward while curving the segments outward (bloating). You can animate the degree of pucker or bloat over time.

5 ANIMATING A MULTIMEDIA PRESENTATION

Lesson overview

In this lesson, you'll learn how to do the following:

- Create a complex animation with multiple layers.

- Adjust the duration of a layer.

- Animate with Position, Scale, and Rotation keyframes.

- Use parenting to sync the animation of layers.

- Use Bezier curves to smooth a motion path.

- Animate a precomposed layer.

- Apply effects to a solid layer.

- Add color labels to keyframes.

- Fade out audio.

 This lesson will take about an hour to complete. If you haven't already done so, download the project files for this lesson from peachpit.com/ AfterEffectsCIB2024, following the instructions in the Getting Started section under "Accessing the lesson files and Web Edition."

PROJECT: ANIMATED VIDEO

Adobe After Effects projects typically use a variety of imported footage, arranged in a composition, that is edited and animated using the Timeline panel. In this lesson, you'll become more familiar with animation fundamentals as you build a multimedia presentation.

117

Getting started

In this project, you will animate a hot air balloon floating through the sky. All seems peaceful until a gust of wind blows the balloon's colorful canvas off to cover the clouds.

1 Make sure the following files are in the Lessons/Lesson05 folder on your hard disk, or download them from peachpit.com now:

 • In the Assets folder: Balloon.ai, Fire.mov, Sky.ai, Soundtrack.wav

 • In the Sample_Movie folder: Lesson05.mp4

2 Open and play the Lesson05.mp4 sample movie in Windows Movies & TV or QuickTime Player to see what you'll create in this lesson. When you are done, close Windows Movies & TV or QuickTime Player. You may delete the sample movie from your hard disk if you have limited storage space.

As you start After Effects, restore the default application settings. See "Restoring default preferences" on page 3.

3 Start After Effects, and then immediately hold down Ctrl+Alt+Shift (Windows) or Command+Option+Shift (macOS) to restore default preferences settings. In the Startup Repair Options dialog box, click Reset Preferences.

4 Click New Project in the Home window.

5 Choose File > Save As > Save As.

6 In the Save As dialog box, navigate to the Lessons/Lesson05/Finished_Project folder. Name the project **Lesson05_Finished.aep**, and then click Save.

Importing the footage

Next, you'll import the footage you need for the project, including the balloon.ai composition.

1 Double-click an empty area of the Project panel to open the Import File dialog box.

2 Navigate to the Lessons/Lesson05/Assets folder on your hard disk, and select the Sky.ai file.

3 Choose Footage from the Import As menu, and then click Import or Open.

4 In the Sky.ai dialog box, make sure Merged Layers is selected, and then click OK.

5 Double-click an empty area of the Project panel, navigate to the Lessons/ Lesson05 /Assets folder, and select the Balloon.ai file.

6 Choose Composition – Retain Layer Sizes from the Import As menu, and click Import or Open.

7 Press Ctrl+I (Windows) or Command+I (macOS) to open the Import File dialog box again.

Using Creative Cloud Libraries in After Effects

Easily access images, videos, colors, and other assets you've created in After Effects and other Adobe applications. Through Creative Cloud Libraries, you can also use Looks, shapes, and other assets you create with Adobe Capture and other mobile apps. Creative Cloud Libraries also make it easy to access After Effects motion graphic templates in Adobe Premiere Pro.

Even Adobe Stock images and videos are available in the Libraries panel: Search and browse assets within the panel, download watermarked versions to see how they work with your projects, and license the ones you want to keep—all without leaving After Effects.

The same search bar you use to search Adobe Stock makes it easier to find specific items in your Creative Cloud Libraries, too.

To learn more about all the ways you can use Creative Cloud Libraries, see After Effects Help.

8 Navigate to the Lessons/Lesson05/ Assets folder, and select the Fire.mov file.

9 Make sure Footage is chosen in the Import As menu, and click Import or Open.

Creating the composition

You'll create the composition and add the sky.

1 Click New Composition in the Composition panel.

2 In the Composition Settings dialog box, do the following:

● **Note:** If you change Pixel Aspect Ratio or Width settings, the Preset name may change to Custom in the Composition Settings panel.

- Name the composition **Balloon Scene**.
- Choose HD • 1920x1080 • 25fps from the Preset menu.
- Make sure Square Pixels is chosen from the Pixel Aspect Ratio menu.
- Make sure the Width is 1920 px and Height is 1080 px.
- Choose Quarter for the Resolution.
- Set Duration to **20** seconds (20:00).
- Click OK.

3 Drag the Sky.ai footage item from the Project panel into the Timeline panel.

The balloon will float across the Sky.ai image. The far right of the image contains the canvas-wrapped clouds that appear at the end of the scene. The wrapped clouds shouldn't be visible earlier in the movie.

4 In the Composition panel, drag the Sky layer so that its lower left corner is even with the lower left corner of the composition.

Adjusting anchor points

The anchor point is the point around which transformations, such as scaling or rotation, are performed. By default, a layer's anchor point is at the center of the layer.

You'll change the anchor points for the character's arm and head so that you can better control the character's movements as he tugs on the cord to ignite the fire and as he looks up and down.

1 Double-click the Balloon composition in the Project panel to open it in the Composition panel and the Timeline panel.

The Balloon composition includes layers for the canvas colors, the balloon itself, and the character's eyes, head, forearm, and upper arm.

2 Zoom in using the Magnification Ratio pop-up menu at the bottom of the Composition panel so you can see the balloon's detail more clearly.

3 Select the Hand tool (✋) in the Tools panel, and then pan so that the character is centered in the Composition panel.

4 Select the Selection tool (▶) in the Tools panel.

5 Select the Upper arm layer in the Timeline panel.

6 Select the Pan Behind tool (✥) in the Tools panel (or press Y to activate it).

With the Pan Behind tool, you can move the anchor point without moving the entire layer in the Composition window.

7 Move the anchor point to the character's shoulder.

8 Select the Forearm layer in the Timeline panel, and then move its anchor point to the elbow.

9 Select the Head layer in the Timeline panel, and move its anchor point to the character's neck.

10 Select the Selection tool in the Tools panel.

11 Choose File > Save to save your work so far.

Parenting layers

This composition includes several layers that need to move together. For example, as the balloon floats, the character's arm and head should move along with it. As you've seen in previous lessons, a parenting relationship synchronizes changes in the parent layer with corresponding changes in the child layer. You'll establish parenting relationships among the layers in this composition, and you'll add the fire video as well.

1 Deselect all layers in the Timeline panel, and then press Ctrl (Windows) or Command (macOS) as you select the Head and Upper arm layers.

2 In the Parent column for either of the selected layers, choose 7. Balloon from the pop-up menu.

This establishes both the Head and Upper arm layers as child layers of the Balloon layer. When the Balloon layer moves, the other two layers will move with it.

The eyes not only need to move with the balloon, they need to move with the head, so you'll create that parenting relationship next.

3 In the Parent column for the Eyes layer, choose 6. Head from the pop-up menu.

The forearm should move with the upper arm as well.

4 In the Parent column for the Forearm layer, choose 9. Upper arm from the pop-up menu.

Now you need to ensure that the fire video travels with the balloon.

5 Drag the Fire.mov file from the Project panel to the Timeline panel, positioning it directly below the canvas layers so that the fire will appear to go inside the balloon, rather than outside it. (The Fire layer should be between the Yellow Canvas layer and the Eyes layer.)

The fire video is positioned in the center of the composition, so you'll need to zoom out a bit to see it.

6 Choose 25% from the Magnification Ratio pop-up menu so that you can see the outline of the selected video.

7 In the Composition window, drag the fire video over the burner. To see the flame in action so you can position it correctly, drag the current-time marker across the first second of the time ruler.

8 When you're satisfied with the Fire layer's position, choose 8. Balloon from the pop-up menu in the Fire layer's Parent column.

9 Choose File > Save to save your work so far.

Precomposing layers

As you've seen in previous lessons, sometimes it's easier to work with a set of layers. Precomposing layers moves them to a new composition, nested inside the original composition. You'll precompose the canvas layers so that you can work with them separately when you animate them sailing off the balloon.

1 In the Balloon Timeline panel, Shift-click the Green Canvas and Yellow Canvas layers to select all four canvas layers.

2 Choose Layer > Pre-compose.

3 In the Pre-compose dialog box, name the composition **Canvas**, select Move All Attributes Into The New Composition, and click OK.

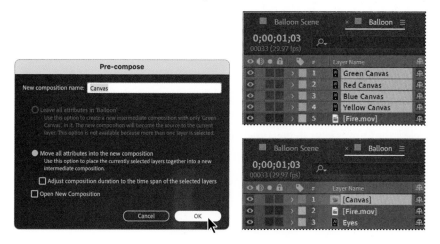

The four layers you selected in the Timeline panel are replaced by a single Canvas composition layer.

4 Double-click the Canvas layer in the Timeline panel to edit the composition.

5 Choose Composition > Composition Settings.

6 In the Composition Settings dialog box, deselect Lock Aspect Ratio, change the Width value to **5000** px, and click OK.

7 Shift-select all four layers in the Timeline panel, and then drag them to the far left side of the Composition panel. You may need to change the magnification.

Increasing the width of the composition and then moving the canvas to the far left side will give you room to animate the canvas layers later.

8 Switch to the Balloon Timeline panel.

You moved the canvas to the far left side of the Canvas composition, revealing the uncovered balloon in the Balloon composition. At the beginning of the animation, though, the canvas should be *on* the balloon. You'll reposition the Canvas layer.

9 Choose Fit from the Magnification Ratio pop-up menu in the Composition panel so you can see the full balloon.

10 Select the Canvas layer in the Timeline panel, and then drag the layer so that it covers the bare balloon in the Composition panel.

11 In the Parent column of the Canvas layer, choose 5. Balloon from the pop-up menu so that the canvas will follow the balloon.

Keyframing a motion path

Now that all the initial pieces are set up, you're ready to animate the balloon and the character using position and rotation keyframes.

Copying layers into a composition

You've worked with the balloon, character, and fire layers in the Balloon composition. Now, you'll copy those layers into the Balloon Scene composition.

1 In the Balloon Timeline panel, select the Canvas layer and then Shift-click the Upper arm layer to select all the layers in the composition.

2 Press Ctrl+C (Windows) or Command+C (macOS) to copy all the layers.

3 Switch to the Balloon Scene Timeline panel.

4 Press Ctrl+V (Windows) or Command+V (macOS) to paste the layers.

5 Click an empty area in the Timeline panel to deselect all layers.

● **Note:** Make sure to select the Canvas layer first and then Shift-click the Upper arm layer to copy layers in their original order.

The layers appear in the same order they were when you copied them, and they retain all the properties they had in the Balloon composition, including parenting relationships.

Placing initial keyframes

The balloon will enter the scene from the bottom, drift through the sky, and eventually depart from the upper right corner of the frame. You'll keyframe the balloon's starting and ending points first.

1 Select the Balloon/Balloon.ai layer in the Timeline panel.

2 In the Properties panel, change the Scale property to **60**%.

The balloon and all of its child layers scale to 60%.

3 Choose 12.5% or 25% from the Magnification Ratio pop-up menu in the Composition panel so that you can see the pasteboard around the composition.

4 In the Composition panel, drag the balloon and its child layers offscreen, below the scene. (We used Position values 844.5, 2250.2.)

5 Drag the Rotation value to rotate the balloon so it tilts to the right. (We used 19 degrees.)

6 Click the stopwatch icons (🕑) for the Position, Scale, and Rotation properties to create initial keyframes.

7 Go to 14:20 and scale the balloon to about one-third its original size. We used 39.4%.

8 Drag the balloon off the upper right corner of the frame, tilted slightly to the left. We used the following values: Position 2976.5, −186; Rotation −8.1 degrees.

9 Move the current-time indicator across the timeline to see the animation so far.

Customizing a motion path

The balloon moves through the scene, but its path isn't very interesting, and it isn't onscreen long. You'll customize the path between its start point and end point. You can use the values we used or create your own path, as long as the balloon stays fully visible on the screen until a little after 11 seconds, and then slowly makes its way offscreen.

1 Go to 3:00.

2 Drag the balloon straight up so that the character and the basket are fully visible, and then rotate it slightly to the left. (We used Position 952.5, 402.2; Rotation −11.1 degrees.)

3 Go to 6:16.

4 Shift the balloon's rotation the other direction. (We used 9.9 degrees.)

5 Move the balloon to the left side of the scene. (We used Position 531.7, 404.)

6 Go to 7:20.

7 Change the scale to **39.4**%.

8 Set additional Rotation keyframes to create swirling motions. If you're using our values, do the following:

- At 8:23, change the Rotation value to **−6.1**.

- At 9:16, change the Rotation value to **22.1**.

- At 10:16, change the Rotation value to **−18.3**.

- At 11:24, change the Rotation value to **11.9**.

- At 14:19, change the Rotation value to **−8.1**.

Tip: You can change settings in the Properties panel or the Timeline panel; in this exercise, it's more efficient to set Rotation keyframes in the Timeline panel.

9 Set additional Position keyframes to move the balloon. If you're using our values, do the following:

- At 9:04, change the Position to **726.5**, **356.2**.

- At 10:12, change the Position to **1396.7**, **537.1**.

10 Press the spacebar to preview the balloon's current path, and then press the spacebar again to stop the preview. Save your work so far.

Using Bezier handles to smooth a motion path

The basic path is in place, but you can smooth it out a bit. Each keyframe includes Bezier handles that you can adjust to change the angle of the curve. You'll learn more about Bezier curves in Lesson 7.

1 Choose 50% from the Magnification Ratio pop-up menu in the Composition panel.

2 Make sure the Balloon/Balloon.ai layer is selected in the Timeline panel. Then move the current-time indicator to a position where you can clearly see the motion path in the Composition panel. (Between 4 and 6 seconds is probably good.)

● **Note:** If Bezier handles don't appear when you click with the Selection tool, use the Convert Vertex tool (hidden behind the Pen tool) to display them.

3 Click a keyframe point in the Composition panel to reveal its Bezier handles, if they aren't already shown.

4 Drag a Bezier handle to change the curve for that keyframe.

5 Continue to drag Bezier handles for the keyframe points until you achieve the path you want. Our final path is shown below in the image on the right.

6 Preview the balloon on the path by moving the current-time indicator across the time ruler. Make any adjustments you want. You can also make adjustments later, after you've animated the canvas and sky.

7 Hide the properties for the Balloon layer in the Timeline panel, and save your work so far.

Animating additional elements

The balloon swoops and swirls through the sky, and its child layers go with it. But the character is currently static in his balloon. You'll animate his arm tugging on the cord to ignite the burner.

1 Go to 3:08.

2 Choose 100% from the Magnification Ratio pop-up menu in the Composition window so that you can see the character clearly. Use the Hand tool to adjust the image in the Composition window if you need to.

3 Shift-select the Forearm/Balloon.ai layer and the Upper arm/Balloon.ai layer.

4 In the Properties panel, click the stopwatch icon next to the Rotation property to create an initial keyframe for each layer.

After Effects displays the Rotation property and initial keyframe for each layer in the Timeline panel.

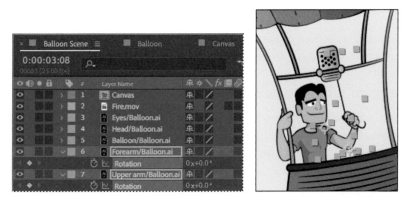

5 Go to 3:17, the point at which the character will tug the cord to ignite the burner.

6 Deselect the layers.

7 In the Timeline panel, change the Rotation property for the Forearm layer to −35 and the Rotation property for the Upper arm layer to 46.

The character tugs the cord down. You may need to deselect the layers so you can see the action clearly in the Composition window.

8 Go to 4:23, and change the Rotation property for the Forearm layer to **−32.8**.

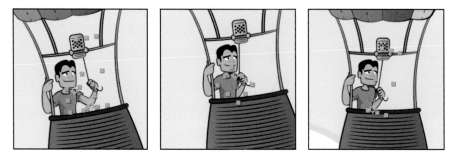

9 Click the Add Or Remove Keyframe At Current Time button (◆) to the left of the Rotation property for the Upper arm layer.

10 Go to 5:06, and change the Rotation value for both layers to **0**.

11 Deselect both layers, and then manually preview from 3:00 to 5:07 to see the character tug the cord. You may need to zoom out to see the animation.

Adding color labels to keyframes

In a complex composition, you may have to create hundreds of keyframes. Assigning color labels to keyframes lets you organize, identify, and quickly select components of your work. You'll assign colors to the keyframes you just created to make it easier to identify and duplicate them.

1 Right-click (Windows) or Control-click (macOS) one of the keyframes you just created.

2 Choose Label > Red.

The keyframe is now red. You can add labels individually, but since you want to label all the keyframes currently in the layer, it will be faster to assign the label to them all at once.

3 Select the Rotation property for the Forearm/Balloon layer to select all four of its keyframes.

4 Shift-select the Rotation property for the Upper arm/Balloon layer to also select its keyframes.

5 Right-click or Control-click a selected keyframe, and choose Label > Red.

6 Press F2 or click an empty area in the Timeline panel to deselect all layers.

Duplicating keyframes to repeat an animation

Now that you've labeled the initial keyframes, you can easily repeat them at different times in the timeline. You'll duplicate the tugging arm, and then create corresponding head and eye movements.

1 Right-click (Windows) or Control-click (macOS) one of the keyframes in the Forearm layer, and choose Select Keyframe Label Group > On Selected Layers to select all its keyframes.

2 Press Ctrl+C (Windows) or Command+C (macOS) to copy the keyframes.

3 Go to 7:10, the point at which the character tugs the cord again.

4 Press Ctrl+V (Windows) or Command+V (macOS) to paste the keyframes.

5 Repeat steps 1–4 to copy the Upper arm Rotation property keyframes.

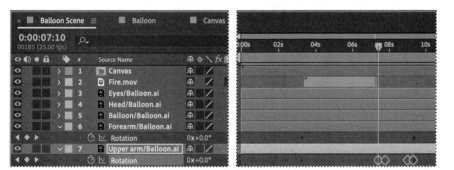

6 Hide the properties for all layers.

7 Go to 3:08. Select the Head layer, and click the stopwatch icon for the Rotation property in the Properties panel to create an initial keyframe.

8 Go to 3:17, and change the Rotation property to **–10.3**.

9 Go to 4:23, and click the Add Or Remove Keyframe At Current Time icon to add a keyframe at the current value.

10 Go to 5:06, and change the Rotation property to **0**.

11 In the Timeline panel, select the Rotation property to select all of its keyframes. Right-click or Control-click a selected keyframe, and choose Label > Blue.

Now the character tilts his head up when he tugs the cord. You'll also animate the position of his eyes to create a subtle change when he tilts his head.

12 Select the Eyes layer.

13 Go to 3:08, and click the stopwatch icon for the Position property in the Properties panel to create an initial keyframe at the current value (62, 55).

14 Go to 3:17, and change the Position value to **62.4**, **53**.

15 Go to 4:23, and create a keyframe at the current value.

16 Go to 5:06, and change the Position value to **62**, **55**.

17 In the Timeline panel, select the Position property to select all its keyframes, and then right-click or Control-click one, and choose Label > Blue.

18 Right-click or Control-click a Rotation keyframe in the Head layer, choose Select Keyframe Label Group > On Selected Layers, and then press Ctrl+C (Windows) or Command+C (macOS) to copy the keyframes.

19 Go to 7:10, and paste the keyframes.

20 Repeat steps 18-19 for the Position property in the Eyes layer.

21 Hide all layer properties, and then deselect all layers.

22 Choose Fit from the Magnification Ratio pop-up menu in the Composition window so that you can see the entire scene. Then preview the animation.

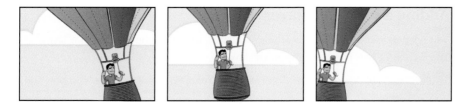

23 Save your work.

Positioning and duplicating a video

When the character tugs the cord, flame should emerge from the burner. You'll use the four-second Fire.mov video to represent the flame each time the cord is tugged.

1 Go to 3:10.

2 Drag the Fire.mov video in the Timeline panel so that it starts at 3:10.

3 Select the Fire.mov layer, and choose Edit > Duplicate.

4 Go to 7:10.

5 Press the left bracket key ([) on your keyboard to move the In point of the duplicate Fire.mov layer to 7:10.

Applying an effect

Now that the balloon and character are taken care of, you'll create the gust of wind that blows the canvas off the balloon. The Fractal Noise and Directional Blur effects will work well.

Adding a solid-color layer

You need to apply the effects on their own layer, which will be a solid-color layer. You'll create a new composition for the layer.

1 Press Ctrl+N (Windows) or Command+N (macOS) to create a new composition.

2 In the Composition Settings dialog box, do the following:

• Name the composition **Wind**.

• Change the width to **1920** px.

• Change the height to **1080** px.

• Change the duration to **20** seconds.

• Change the Frame Rate to **25** fps to match the Balloon Scene composition.

• Click OK.

3 Right-click or Control-click in the Timeline panel, and choose New > Solid.

About solid-color layers

Use solid layers to color a background or to create simple graphic images. You can create solid layers of any color or size (up to 30,000 x 30,000 pixels) in After Effects. After Effects treats solids as it does any other footage item: You can modify the mask, transform properties, and apply effects to a solid layer. If you change settings for a solid that is used by more than one layer, you can apply the changes to all layers that use the solid or to only the single occurrence of the solid.

4 In the Solid Settings dialog box, do the following:

- Name the layer **Wind**.
- Select black for the color.
- Click the Make Comp Size button.
- Click OK.

Applying the effects

You're ready to apply the effects to the solid layer. The Fractal Noise effect will create the gust of wind. The Directional Blur effect will create a blur in the direction the canvas flies.

1 In the Effects & Presets panel, search for the Fractal Noise effect; it's in the Noise & Grain category. Double-click the Fractal Noise effect to apply it.

2 In the Effect Controls panel, do the following:

- Choose Smeary for the Fractal Type.
- Choose Soft Linear for the Noise Type.
- Set the Contrast to **700**.
- Set the Brightness to **59**.
- Expand the Transform properties, and set the Scale to **800**.

3 Click the stopwatch icon next to Offset Turbulence to create an initial keyframe at the beginning of the time ruler.

4 Go to 2:00, and change the x value for Offset Turbulence to **20,000**.

5 Hide the Fractal Noise properties in the Effect Controls panel.

6 In the Effects & Presets panel, search for the Directional Blur effect, and then double-click it to apply it.

7 In the Effect Controls panel, set the Direction to **90** degrees and the Blur Length to **236**.

You've created a sense of motion. Now you need to add the Wind composition to the Balloon Scene composition.

8 Switch to the Balloon Scene Timeline panel.

9 Click the Project tab, and then drag the Wind composition from the Project window into the Balloon Scene Timeline above all the other layers.

10 Go to 8:10, and then press the left bracket key ([) so that the Wind layer starts at 8:10.

Finally, you'll apply a blending mode and adjust the opacity to make the effect of the wind more subtle.

11 Click Toggle Switches/Modes at the bottom of the Timeline panel to view the Mode column.

12 Choose Screen from the Wind layer's Mode pop-up menu.

13 With the Wind layer selected, click the stopwatch icon for the Opacity property in the Properties panel to create a keyframe at the beginning of the layer (8:10).

14 Go to 8:20, and change the opacity to **35**%.

15 Go to 10:20, and change the opacity to **0**%.

16 Hide the Opacity property in the Timeline panel, and then save your work so far.

Animating precomposed layers

Earlier, you precomposed the four canvas layers, creating a composition called Canvas. You then positioned the Canvas composition layer to match the balloon, and parented the two. Now, you'll animate the canvas layers so that they blow off the balloon when the gust of wind occurs.

1 Double-click the Canvas layer to open the Canvas composition in the Composition panel and the Timeline panel.

2 Go to 9:10, which is about a second after the wind effect begins.

3 Shift-select all four layers, and then, in the Properties panel, click the stopwatch icons for the Position and Rotation properties to create initial keyframes for all of the layers.

4 Go to 9:24.

5 With all layers still selected, drag a Rotation value until the canvas is nearly horizontal (about 81 degrees). All four canvas layers rotate.

6 Press F2 or click an empty area in the Timeline panel to deselect all layers so you can adjust their Rotation values separately.

7 Adjust each Rotation value, using positive and negative numbers so that there is some variation in their appearance. (We used these values: Green +100, Red −74, Blue +113, Yellow −103.)

8 Go to 10:12.

9 Move all the canvas layers off the screen to the right. Vary their motion paths to make them more interesting. You can add intermediate rotation and position keyframes (between 10:06 and 10:12), edit Bezier curves, or just drag the canvas layers off the edge. If you edit the Bezier curves, make changes only to the keyframes on the right side of the motion path (at 10:12) so you don't disturb the original balloon formation.

10 Move the current-time indicator across the time ruler to preview the animation, and then make any adjustments you want.

11 Hide the properties for all layers, and save your work.

Adding an adjustment layer

You'll add a warp effect to the canvas. You can use an adjustment layer to apply an effect to all the layers beneath it at once.

1 Click an empty area in the Timeline panel to deselect all layers.

2 Choose Layer > New > Adjustment Layer.

A new adjustment layer is automatically added to the top of the layer stack.

3 In the Effects & Presets panel, navigate to the Wave Warp effect in the Distort category, and then double-click the effect.

4 Go to 9:12.

5 In the Effect Controls panel, change Wave Height to **0** and Wave Width to **1**. Then click the stopwatch icons to create initial keyframes for each of them.

6 Go to 9:16.

7 Change the Wave Height value to **90** and the Wave Width value to **478**.

Trimming a layer

You don't need the Wave Warp effect until the canvas flies off the balloon, but even if the values are 0, After Effects will have to calculate the effect for the entire layer. So you'll trim the layer to speed up the time it takes to render the file.

1 Go to 9:12.

2 Press Alt+[(Windows) or Option+[(macOS) to set the In point to **9:12**.

3 Return to the Balloon Scene Timeline panel.

4 Press the spacebar to preview the movie. Press the spacebar again to stop the preview.

● **Note:** Press [to move the In point of a clip without changing its duration. Press Alt+[or Option+[to trim a clip to a new In point, shortening its duration.

5 Save your work so far.

Animating the background

The movie should end with the revelation that the canvas from the balloon has been draped on the clouds. But right now, the canvas flies off and the balloon floats away. You need to animate the sky so that the canvas-covered clouds are centered at the end of the scene.

1 In the Balloon Scene Timeline panel, go to the beginning of the time ruler (0:00).

2 Select the Sky layer. In the Properties panel, click the stopwatch icon for the Position property to create an initial keyframe.

3 Go to 16:00, and drag the Sky layer down and to the left until the wrapped clouds are in the center of the frame. (Our values are −236.4, 566.7.)

4 Go to 8:00, and move the wrapped clouds completely off the screen, far off to the right.

5 Right-click or Control-click the first keyframe, and choose Keyframe Assistant > Easy Ease Out.

6 Right-click the middle keyframe, and choose Keyframe Assistant > Easy Ease, and then right-click the last keyframe, and choose Keyframe Assistant > Easy Ease In.

7 Move the current-time indicator through the time ruler to see how the departure of the canvas matches up with the appearance of the canvas-covered clouds. The canvas should be completely offscreen before the canvas-covered clouds appear.

8 Move the middle keyframe forward and backward in the time ruler to adjust the sky animation so that it matches the progress of the canvas and the balloon. The bare balloon should float in front of at least a few of the canvas-covered clouds before it disappears.

9 Press the spacebar to preview the entire video. Press the spacebar again to stop the preview.

10 Adjust the motion paths and rotations for the balloon, canvas pieces, or the sky as necessary.

11 Hide the properties for all layers, and save the project.

Supported audio file formats

You can import any of the following types of audio files into After Effects:

- Advanced Audio Coding (AAC, M4A)
- Audio Interchange File Format (AIF, AIFF)
- MP3 (MP3, MPEG, MPG, MPA, MPE)
- Waveform (WAV)

Adding an audio track

Give yourself a hand—you've done a lot of animating in this project. But you're not quite done. You'll add a soundtrack that matches the lighthearted mood of the video, and fade it out. You'll also shorten the composition, since the last few seconds are static.

1 Click the Project tab to bring the Project panel forward. Then, double-click an empty area of the Project panel to open the Import File dialog box.

2 Navigate to the Lessons/Lesson05/Assets folder, and double-click the Soundtrack.wav file.

3 Drag the Soundtrack.wav item from the Project panel into the Balloon Scene Timeline panel, placing it at the bottom of the layer stack.

4 Preview the movie. The music changes just as the canvas flies off the balloon.

5 Go to 18:00, and press N to move the work area end point to the current time.

6 Choose Composition > Trim Comp to Work Area.

7 Go to 16:00. Expand the Soundtrack.wav layer and the Audio properties.

8 Click the stopwatch icon to create an initial keyframe for the Audio Levels value.

9 Go to 18:00, and change the Audio Levels value to **–40** dB.

10 Preview the animation, and then save it.

Congratulations. You've just created a complex animation, practicing all kinds of After Effects techniques and capabilities along the way.

Editing audio files in Adobe Audition

You can make some very simple changes to audio in After Effects. For more substantial edits, use Adobe Audition. Audition is available with a full Adobe Creative Cloud membership.

You can use Audition to change the length of an audio file, alter its pitch, or change its tempo. You can apply effects, record new audio, mix multitrack sessions, and more.

To edit an audio clip you've used in After Effects, select the file in the Project panel, and choose Edit > Edit In Adobe Audition. Then, make your changes in Audition, and save the file. The changes you made are automatically reflected in your After Effects project.

Review questions

1 How does After Effects display an animation of the Position property?

2 What is a solid-color layer, and what can you do with it?

3 What types of audio can you import into an After Effects project?

Review answers

1 When you animate the Position property, After Effects displays the movement as a motion path. You can create a motion path for the position of the layer or for the anchor point of a layer. A position motion path appears in the Composition panel; an anchor-point motion path appears in the Layer panel. The motion path appears as a sequence of dots, where each dot marks the position of the layer at each frame. A box in the path marks the position of a keyframe.

2 You can create solid images of any color or size (up to 30,000 x 30,000 pixels) in After Effects. After Effects treats solids as it does any other footage item: You can modify the mask, transform properties, and apply effects to the solid layer. If you change settings for a solid that is used by more than one layer, you can apply the changes to all layers that use the solid or to only the single occurrence of the solid. Use solid layers to color a background or create simple graphic images.

3 You can import any of the following types of audio files into After Effects: Advanced Audio Coding (AAC, M4A), Audio Interchange File Format (AIF, AIFF), MP3 (MP3, MPEG, MPG, MPA, MPE), and Waveform (WAV).

6 ANIMATING LAYERS

Lesson overview

In this lesson, you'll learn how to do the following:

- Animate a layered Adobe Photoshop file.

- Create an expression using the pick whip.

- Work with imported Photoshop layer styles.

- Apply a track matte to control the visibility of layers.

- Animate a layer using the Corner Pin effect.

- View layer render times using the Composition Profiler.

- Use time remapping and the Layer panel to dynamically retime footage.

- Edit Time Remap keyframes in the Graph Editor.

 This lesson will take about an hour to complete. If you haven't already done so, download the project files for this lesson from peachpit.com/ AfterEffectsCIB2024, following the instructions in the Getting Started section under "Accessing the lesson files and Web Edition."

PROJECT: THEATER MARQUEE IN A FILM SHORT

Animation is all about making changes over time—
changes to an object or image's position, opacity, scale,
and other properties. This lesson provides more practice
animating the layers of a Photoshop file, including
dynamically remapping time.

Getting started

Adobe After Effects provides several tools and effects that let you simulate motion video using a layered Photoshop file. In this lesson, you will import a layered Photoshop file of a theater marquee, and then animate it to simulate the marquee lighting up and text scrolling across its screen. This is a stylized animation in which the motion is first accelerated, and then reverses and moves forward again.

First, you'll preview the final movie and set up the project.

1 Make sure the following files are in the Lessons/Lesson06 folder on your hard disk, or download them from peachpit.com now:

 • In the Assets folder: marquee.psd

 • In the Sample_Movie folder: Lesson06.mp4

2 Open and play the Lesson06.mp4 in Windows Movies & TV or QuickTime Player to see the final animation you will create in this lesson.

3 When you're done, quit Windows Movies & TV or QuickTime Player. You may delete the sample movie from your hard disk if you have limited storage space.

When you begin the lesson, restore the default application settings for After Effects. See "Restoring default preferences" on page 3.

4 Start After Effects, and then immediately hold down Ctrl+Alt+Shift (Windows) or Command+Option+Shift (macOS) to restore default preferences settings. In the Startup Repair Options dialog box, click Reset Preferences.

5 Click New Project in the Home window.

After Effects opens to display an empty, untitled project.

6 Choose File > Save As > Save As.

7 In the Save As dialog box, navigate to the Lessons/Lesson06/Finished_ Project folder.

8 Name the project **Lesson06_Finished.aep**, and then click Save.

Importing the footage

You need to import one source item for this lesson.

1 Double-click an empty area of the Project panel to open the Import File dialog box.

2 Navigate to the Lessons/Lesson06/Assets folder on your hard disk, and select the marquee.psd file.

3 Choose Composition – Retain Layer Sizes from the Import As menu, so the dimensions of each layer will match the layer's content. (In macOS, you may need to click Options to see the Import As menu.)

4 Click Import or Open.

5 In the marquee.psd dialog box, make sure Editable Layer Styles is selected in the Layer Options area, and click OK.

Before continuing, take a moment to study the layers of the file you just imported.

6 In the Project panel, expand the marquee Layers folder to see the Photoshop layers. Resize the Name column to make it wider and easier to read, if necessary.

Each of the elements you'll animate in After Effects—such as the starburst—is on a separate layer. In addition, there is one layer representing the initial marquee with plain light bulbs (Unlit marquee) and a second layer that represents the final marquee with the bulbs brightly lit (Lit marquee).

After Effects preserves the layer order, transparency data, and layer styles from the source Photoshop document. It also preserves other features, such as adjustment layers and type, which you don't happen to be using in this project.

Preparing layered Photoshop files

Before you import a layered Photoshop file, name its layers carefully to reduce preview and rendering time, and to avoid problems importing and updating the layers:

- Organize and name layers. If you change a layer name in a Photoshop file after you have imported the file into After Effects, After Effects retains the link to the original layer. However, if you delete a layer in a Photoshop file after you have imported the file into After Effects, After Effects will be unable to find the original layer and will list it as missing in the Project panel.

- To avoid confusion, make sure that each layer has a unique name.

Creating the composition

For this lesson, you'll use the imported Photoshop file as the basis of the composition.

● **Note:** If you don't see the full image, choose Fit from the Magnification Ratio pop-up menu in the Composition window.

1 Double-click the marquee composition in the Project panel to open it in the Composition panel and in the Timeline panel.

2 Choose Composition > Composition Settings.

3 In the Composition Settings dialog box, change the Duration to **10:00** to make the composition 10 seconds long if it isn't already, and then click OK.

Simulating lighting changes

The first part of the animation involves lighting the marquee. You'll use Opacity keyframes to animate the light.

1 Go to 4:00.

Currently, the lit background is on top of the regular (unlit) background, obscuring it so the initial frame of the animation is bright. However, you want the marquee to appear dark and then lighten. To accomplish this, you will make the Lit marquee layer initially transparent, and then animate its opacity so that the lights appear to turn on over time.

2 Select the Lit marquee layer in the Timeline panel, and click the stopwatch icon (⏱) next to the Opacity value in the Properties panel to create a keyframe. Note that the Opacity value is 100%.

3 Press the Home key or drag the current-time indicator to 0:00. Then change the Opacity to **0%**. After Effects adds a keyframe.

Now, when the animation begins, the Lit marquee layer is transparent, which allows the Unlit marquee layer to show through.

4 Click the Play/Pause button (▶) in the Preview panel, or press the spacebar, to preview the animation.

The bulbs around the marquee transition until they are brightly lit.

5 Press the spacebar to stop playback at any time after 4:00.

6 Choose File > Save.

Duplicating an animation using the pick whip

The Starburst layer includes the Bevel And Emboss layer style from Photoshop. You'll animate the bevel, which makes the starburst appear backlit, so that it lights up as the marquee does.

To do this, you'll use the pick whip to duplicate the animation you just created. You can use the pick whip to create expressions that link the values of one property or effect to another. In this case, you'll link the opacity of the Lit marquee layer to the Depth property of the Bevel And Emboss effect in the Starburst layer.

1 Press the Home key or move the current-time indicator to the beginning of the time ruler.

2 Expand the Starburst layer, and then expand its Layer Styles > Bevel And Emboss properties.

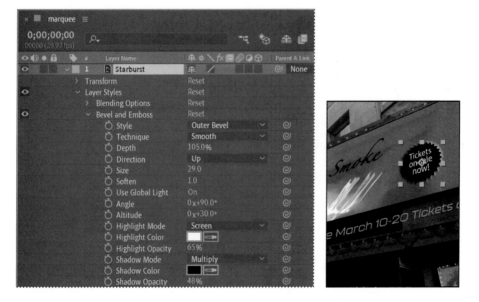

3 If necessary, enlarge the Timeline panel so that you can see both the Lit marquee and Starburst properties.

4 Make sure the Opacity property is still visible for the Lit marquee layer.

5 Click the pick whip icon (⊚) for the Depth property in the Starburst layer, and drag it to the Opacity property name for the Lit marquee layer. When you release the mouse, the pick whip snaps, and the Depth property value is red.

6 Expand the Depth property for the Starburst layer. An expression in the Starburst layer time ruler now reads *"thisComp.layer("Lit marquee").transform.opacity."* This means that the Opacity value for the Lit marquee layer replaces the previous Depth value (105%) for the Starburst layer.

7 Drag the current-time indicator from 0:00 to 4:00. Notice that the Opacity value for the Lit marquee layer and the Depth property for the Starburst layer increase simultaneously. The area around the starburst and the marquee light bulbs brighten in sync.

8 Hide the properties for all layers to keep the Timeline panel tidy. If you enlarged the Timeline panel, return it to its original size.

9 Choose File > Save to save your project.

About Photoshop layer styles

Adobe Photoshop provides a variety of layer styles—such as shadows, glows, and bevels—that change the appearance of a layer. After Effects can preserve these layer styles when you import Photoshop layers. You can also apply layer styles in After Effects.

Though layer styles are referred to as *effects* in Photoshop, they behave more like blending modes in After Effects. Layer styles follow transformations in the standard render order, whereas effects precede transformations. Another difference is that each layer style blends directly with the underlying layers in the composition, whereas an effect is rendered on the layer to which it's applied, the result of which then interacts with the underlying layers as a whole.

The layer style properties are available for the layer in the Timeline panel.

To learn more about working with layer styles in After Effects, see After Effects Help.

Using a track matte to confine animation

Text should scroll across the bottom of the marquee, but only in the black field. You'll animate the text, and then create a track matte to confine it to the designated area, so that it appears to be an electronic ticker.

Animating the text

The text should start scrolling after the marquee lights up, and it should continue scrolling until the end of the clip.

1 In the Timeline panel, select the Scroll text layer.

2 Go to 4:10.

3 Press Alt+[(Windows) or Option+[(macOS) to set the In point to 4:10.

The text will appear on screen at 4:10, shortly after the marquee is fully lit.

4 With the Scroll text layer selected, change the Position property in the Properties panel to **4994, 1106**.

Only the first character of the text appears in the black ticker area.

5 Click the stopwatch icon (⏱) to create an initial keyframe.

6 Go to 9:29, the last frame in the clip.

7 Change the Position property to **462, 2121**.

After Effects creates a keyframe. The last character in the text is visible in the ticker field.

8 Press the spacebar to preview the scrolling text. Press the spacebar again to end the preview.

Creating the track matte

The text scrolls well, but it overlaps the rest of the marquee, and even the lights on the left side. You'll use a track matte to confine the text to the black ticker field. You'll use the alpha channel of the Scroll area layer for the track matte.

1 Click Toggle Switches/Modes at the bottom of the Timeline panel to display the Track Matte column, so you can apply the track matte.

2 Select the Scroll text layer, and choose "3. Scroll area" from the Track Matte pop-up menu.

The alpha channel of the layer you selected (Scroll area) is used to set transparency for the Scroll text layer, so the contents of that layer appear only within the matte defined by the Scroll area layer. The video switch is automatically deselected for the Scroll area layer when you apply the track matte.

With the Scroll area layer deselected there are light artifacts at the top of the text area. You'll make the layer visible to hide those lights without compromising the track matte.

3 Click the eye icon (👁) for the Scroll area layer in the Timeline panel.

4 Deselect all layers, and hide all layer properties.

5 Press the Home key or move the current-time indicator to the beginning of the time ruler, and then press the spacebar to preview the animation. Press the spacebar again when you're done.

6 Choose File > Save to save your project.

About track mattes and traveling mattes

When you want one layer to show through a hole in another layer, set up a *track matte*. You'll need two layers—one to act as a matte, the other to fill the hole in the matte. You can animate either the track matte layer or the fill layer. When you animate the track matte layer, you create a *traveling matte*. If you want to animate the track matte and fill layers using identical settings, you can precompose them.

You define transparency in a track matte using values from either its alpha channel or the luminance of its pixels. Using luminance is handy when you want to create a track matte from a layer without an alpha channel, or a layer imported from a program that can't create an alpha channel. In both alpha-channel mattes and luminance mattes, pixels with higher values are more transparent. In most cases, you use a high-contrast matte so that areas are either completely transparent or completely opaque. Intermediate shades should appear only where you want partial or gradual transparency, such as along a soft edge.

By default, After Effects uses alpha channel values to create a track matte. To use the luminance values instead, click the circle icon (◉) next to the Track Matte column to change it to the sun icon (◼). To invert the matte, click the empty square so that it displays the inverted icon (◪).

A B C

Anatomy of a traveling matte

A. *Track matte layer: A solid with a rectangular mask, set to Luma Matte. The mask is animated to travel across the screen.*

B. *Fill layer: A solid with a pattern effect.*

C. *Result: The pattern is seen in the track matte's shape and added to the image layer, which is below the track matte layer.*

Adding motion blur

The text's movement will look more authentic if it includes motion blur. You'll add the motion blur and then set the shutter angle and phase, which control the intensity of the blur.

1 Go to 8:00, so you can see the scrolling text well.

2 Click Toggle Switches/Modes at the bottom of the Timeline panel.

3 Click the Motion Blur (●) switch for the Scroll text layer.

After Effects enables Motion Blur for the entire composition, and the text layer appears less sharp in the Composition panel.

4 Choose Composition > Composition Settings.

5 In the Composition Settings dialog box, click the Advanced tab, and reduce the Shutter Angle to **90** degrees.

The Shutter Angle setting imitates the effect of adjusting a shutter angle on a real camera, which controls how long the camera aperture is open, gathering light. Larger values create more motion blur.

6 Change the Shutter Phase to **0** degrees, and then click OK.

Animating using the Corner Pin effect

The marquee is looking pretty good, but the starburst isn't terribly noticeable. You'll use the Corner Pin effect to distort it over time and draw attention to it.

Using the Corner Pin effect is similar to animating with the Free Transform tool in Photoshop—the effect distorts an image by repositioning each of its four corners. You can use it to stretch, shrink, skew, or twist an image, or to simulate perspective or movement that pivots from the edge of a layer, such as a door opening.

1 Go to 4:00.

2 In the Timeline panel, click the Solo switch (•) for both the Show title and Starburst layers.

Soloing the layers isolates them to speed animating, previewing, and rendering.

3 Select the Starburst layer in the Timeline panel, and then choose Effect > Distort > Corner Pin. Small circles appear around the corner points of the Starburst layer in the Composition panel.

You'll start by creating initial keyframes at their current locations.

4 If the Effect Controls panel isn't already open, choose Window > Effect Controls.

5 In the Effect Controls panel, click the stopwatch icon (◐) next to each of the pins— Upper Left, Upper Right, Lower Left, and Lower Right—to set initial keyframes.

● **Note:** If you don't see the controls, choose View Options from the Composition panel menu. In the View Options dialog box, select the Handles and Effect Controls options, and then click OK.

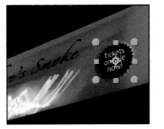

6 Go to 6:00, and then drag each of the four corner-pin handles outward. With the Corner Pin tool, you can move each handle a different amount. Notice that the x and y coordinates update in the Effect Controls panel. After Effects adds keyframes.

Instead of dragging the handles, you can manually enter the values shown in the following figure.

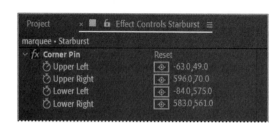 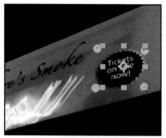

7 Go to 8:00, and then drag the corner-pin handles so that the text is tilted at an angle. Your corner-pin locations should be similar to those in the figure below. After Effects adds keyframes.

8 Click the Solo switches (●) for the Show title and Starburst layers to restore the view of the other layers.

9 Press the Home key or move the current-time indicator to the beginning of the time ruler. Press the spacebar to preview the entire animation, including the corner-pin effect. When you're done, press the spacebar again.

10 Choose File > Save to save your project.

Simulating a darkening sky

The lights come on, but the sky and building remain in daylight. The background should darken as the marquee lights up, showing off the marquee contents and creating a sense of excitement. You'll use a mask, a solid layer, and a blending mode to provide the contrast.

Creating a mask

You want darkness to fall on the building and sky behind the theater sign. You'll duplicate the layer, and then create a mask to isolate the area you want to darken.

1 Press the Home key or move the current-time indicator to the beginning of the time ruler.

2 In the Timeline panel, select the Lit marquee layer.

3 Choose Edit > Duplicate. After Effects adds a Lit marquee 2 layer to the layer stack, immediately above the Lit marquee layer.

4 Select the Pen tool (✐) in the Tools panel.

5 With the Lit marquee 2 layer selected in the Timeline panel, click the upper left corner of the marquee to start drawing.

6 Click additional points to continue the mask around the left edge of the marquee, the left and upper edge of the background, and the theatre sign, as in the image below. You'll need to create some points of the mask on the pasteboard outside the image.

7 Continue around the theatre sign, and then click your starting point again to close the mask.

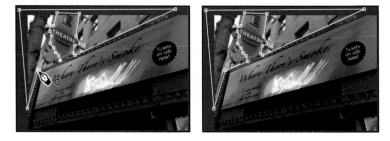

Adding a solid layer

Now that you've masked the background, you'll add the layer that will affect it, and then animate the opacity of that layer.

1 Select the Lit marquee layer in the Timeline panel.

2 Choose Layer > New > Solid.

3 In the Solid Settings dialog box, make sure a dark gray color is selected, click Make Comp Size, and then click OK. After Effects adds a layer named Dark Gray Solid 1 between the Lit marquee and Lit marquee 2 layers.

With the current-time indicator at the beginning of the time ruler, most of the image will darken, because neither the Lit marquee layer nor the Lit marquee 2 layer (with its mask) are visible yet. Don't worry; you'll animate the solid layer's opacity to account for that.

4 Select the Lit marquee 2 layer, and press M if the Mask property isn't already displayed.

5 Choose Darken from the Mask Mode menu, and select Inverted.

You drew around the background, but that's the area you want to remain unmasked. When you invert the mask, the unselected area becomes masked instead.

6 Select the Dark Gray Solid layer. Make sure the current-time indicator is at the beginning of the time ruler (0:00). Then, change the Opacity value to **0%** in the Properties panel, and click the stopwatch icon (⏱) to create an initial keyframe.

7 Go to 1:23, and change the Opacity to **5%**.

8 Go to 4:09, and click the Add Or Remove Keyframe button to create an additional keyframe with Opacity at 5%.

9 Go to 7:00, and change the Opacity to **75%**.

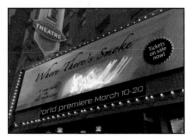

10 Press the Home key or move the current-time indicator to the beginning of the time ruler. Press the spacebar to preview the animation. When you're done, press the spacebar again.

As the lights brighten and the text begins to move, the surrounding building and sky gradually darken. Your scene is complete.

11 Hide the properties for all layers, and save your work.

Viewing render times for layers

In a complex project, it can be helpful to know which components are contributing to long render times. For example, you may find it helpful to turn off some layers or specific effects while you work on other aspects of your project.

You can see the overall render time for the current frame at the bottom of the Timeline panel. When you turn on the Composition Profiler, you can see the rendering time of each layer, effect, mask, and layer style in the current frame in the Render Time column.

1 Click the snail icon (🐌) at the bottom of the Timeline panel.

The Render Time column appears in the Timeline panel, displaying the render time for each layer active in the current frame.

2 Drag the current-time indicator across the time ruler to see how render times differ for each layer on different frames.

3 Expand the Starburst layer. Notice that the layer styles that were applied in Photoshop increase the render time.

4 Hide layer properties. Click the snail icon again to turn off the Composition profiler, or leave it on if you want to see how rendering times are affected by changes you make to layers.

Retiming the composition

▶ **Tip:** You can get even finer control with the Timewarp effect, which you'll use in Lesson 14, "Advanced Editing Techniques."

So far, you have created a straightforward time-lapse simulation. That's fine, but After Effects offers more ways to play with time using the time-remapping feature. Time remapping lets you dynamically speed up, slow down, stop, or reverse footage.

You can also use it to do things like create a freeze-frame result. The Graph Editor and the Layer panel are a big help when remapping time, as you'll see in the following exercise, when you retime the project so that the time-lapse speed changes over the course of the movie.

Precomposing layers

For this exercise, you'll duplicate the composition and then precompose the layers, which will be easier to remap than the original.

1 Select the marquee composition in the Project panel, and choose Edit > Duplicate.

A marquee 2 composition appears in the Project panel.

2 Double-click the marquee 2 composition to open it in the Composition and Timeline panels.

3 In the marquee 2 Timeline panel, select the Starburst layer and then Shift-select the Unlit marquee layer, so that all the layers are selected.

4 Choose Layer > Pre-compose.

5 In the Pre-compose dialog box, make sure Move All Attributes Into The New Composition is selected, and then click OK.

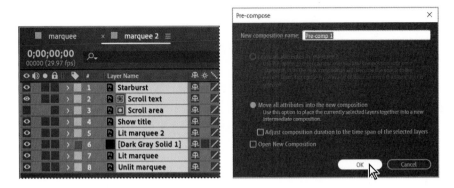

After Effects creates a new composition named Pre-comp 1, which replaces the layers you selected in the marquee 2 composition. Now you can remap all of the elements of the project at once.

Remapping time

You're ready to manipulate the speed and direction of time in your project.

1 With the Pre-comp 1 layer selected in the Timeline panel, choose Layer > Time > Enable Time Remapping.

After Effects adds two keyframes, at the first and last frames of the layer, visible in the time ruler. A Time Remap property also appears under the layer name in the Timeline panel; this property lets you control which frame is displayed at a given point in time.

2 With the Pre-comp 1 layer active, choose Layer > Open Layer to open it in the Layer panel.

The Layer panel provides a visual reference of the frames you change when you remap time. It displays two time rulers: The time ruler at the bottom of the panel displays the current time. The Source Time ruler, just above the time ruler, has a remap-time marker that indicates which frame is playing at the current time.

3 Press the spacebar to preview the layer, and notice that the source-time and current-time markers in the two Layer panel rulers are synchronized. That will change as you remap time.

Over the first four seconds, the lights come on slowly. You'll speed that section up so that the lights come on twice as fast.

4 Go to 2:00, and change the Time Remap value to **4:00**.

This remaps time so that frame 4:00 plays at 2:00. In other words, the clip now plays back at twice the speed for the first two seconds of the composition.

5 Press the spacebar to preview the animation. The composition now runs at double-speed until 2:00, and at a slower speed thereafter. Press the spacebar again when you have finished previewing the animation.

Viewing time remapping in the Graph Editor

Using the Graph Editor, you can view and manipulate all aspects of effects and animations, including effect property values, keyframes, and interpolation. The Graph Editor displays changes in effects and animations as a two-dimensional graph, with playback time represented horizontally (from left to right). In layer bar mode, in contrast, the time ruler represents only the horizontal time element, without a graphical display of changing values.

1 Make sure the Time Remap property is selected for the Pre-comp 1 layer in the Timeline panel.

2 Click the Graph Editor button (⬚) to display the Graph Editor.

The Graph Editor displays a time-remap graph that shows a white line connecting the keyframes at 0:00, 2:00, and 10:00. The angle of the line is steep up to 2:00, and then becomes shallower. The steeper the line, the faster the playback time.

Using the Graph Editor to remap time

When remapping time, you can use the values in the time-remap graph to determine and control which frame of the movie plays at which point in time. Each Time Remap keyframe has a time value associated with it that corresponds to a specific frame in the layer; this value is represented vertically on the time-remap graph. When you enable time remapping for a layer, After Effects adds a Time Remap keyframe at the start and end points of the layer. These initial Time Remap keyframes have vertical time values equal to their horizontal positions.

By setting additional Time Remap keyframes, you can create complex motion effects. Every time you add a Time Remap keyframe, you create another point at which you can change the playback speed or direction. As you move the keyframe up or down in the time-remap graph, you adjust which frame of the video is set to play at the current time.

You'll have some fun with the timing of this project.

1 Select the Selection tool in the Tools panel.

2 In the Timeline panel, go to 3:00.

3 In the time-remap graph, Ctrl-click (Windows) or Command-click (macOS) the line at 3:00 to create a new keyframe.

▶ **Tip:** Watch the Info panel as you drag to see more information as you adjust the keyframe.

4 Drag the new keyframe down to 0 seconds.

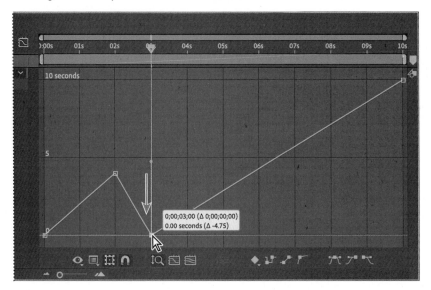

5 Go to 0:00, and then press the spacebar to preview the results. Watch the time ruler and Source Time ruler in the Layer panel to see which frames are playing at any given point in time.

The animation progresses rapidly over the first two seconds of the composition, and then plays in reverse for a second, and the lights go out. The entire animation plays again.

6 Press the spacebar to stop the preview.

Having fun yet? Keep going. You'll adjust the timing so that the lights blink twice before coming on permanently.

7 Drag the keyframe from 2:00 to 1:00, so that the lights come on in the first second. Then move the next keyframe to 2:00, so that the lights blink off.

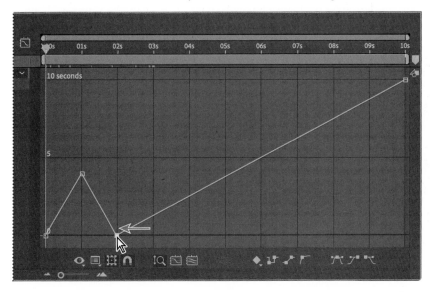

Shifting the keyframe affects the timing for the rest of the clip as well. Currently, it's set to play the 10-second point in the composition at ten seconds, so the angle of speed adjusts accordingly.

You'll set the lights to blink one more time before continuing the animation. Notice how the angle for the rest of the animation changes as a result; it becomes steeper because there is more animation to cover in less time.

▶ Tip: You can scale the entire animation in time: Click the Time Remap property name to select all of its keyframes, so that you see a free-transform selection box. Then resize the selection box.

8 Ctrl-click (Windows) or Command-click (macOS) the line to create additional keyframes at 3:00 and 4:00, moving them to the 4-second and 0-second marks, respectively, so that the lights blink on and off again before the animation begins to play in full.

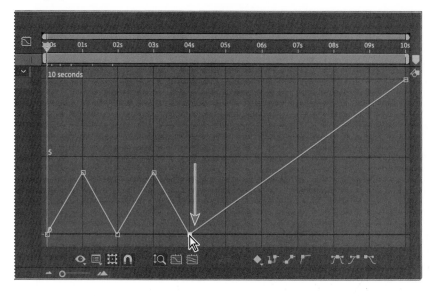

9 Press the spacebar to preview the animation, and press it again to stop it.

The lights blink on and off, but the text scrolls across the ticker too quickly. You'll adjust the timing so that it moves more slowly, even though it means the entire text won't appear before the end of the clip.

10 Go to 10:00. Then enter **7:00** for the Time Remap value.

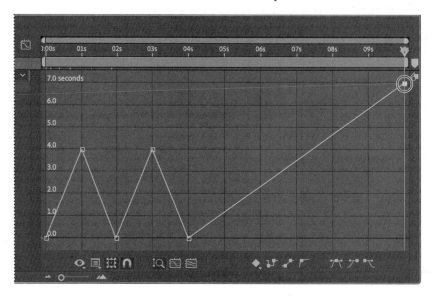

11 Press the Home key or move the current-time indicator to the beginning of the time ruler, and then press the spacebar to preview the animation. Press the spacebar again when you're done.

The clip plays for ten seconds, but it ends at the 7-second point in the composition. Now the text moves more slowly—and much more realistically—across the ticker.

12 Choose File > Save to save your work so far.

Adding Easy Ease

You'll soften the shift in time that occurs when the lights blink with Easy Ease.

1 Click to select the keyframe at 1:00, and then click the Easy Ease icon (✶) at the bottom of the Graph Editor. This slows the shift into reverse so that the lights stay bright just a little longer.

2 Click to select the keyframe at 3:00, and apply Easy Ease for the same effect.

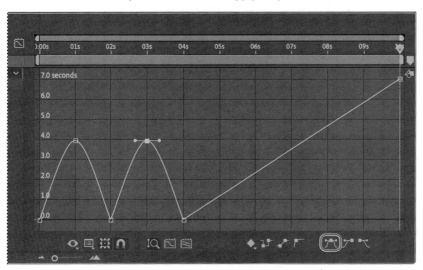

Notice that there are Bezier handles where you added ease. You can refine the amount of ease on a transition further by dragging the Bezier handle. If you drag the handle further from the keyframe, the transition is softer; if you drag it down or closer to the keyframe, the transition is more pronounced.

3 Go to the beginning of the time ruler, and preview the entire movie.

4 Choose File > Save to save the final project.

Congratulations. You've completed a complex animation, including shifts in time. You can render and export the time-remap project if you'd like. See Lesson 15, "Rendering and Outputting," for detailed instructions on rendering and exporting a composition.

Review questions

1 Why would you import a layered Photoshop file as a composition?

2 What is the pick whip, and how do you use it?

3 What is a track matte, and how do you use it?

4 How do you remap time in After Effects?

Review answers

1 When you import a layered Photoshop file into After Effects as a composition, After Effects preserves the layer order, transparency data, and layer styles from the source Photoshop document. It also preserves other features, such as adjustment layers and type.

2 The pick whip creates expressions that link the values of one property or effect to another layer. The pick whip is also a way to create parenting relationships. To use the pick whip, simply drag the pick whip icon from one property to another.

3 When you want one layer to show through a hole in another layer, you can use a track matte. To create a track matte, you need two layers: one to act as a matte, and another to fill the hole in the matte. You can animate either the track matte layer or the fill layer. When you animate the track matte layer, you create a traveling matte.

4 There are several ways to remap time in After Effects. Time remapping lets you dynamically speed up, slow down, stop, or reverse footage. When remapping time, you can use the values in the time-remap graph in the Graph Editor to determine and control which frame of the movie plays at which point in time. When you enable time remapping for a layer, After Effects adds a Time Remap keyframe at the start and end points of the layer. By setting additional Time Remap keyframes, you can create complex motion effects. Every time you add a Time Remap keyframe, you create another point at which you can change the playback speed or direction.

7 WORKING WITH MASKS

Lesson overview

In this lesson, you'll learn how to do the following:

- Create a mask using the Pen tool.

- Change a mask's mode.

- Edit a mask shape by controlling vertices and direction handles.

- Feather a mask edge.

- Replace the contents of a mask shape.

- Adjust the position of a layer in 3D space to blend it with the rest of a shot.

- Create a shadow effect.

- Create a vignette.

 This lesson will take about an hour to complete. If you haven't already done so, download the project files for this lesson from peachpit.com/ AfterEffectsCIB2024, following the instructions in the Getting Started section under "Accessing the lesson files and Web Edition."

PROJECT: SEQUENCE FROM A COMMERCIAL

There will be times when you won't need (or want) everything in a shot to be included in the final composite. Use masks to control what appears.

About masks

A mask in Adobe After Effects is a path, or outline, that is used to modify layer effects and properties. The most common use of masks is to modify a layer's alpha channel. A mask consists of segments and vertices: *Segments* are the lines or curves that connect vertices. *Vertices* define where each segment of a path starts and ends.

A mask can be either an open or a closed path. An open path has a beginning point that is not the same as its end point; for example, a straight line is an open path. A closed path is continuous and has no beginning or end, such as a circle. Closed-path masks can create transparent areas for a layer. Open paths cannot create transparent areas for a layer, but are useful as parameters for an effect. For example, you can use an effect to generate a running light around a mask.

A mask belongs to a specific layer. Each layer can contain multiple masks.

You can draw masks in common geometric shapes—including polygons, ellipses, and stars—with the shape tools, or you can use the Pen tool to draw an arbitrary path. If you draw a shape when a layer is selected, the shape becomes a mask for that layer; the cursor displays a masked box (⬔▫) as you start to draw. If you draw a shape when no layer is selected, After Effects creates a shape layer; the cursor displays a star (⬔★)as you start to draw.

Getting started

In this lesson, you will create a mask for the screen of a tablet and replace the screen's original content with a movie. Then you'll adjust the positioning of the new footage so that it fits the perspective of the shot. Finally, you'll polish the scene by adding a shadow and creating a vignette effect.

Begin by previewing the movie and setting up the project.

1 Make sure the following files are in the Lessons/Lesson07 folder on your hard disk, or download them from peachpit.com now:

 • In the Assets folder: SeaTurtle.mov, TabletVideo.mov

 • In the Sample_Movie folder: Lesson07.mp4

2 Open and play the Lesson07.mp4 sample movie in Windows Movies & TV or QuickTime Player to see what you will create in this lesson. When you are done, close Windows Movies & TV or QuickTime Player. You may delete the sample movie from your hard disk if you have limited storage space.

When you begin the lesson, restore the default application settings for After Effects. See "Restoring default preferences" on page 3.

3 Start After Effects, and then immediately hold down Ctrl+Alt+Shift (Windows) or Command+Option+Shift (macOS) to restore default preferences settings. In the Startup Repair Options dialog box, click Reset Preferences. Then, click New Project in the Home window.

After Effects opens to display a new, untitled project.

4 Choose File > Save As > Save As, and navigate to the Lessons/Lesson07/Finished_Project folder.

5 Name the project **Lesson07_Finished.aep**, and then click Save.

Creating the composition

You'll import two footage items for this exercise. Then, you'll create the composition based on the aspect ratio and duration of one of the footage items.

1 Double-click an empty area of the Project panel to open the Import File dialog box.

2 Navigate to the Lessons/Lesson07/Assets folder, Shift-click to select the SeaTurtle.mov and TabletVideo.mov files, and then click Import or Open.

3 Deselect both files in the Project panel. Then select the TabletVideo.mov footage item, and drag it onto the Create A New Composition button (▣) at the bottom of the Project panel.

After Effects creates a composition named TabletVideo and opens it in the Composition and Timeline panels.

4 Choose File > Save to save your work so far.

Creating a mask with the Pen tool

► **Tip:** You can also create a mask using the Mocha effect. To learn more about using the Mocha effect, see After Effects Help.

The tablet screen is currently blank. To fill it with the video of a sea turtle, you need to mask the screen.

1 Go to 2:00, where the video is in full color.

2 Make sure the TabletVideo.mov layer is selected in the Timeline panel, and then select the Pen tool (✐) in the Tools panel.

The Pen tool creates straight lines or curved segments. The tablet screen itself is rectangular, so you'll try using straight lines first.

3 Click the lower left corner of the tablet screen to place the first vertex.

4 Click the upper left corner of the tablet screen to place the second vertex. After Effects connects the two points with a segment.

5 Click to place a third vertex in the upper right corner of the tablet screen, and then click to place a fourth vertex where the fabric intersects with the right edge of the screen.

6 Move the Pen tool over the first vertex you created (in the lower left corner). When a circle appears next to the pointer (as in the image on the right below), click to close the mask path.

Tips for creating masks

If you have worked with Adobe Illustrator or Photoshop, or similar applications, you're probably familiar with masks and Bezier curves. If not, here are a few additional tips to help you create them effectively:

- Use as few vertices as possible.

- You can close a mask by clicking the starting vertex. To open a closed mask, click a mask segment, choose Layer > Mask And Shape Path, and deselect Closed.

- To add points to an open path, press Ctrl (Windows) or Command (macOS), and click the last point on the path with the Pen tool. When the point is selected, you can continue adding points.

About mask modes

Blending modes for masks (mask modes) control how masks within a layer interact with one another. By default, all masks are set to Add, which combines the transparency values of any masks that overlap on the same layer. You can apply one mode to each mask, but you cannot change a mask's mode over time.

The first mask you create interacts with the layer's alpha channel. If that channel doesn't define the entire image as opaque, then the mask interacts with the layer frame. Each additional mask that you create interacts with masks located above it in the Timeline panel. The results of mask modes vary depending on the modes set for the masks higher up in the Timeline panel. You can use mask modes only between masks in the same layer. Using mask modes, you can create complex mask shapes with multiple transparent areas. For example, you can set a mask mode that combines masks and sets the opaque area to the regions where the masks intersect.

Original masks *None* *Add* *Subtract*

Intersect *Lighten* *Darken* *Difference*

Editing a mask

Instead of masking the information *inside* the tablet, the mask has removed everything *outside* the tablet. You need to invert the mask. You'll also use Bezier curves to create a more accurate mask.

Inverting the mask

For this project, you need everything inside the mask to be transparent and everything outside the mask to be opaque. You'll invert the mask now.

1 Select the TabletVideo.mov layer in the Timeline panel, and press the M key to see the Mask Path property for the mask.

There are two ways to invert this mask: by choosing Subtract from the Mask Mode pop-up menu, or by selecting the Inverted option.

> ▶ **Tip:** Pressing the M key twice in quick succession displays all mask properties for the selected layer.

2 Select the Inverted option for Mask 1.

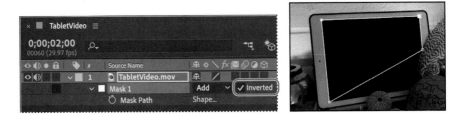

The mask inverts.

3 Press F2 or click an empty area of the Timeline panel to deselect the
 TabletVideo.mov layer.

Creating curved masks

Curved or freeform masks use Bezier curves to define the shape of the mask. Bezier
curves give you the greatest control over a mask's shape. With them, you can create
straight lines with sharp angles, perfectly smooth curves, or a combination
of the two.

You'll use Bezier curves to adjust the mask's edges around the fabric, red ball, and
sea urchin shell that obscure part of the screen.

1 In the Timeline panel, select Mask 1, the mask for the TabletVideo.mov layer.
 Selecting Mask 1 makes the mask active and also selects all the vertices.

2 In the Tools panel, select the Add Vertex
 tool (🖊), which is hidden behind the Pen tool.

3 With the Add Vertex tool, click along the
 bottom edge of the mask to add a vertex.

4 Drag the new vertex down to the point where
 the red ball intersects with the screen.

5 Add another vertex next to the fabric, and drag it down to the point where
 the fabric and red ball intersect.

6 Add vertices at the two points where the sea urchin shell intersects the bottom
 edge of the screen.

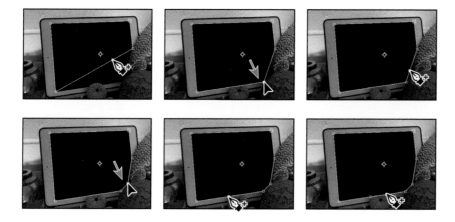

7 In the Tools panel, select the Convert Vertex tool (Ν), which is hidden behind
 the Add Vertex tool.

8 In the Composition panel, click the vertex where the fabric and red ball intersect.
 The Convert Vertex tool changes the corner vertex to smooth points.

9 Adjust the direction handles until the mask follows the contour of the fabric
 and the red ball.

10 Finally, adjust the direction handles for the vertices at the points where
 the sea urchin intersects with the bottom edge of the screen.

11 Deselect the TabletVideo.mov layer in the Timeline panel to check the edge of
 your mask. If you need to make adjustments, select Mask 1 in the TabletVideo.mov
 layer, and use the Convert Vertex tool to fine-tune the shape of the mask.

12 Choose File > Save to save your work.

Feathering the edges of a mask

The mask looks good, but the edge of the screen looks a little too sharp and unrealistic. To address this, you'll feather, or soften, the edges.

1 Select the TabletVideo.mov layer in the Timeline panel, and press the F key to display the Mask Feather property for the mask.

2 Increase the Mask Feather amount to 3.0, 3.0 pixels.

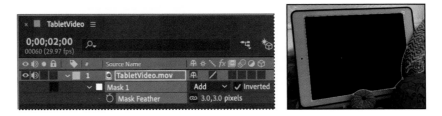

3 Hide the properties for the TabletVideo.mov layer, and then choose File > Save to save your work.

Replacing the content of the mask

> **Tip:** In effects that reference layers, you can use masks for greater control over the effect's influence. You can also use expressions to animate mask points.

You are now ready to replace the background with the video of a sea turtle and blend it with the overall shot.

1 In the Project panel, select the SeaTurtle.mov file and drag it to the Timeline panel, placing it below the TabletVideo.mov layer.

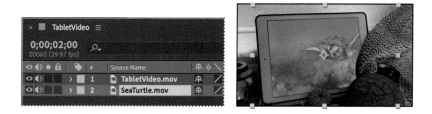

2 Choose Fit Up To 100% from the Magnification Ratio pop-up menu at the bottom of the Composition panel so that you can see the whole composition.

● **Note:** If you're using a Mac with Retina display, you'll see Fit Up To 200%.

3 Select the Selection tool (▶), and then drag the SeaTurtle.mov layer in the Composition panel slightly to the left, centering it in the tablet screen.

4 Go to 2:07. In the Timeline panel, drag the entire SeaTurtle.mov layer to the right so that it begins at 2:07 and ends at the same time as the TabletVideo.mov layer.

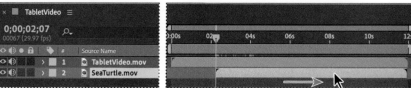

Zooming and panning by touch

If you're using a touch-enabled device, such as a Microsoft Surface, Wacom Cintiq Touch, or multi-touch trackpad, you can use your fingers to zoom and pan. Touch gestures let you zoom and pan in the Composition, Layer, Footage, and Timeline panels.

To zoom: Pinch two fingers closer together to zoom in, or move them further apart to zoom out.

To pan: Move two fingers in unison to pan up, down, left, or right in the panel's current view.

Repositioning and resizing the clip

The sea turtle clip is a little too big for the tablet screen and it's not quite the right angle. You'll convert it to a 3D layer, which will give you more control over its shape and size.

1 Still at 2:07, select the SeaTurtle.mov layer.

2 With the SeaTurtle.mov layer selected in the Timeline panel, click the 3D switch (⦿) for the layer.

● **Note:** You'll learn more about 3D layers in Lessons 12, "Using 3D Features," and 13, "Working with the 3D Camera Tracker."

The 3D Transformation Gizmo appears in the Composition panel, and the Properties panel includes the Orientation property and multiple Rotation properties. Most properties in the Properties panel now have three values: From left to right, they represent the x, y, and z axes of the image. The z axis controls the depth of the layer. These axes are represented in the 3D Transformation Gizmo.

3 In the Properties panel, change the Scale to **90**%.

4 Make sure the Selection tool is selected, and then use the 3D Transformation Gizmo in the Composition panel to adjust the position of the video in the screen.

Drag the red arrow to move the layer horizontally, the green arrow to move it vertically, and the blue arrow to change the depth. Drag the ball along the curved red line to rotate the layer around the x axis; drag the green ball along the curved green line to rotate it around the y axis; and drag the blue ball along the curved blue line to rotate it around the z axis.

5 Make any additional adjustments, including changes to the Rotation values, so that your composition resembles the following image. Your values may not match ours, depending on how you shifted the SeaTurtle layer earlier.

▶ **Tip:** To specify whether the 3D Transformation Gizmo affects Rotation or Orientation values, select the Rotation tool in the Tools panel and choose an option from the Set menu. You can also type values directly in the Properties panel instead of dragging in the Composition panel.

Properties: SeaTurtle.mov			≡
Layer Transform	Reset		
⟳ Anchor Point	872.5	540	0
⟳ Position	920	540	100
⟳ Scale ∞	90%	90%	90%
⟳ Orientation	350.2°	8°	357°
⟳ X Rotation	0x+8°		
⟳ Y Rotation	0x-30°		
⟳ Z Rotation	0x-3°		

6 Choose File > Save to save your work.

Adjusting the opacity

The video appears abruptly. You'll smooth its appearance by adjusting the opacity at the beginning.

1 Make sure you are still at 2:07 in the time ruler and the SeaTurtle.mov layer is selected.

2 In the Properties panel, change the Opacity to **0**%, and then click the stopwatch icon (⏱) to create an initial keyframe.

3 Go to 3:15, and change the Opacity to **100**%.

4 Hide properties for all layers in the Timeline panel, and deselect all layers.

5 Press the Home key or move the current-time indicator to the beginning of the time ruler, and then press the spacebar to preview your work. Press the spacebar again when you're done.

Adding a shadow

The masked image looks convincing, but you can make it look even more realistic by adding a shadow to the screen.

1 Click an empty area in the Timeline panel to deselect all layers, and then choose Layer > New > Solid.

2 In the Solid Settings dialog box, name the layer **Shadow**, click the Make Comp Size button, choose a dark gray color (we used R=34, G=34, B=34,), and then click OK.

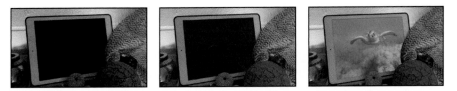

Instead of trying to exactly re-create the shape of the TabletVideo.mov layer's mask, it's easier to copy it to the Shadow layer and adjust it.

3 Press the Home key or move the current-time indicator to the beginning of the time ruler.

4 Select the TabletVideo.mov layer in the Timeline panel, and press the M key to display the Mask Path property for the mask.

5 Select Mask 1, and then choose Edit > Copy or press Ctrl+C (Windows) or Command+C (macOS).

6 Select the Shadow layer in the Timeline panel, and then choose Edit > Paste or press Ctrl+V (Windows) or Command+V (macOS).

7 Hide the properties for the TabletVideo.mov layer.

This time, you want to keep the area inside the mask opaque and make the area outside the mask transparent.

8 Select the Shadow layer, and press the F key to reveal the Mask Feather property for the mask.

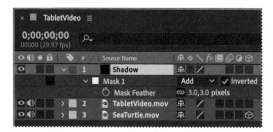 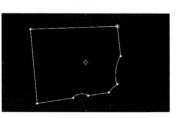

9 Change the Mask Feather value to **0** (zero).

10 Deselect the Inverted option.

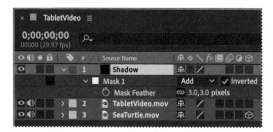 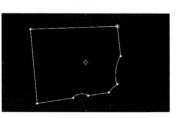

The Shadow layer now obscures the SeaTurtle.mov layer.

Adjusting the shape of the mask

The neighboring objects should cast a shadow, but it shouldn't affect the entire screen. You'll use the Pen tools to reduce the mask to cover only the lower right section of the screen.

1 Select the Delete Vertex tool (✏️), hidden beneath the Convert Vertex tool in the Tools panel.

2 Click the upper left vertex to delete it.

3 Select the Selection tool (▶) in the Tools panel, and then drag the lower left and upper right vertices closer to the lower right corner of the screen, as in the following image.

4 Select the Add Vertex tool (✏️), hidden beneath the Delete Vertex tool in the Tools panel.

5 Add vertices to the upper path (currently a diagonal line), and then use the Convert Vertex (∧) and Selection tools to position and shape the path into a curve similar to the following images.

Feathering the edges of the shadow

Shadows rarely have sharp edges. You'll adjust the feather for the mask so that the shadow fades into the rest of the screen.

1 Go to 3:15.

2 Select the Mask Feather tool (✐), hidden beneath the Convert Vertex tool (▷) in the Tools panel.

You used the Mask Feather property to adjust the width of the feather the same amount all the way around the original mask. However, the Mask Feather tool gives you more flexibility, letting you vary the feathering width at points you define on the closed mask.

3 In the Timeline panel, select the Shadow layer. Then, in the Composition panel, click the lower left vertex to create a feather point.

4 Click the feather point again, and without releasing the mouse button, drag that feather point outward to increase the feathering margin for the entire mask.

Currently the feather, represented by dashed lines, extends evenly across the mask. You'll add more feather points for greater flexibility.

5 Click the vertex on the right side of the sea urchin.

A feathering point is created, and the feather shrinks back to the mask edge on the lower and right sides of the screen, but the feathering remains on the upper side of the mask. The objects that are casting the shadow shouldn't be shadowed.

6 Click the dashed line just under the vertex on the left side of the sea urchin, and drag the feathering boundary up to the screen.

7 (Optional) Adjust the feathering elsewhere by creating a feather point on the boundary and dragging it.

Now the shadow doesn't appear on any of the objects.

The shape of the shadow is good, but it's obscuring the image. You'll change the opacity to reduce its effect.

8 Select the Shadow layer in the Timeline panel, and then change its Opacity value to **20%** in the Properties panel.

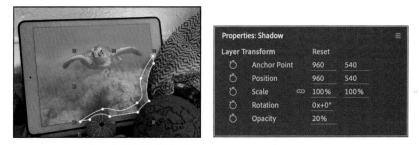

9 Hide all properties in the Timeline panel, and then press F2 or click an empty area in the Timeline panel to deselect all layers.

Applying a blending mode

To create unique interactions between layers, you may want to experiment with blending modes. Blending modes control how each layer blends with, or reacts to, layers beneath it. Blending modes for layers in After Effects are identical to blending modes in Adobe Photoshop.

1 From the Timeline panel menu, choose Columns > Modes to display the Mode pop-up menu.

2 Choose Darken from the Shadow layer's Mode pop-up menu, and then deselect all layers so you can see the result.

The Darken blending mode enhances the screen image and boosts the colors underneath the Shadow layer.

3 Choose File > Save to save your work.

Creating a vignette

A popular effect in motion graphic design is to apply a vignette to the composition. This is often done to simulate light variations of a glass lens. It creates an interesting look that focuses the attention on the subject and sets the shot apart.

1 Make sure no layers are selected, and then choose Layer > New > Solid.

2 In the Solid Settings dialog box, name this layer **Warm Vignette**, click the Make Comp Size button, use the eyedropper to select a dark brown tone from the metal rim of the vase to the left of the tablet, and then click OK.

In addition to the Pen tool, After Effects provides tools that let you easily create square and elliptical masks.

3 In the Tools panel, select the Ellipse tool (⬭), hidden behind the Rectangle tool (▢).

4 In the Composition panel, position the cross-hairs pointer in the upper left corner of the image. Drag to the opposite corner to create an elliptical shape that fills the image. Adjust the shape and position using the Selection tool, if necessary.

▶ **Tip:** To quickly create a mask that fills the screen, double-click the Ellipse or Rectangle tool.

5 Expand the Mask 1 property in the Warm Vignette layer to display all of the mask properties for the layer.

6 Choose Subtract from the Mask 1 Mode pop-up menu.

Using the Rectangle and Ellipse tools

The Rectangle tool, as the name suggests, creates a rectangle or square. The Ellipse tool creates an ellipse or circle. You create mask shapes with these tools by dragging them in the Composition or Layer panel.

If you want to draw a perfect square or circle that fills the screen, press the Shift key as you double-click the Rectangle or Ellipse tool. To draw a perfect square or circle of a different size, press the Shift key as you drag with the Rectangle tool or the Ellipse tool. To create your mask from the center, press Ctrl (Windows) or Command (macOS) after you start to drag. Press Ctrl+Shift or Command+Shift after you start to drag to create a perfect square or circle mask from a center anchor point.

Be careful! If you use these tools without a layer selected, you'll draw a shape, not a mask.

7 Increase the Mask Feather amount to **200, 200** pixels.

Your composition should now resemble the following figure.

Even with this large feather amount, the vignette is intense and constricting. You can make the vignette warmer and less overwhelming by adjusting the Mask Expansion property. The Mask Expansion property represents, in pixels, how far from the original mask edge you are expanding or contracting the adjusted edge.

8 Increase Mask Expansion to **90** pixels.

Finally, you can use a blending mode to make the effect more subtle.

9 Choose Screen from the Mode pop-up menu for the Warm Vignette layer.

10 Hide the properties for the Warm Vignette layer, and then choose File > Save.

11 Deselect all layers. Then, press the spacebar to preview the movie. Press the spacebar again when you're done.

Review questions

1 What is a mask?

2 What is a direction handle used for?

3 What is the difference between an open mask and a closed mask?

4 How is the Mask Feather tool useful?

Review answers

1 In After Effects, a mask is a path, or outline, that is used to modify layer effects and properties. The most common use of masks is to modify a layer's alpha channel. A mask consists of segments and vertices.

2 A direction handle is used to control the shape and angle of a Bezier curve.

3 An open mask can be used to control effects or the placement of text; it does not define a region of transparency. A closed mask defines a region that will affect the alpha channel of a layer.

4 The Mask Feather tool lets you vary the width of feathering at different points on a mask. With the Mask Feather tool, click to add a Feather point, and then drag it.

8 DISTORTING OBJECTS WITH THE PUPPET TOOLS

Lesson overview

In this lesson, you'll learn how to do the following:

- Place Position pins using the Puppet Position Pin tool.

- Deform an image using Advanced pins.

- Define areas of overlap using the Overlap pins.

- Manipulate rotation and scale using Bend pins.

- Stiffen parts of an image using Starch pins.

- Animate the position of puppet pins.

- Record animation using the Puppet Sketch tool.

- Animate facial expressions with Character Animator.

 This lesson will take about an hour to complete. If you haven't already done so, download the project files for this lesson from peachpit.com/ AfterEffectsCIB2024, following the instructions in the Getting Started section under "Accessing the lesson files and Web Edition."

PROJECT: ANIMATED ILLUSTRATION

Pull, squash, stretch, and otherwise deform objects on the screen using the Puppet tools. Whether you're creating realistic animations, fantastic scenarios, or modern art, the Puppet tools will expand your creative freedom.

Getting started

Using the Puppet tools in After Effects, you can add natural motion to raster images and vector graphics. Five tools create pins to define the points of deformation, areas of overlap, and areas that should remain more rigid. An additional tool, the Puppet Sketch tool, lets you record animation in real time. In this lesson, you'll use the Puppet tools to animate a crab's pincers in an advertisement.

Start by previewing the final movie and then setting up the project.

1 Make sure the following files are in the Lessons/Lesson08 folder on your hard disk, or download them from peachpit.com now:

- In the Assets folder: crab.psd, text.psd, Water background.mov
- In the Sample_Movie folder: Lesson08.mp4

2 Open and play the Lesson08.mp4 sample movie in Windows Movies & TV or QuickTime Player to see what you will create in this lesson. When you are done, close Windows Movies & TV or QuickTime Player. You may delete the sample movie from your hard disk if you have limited storage space.

When you begin this lesson, restore the default application settings for After Effects. See "Restoring default preferences" on page 3.

3 Start After Effects, and then immediately hold down Ctrl+Alt+Shift (Windows) or Command+Option+Shift (macOS). In the Startup Repair Options dialog box, click Reset Preferences. Then click New Project in the Home window.

After Effects opens to display a blank, untitled project.

4 Choose File > Save As > Save As.

5 In the Save As dialog box, navigate to the Lessons/Lesson08/ Finished_Project folder.

6 Name the project **Lesson08_Finished.aep**, and then click Save.

Importing footage

You'll import two Adobe Photoshop files and a background movie.

1 Choose File > Import > File.

2 Navigate to the Lessons/Lesson08/Assets folder. Press Ctrl or Command to select the crab.psd and Water background.mov files. Then click Import or Open. The assets appear in the Project panel.

3 Double-click an empty area in the Project panel to open the Import File dialog box again. Select the text.psd file in the Lessons/Lesson08/Assets folder.

4 Choose Composition – Retain Layer Sizes from the Import As menu. (In macOS, you may need to click Options to see the Import As menu.) Then click Import or Open.

5 In the Text.psd dialog box, select Editable Layer Styles, and click OK. The imported file is added as a composition to the Project panel; its layers are added in a separate folder.

Creating the composition

As with any project, you need to create a new composition.

1 Click New Composition in the Composition panel.

2 Name the composition **Blue Crab**.

3 Deselect Lock Aspect Ratio if it's selected. Then, change the Width to **720** px and the Height to **480** px.

4 Choose 30 for the Frame Rate, and then choose D1/DV NTSC (0.91) from the Pixel Aspect Ratio menu.

5 In the Duration field, type **1000** to specify 10 seconds.

6 Change the Background Color to a deep cyan color. (We used R=5, G=62, B=65.) Then click OK to close the Composition Settings dialog box.

After Effects opens the new composition in the Timeline and Composition panels.

Adding the background

It's easier to animate the image in context, so first you'll add the background to the composition.

1 Press the Home key or move the current-time indicator to the beginning of the composition.

2 Drag the Water background.mov file to the Timeline panel.

3 Click the Lock icon (🔒) for the layer to prevent accidental changes to it for now.

Animating imported text

The final movie includes two lines of animated text. Because you imported the text.psd file as a composition with layers intact, you can work on it in its own Timeline panel, editing and animating its layers independently. You'll add an animation preset to each layer.

1 Drag the text composition from the Project panel into the Timeline panel, placing it at the top of the layer stack.

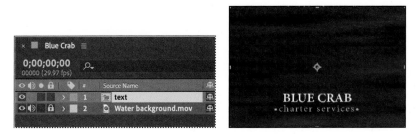

2 Double-click the text composition to open it in its own Timeline panel.

3 Shift-click to select both layers in the text Timeline panel, and choose Layer > Create > Convert to Editable Text.

Now the text layers can be edited, so you can apply animation presets.

4 Go to 3:00. Then deselect both layers, and select only the BLUE CRAB layer.

5 In the Effects and Presets panel, search for the Fly In With A Twist animation preset. Then drag it onto the BLUE CRAB layer.

By default, the animation preset lasts just over two and a half seconds, so the text will begin to fly in at 3:00 and finish at 5:16. After Effects adds the keyframes for the effect.

6 Go to 5:21, and select the charter services layer.

7 In the Effects and Presets panel, search for the Slow Fade On animation preset. Then drag it onto the charter services layer.

8 Return to the Blue Crab Timeline panel, and move the current-time indicator to the beginning of the time ruler. Press the spacebar to preview the animation. Press the spacebar again to stop playback.

9 Choose File > Save to save your work so far.

Scaling an object

Next, you'll add the crab. You'll animate it so that it fills the screen at the beginning of the movie, and then quickly shrinks and moves into position above the area where the text will appear.

1 Drag the crab.psd file from the Project panel to the top layer in the Timeline panel.

2 Press the Home key to move the current-time indicator to the beginning of the time ruler.

3 Select the crab.psd layer in the Timeline panel, and change its Scale value to **400%** in the Properties panel.

4 Click the stopwatch icon (⏱) next to Scale to create an initial keyframe.

5 Move to 2:00, and change the Scale to **75%**.

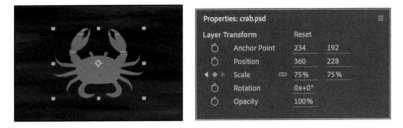

The crab scales appropriately, but its position isn't quite right.

6 Press the Home key to return to the beginning of the time ruler.

7 In the Properties panel, change the Position to **360, 82**. The crab moves up to fill the composition.

8 Click the stopwatch icon next to Position to create an initial keyframe.

9 Go to 1:15, and change the Position to **360, 228**.

10 Go to 2:00, and change the Position to **360, 182**.

11 Drag the current-time indicator across the first two seconds of the time ruler to see the crab animation.

12 Hide the properties for the crab.psd layer, and choose File > Save.

About the Puppet tools

The Puppet tools turn raster and vector images into virtual marionettes. When you move a string on a marionette, the body part attached to that string moves; pull the string attached to the hand, and the hand goes up. The Puppet tools use pins to indicate where strings would be attached.

The Puppet effect deforms parts of an image based on the positions of pins that you place and animate. These pins determine which parts of the image should move or rotate, which parts should remain rigid, and which parts should be in front when areas overlap.

There are five kinds of pins, each placed by a different tool:

- The Puppet Position Pin tool (✦) places and moves Position pins, which change the position of specific points in an image.

- The Puppet Starch Pin tool (✐) places Starch pins, which stiffen parts of the image so that they are distorted less.

- The Puppet Bend Pin tool (⟳) places Bend pins, which let you change the rotation or scale of part of an image without changing its position.

- The Puppet Advanced Pin tool (⟆) places Advanced pins, which give you complete control over rotation, scale, and position.

- The Puppet Overlap Pin tool (✦≣) places Overlap pins, which indicate the parts of an image that should be in the front when areas overlap.

● **Note:** The mesh is calculated at the frame where the Deform pins are applied. If you add more pins anywhere in the timeline, they are placed based on the original position of the mesh.

As soon as you place a pin, the area within an outline is automatically divided into a mesh of triangles. Each part of the mesh is associated with the pixels of the image, so as the mesh moves, so do the pixels. When you animate a Position pin, the mesh deforms more in the area closest to the pin, while keeping the overall shape as rigid as possible. For example, if you animate a pin in a character's hand, the hand and arm will be deformed, but most of the character will remain in place.

Adding Position pins

Position pins are the basic component of the Puppet effect. Where you place these pins and how you position them determine how the objects move on the screen. You'll place Position pins and display the mesh that After Effects creates to determine the area of influence for each pin.

When you select the Puppet Position Pin tool, the Tools panel displays the Puppet tool options. Each pin has its own properties in the Timeline panel, and After Effects automatically creates an initial keyframe for each pin.

1 Select the Puppet Position Pin tool (✦) in the Tools panel.

2 Go to 1:27, just before the crab scales down to its final size.

3 In the Composition panel, place a Position pin in the middle of the crab's left pincer.

A yellow dot representing the Position pin appears in the Composition panel. If at this point you were to use the Selection tool (▶) to move the Position pin, the entire crab would move with it. You need more pins to keep the other parts of the mesh in place.

4 Using the Puppet Position Pin tool, place another Position pin in the middle of the right pincer.

Now you can move a pincer with the Selection tool. The more pins you place, the smaller the area of influence for each pin, and the less each area will stretch.

5 Select the Selection tool (▶), and drag one of the Position pins to see its effect. Then return it to its original position by pressing Ctrl+Z (Windows) or Command+Z (macOS).

6 Select the Puppet Position Pin tool again, and then place additional Position pins at the top of each antenna, at the end of each side leg, and at the tip of each of the crab's swimming legs.

7 In the Timeline panel, expand the Mesh 1 > Deform properties. Each Position pin is listed.

Adding Advanced and Bend pins

You can move Advanced pins in the same way that you move Position pins. But you can also use them to rotate and scale the area of the image. You'll replace the Position pins in the pincers with Advanced pins. Bend pins don't affect position, but they do let you rotate or scale an area while keeping it in place. You'll add Bend pins to the middle of the crab's swimmer legs. Then, you'll display the mesh that After Effects creates to determine the area of influence for each pin.

1 Select the Selection tool in the Tools panel. Then, select and delete each of the Position pins in the pincers.

2 Select the Puppet Advanced Pin tool (🖈), hidden beneath the Puppet Position Pin tool in the Tools panel.

3 Place an Advanced pin in the middle of the left pincer, and then place another one in the middle of the right pincer.

Advanced pins appear as dots surrounded by rings. To scale an area, drag the box in the ring outward or inward. To rotate an area, drag the ring itself clockwise or counterclockwise. You'll use the Advanced pins to animate the pincers.

4 Select the Puppet Bend Pin tool (🖈), hidden beneath the Puppet Advanced Pin tool in the Tools panel.

5 Place a Bend pin in the middle of the crab's left swimmer leg, and then place another one in the middle of the right swimmer leg.

Depending on the type of animation you're performing, you may want to name the pins. In this case, you'll name just the pincer and antenna pins.

6 In the Timeline panel, select Puppet Pin 13, press Enter or Return, and rename the pin **Left Pincer**. Press Enter or Return again to accept the new name.

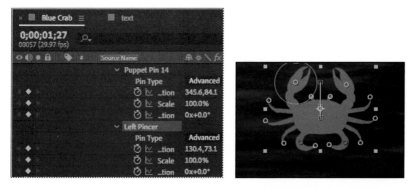

7 Hide the pins' properties. Then, rename the corresponding pins **Right Pincer**, **Left Antenna**, and **Right Antenna.** (They're probably Puppet Pins 14, 3, and 4, respectively.) The default pin names are numbered in the order they were created. You do not need to name the pins on the legs unless you want to.

8 Select Show in the options section of the Tools panel to display the distortion mesh.

The crab is nearly the same color as the triangles in the mesh, so you'll need to change the mesh color. The mesh takes its color from the layer's color label.

9 In the Timeline panel, click the color label next to the Crab.psd layer, and then choose a contrasting color, such as red or purple.

▶ **Tip:** You can extend the mesh beyond the outline of the layer in order to ensure a stroke is included in the deformation. To expand the mesh, increase the Expansion property in the options section of the Tools panel.

10 Select Mesh 1 in the Crab.psd layer to display the mesh again.

11 Change the Density value in the options section of the Tools panel to **12**. You may need to select Mesh 1 to see the mesh again.

The Density setting determines how many triangles are included in the mesh. Increasing the number of triangles results in a smoother animation, but also increases rendering time.

12 Choose File > Save to save your work so far.

Defining areas of overlap

If your animation requires part of an object or character to pass in front of another, use the Puppet Overlap Pin tool to define what should appear in front when areas overlap. Select the Puppet Overlap Pin tool in the Tools panel, click Show to display the mesh, and then click intersections in the mesh to place Overlap pins in the areas that should always remain in front.

You can adjust the effect of the Overlap pins in the options area of the Tools panel. The In Front value determines the apparent proximity to the viewer; setting the value to 100% prevents those parts of the object that are overlapped from showing through. The Extent value determines how far the overlap influence extends for the pin; the affected area appears lighter in the Composition panel.

Stiffening an area

The pincers, legs, and antennae of the crab will move in the animation, but the carapace should stay firm. You'll use the Puppet Starch Pin tool to add Starch pins to ensure the carapace isn't affected by the pins' movements.

1 Select the Puppet Starch Pin tool (), which is hidden behind the Puppet Bend Pin tool in the Tools panel.

2 If the mesh isn't showing, select Show in the options area of the Tools panel to display it.

3 Place Starch pins at the base of each pincer, leg, and antenna to stiffen the entire carapace, as in the image below.

4 Hide the properties for the crab.psd layer in the Timeline panel.

5 Choose File > Save to save your work so far.

Squash and stretch

Squash and stretch is a traditional animation technique that adds realism and weight to objects. It's an exaggeration of the effect that occurs in real life when a moving object comes into contact with a stationary object, such as the ground. When squashing and stretching are applied correctly, the volume of the character doesn't change. If you use the Puppet tools to animate cartoon characters or similar objects, consider how they interact with other objects.

The easiest way to understand the principle of squash and stretch is to view an animation of a bouncing ball. As the ball lands, it partially flattens, or squashes. As it bounces up, it stretches.

Animating pin positions

The pins are in place. Now you can change them to animate the crab. The Starch pins keep specific areas (in this case, the carapace) from moving too much.

When you placed the pins, After Effects created initial keyframes for each pin at 1:27. You'll animate the pins so that the crab waves its pincers, legs, and antennae, and then returns to its original position.

1 Select the crab.psd layer in the Timeline panel, press U to display all the keyframes for the layer, and select the Puppet effect to make the puppet pins visible.

2 Select the Selection tool in the Tools panel. Then go to 4:00, and select the Advanced pin on the left pincer. Drag the ring around it to the left to rotate the pincer outward, and then drag the center pin so that the pincer is almost vertical. Repeat the steps (but dragging the ring to the right) for the right pincer.

3 Go to 5:00, and move the Left Pincer and Right Pincer pins so that the pincers are further apart and turn them outward. Then drag the small rectangle on each ring outward to bloat the pincers slightly.

4 At 6:19, turn the pincers back inward. Then, at 8:19, position them so that they're roughly vertical again. At 9:29, reduce the pincers' scale back to their original size, and move the pincers so that they're fully turned inward.

5 Move the current-time indicator across the time ruler to see the pincers wave.

Next, you'll move the antennae closer together. The first keyframe already exists, so you need to create only one more.

6 Go to 7:14, and pull the pins on the antennae closer to each other.

Now you can animate all the legs. You want them to start moving even before the pincers do, and they should wave around a bit.

7 Go to 1:19, and move the pin on each leg so that each leg is slightly longer and curved outward. Use the Bend pin on each of the swimmer legs to scale each leg slightly larger.

8 Make changes to each leg at 2:01, 4:00, 6:17, and 8:10 so that the legs move slightly upward or downward, in and out as the video progresses. Move each pin about the same amount each time, in whatever direction you choose. At 8:10, use the Bend pins to return the swimmer legs to their original size.

9 Hide the properties for the crab.psd layer. Then press F2 or click an empty area of the Timeline panel to deselect all layers. Then, press the Home key or move the current-time indicator to the beginning of the time ruler.

10 Press the spacebar to preview your animation. Press the spacebar again to stop playback. If you want to change the animation, adjust pins at each keyframe.

11 Choose File > Save to save your animation.

Using the Puppet tools to animate video

You've used the Puppet tools to animate an image on a layer, but you can also use them to warp or create other special effects on video layers. You'll use Advanced pins to make the water swirl.

1 In the Timeline panel, click the Lock icon to unlock the Water background.mov layer so you can edit it.

2 Go to 4:00, where you can see the water clearly.

3 Select the Water background.mov layer.

4 Select the Puppet Advanced Pin tool in the Tools panel, and then create two Advanced pins in the water on either side of the crab and one each above and below it.

5 Deselect Show in the Tools panel so you can see the water clearly.

6 Rotate each pin to create waves in the water. You'll probably need to scale and reposition the pins as well to ensure that the water reaches the edges of the scene. If you aren't happy with the effect, you can delete the pins and start over.

7 Press the Home key or move the current-time indicator to the beginning of the time ruler. Then press the spacebar to preview the animation. Press the spacebar again to stop playback.

8 Hide all properties in the Timeline panel, and then save the project.

Recording animation

Changing the position of each pin at each keyframe worked, but you probably found the process to be slow and tedious. Instead of manually animating keyframes, you can use the Puppet Sketch tool to drag the pins into position in real time. After Effects starts recording the motion as soon as you begin dragging a pin, and it stops recording when you release the mouse button. The composition moves forward through time as you move the pin. When you stop recording, the current-time indicator returns to the point at which you began recording, so that you can record the path for another pin during the same time period.

Experiment with this method of animation as you re-create the pincers' movement using the Puppet Sketch tool.

Tip: By default, the motion is played back at the speed at which it was recorded. To change the ratio of recording speed to playback speed, click Record Options in the Tools panel, and change the Speed value before recording.

1 Choose File > Save As > Save As, and name the project **Motionsketch.aep**. Save it in the Lesson08/Finished_Project folder.

2 Move the current-time indicator to 1:27.

3 In the Timeline panel, select the crab.psd layer, and press U to display all the keyframes for the layer.

4 Scroll down to the Left Pincer and Right Pincer pins. Drag to select all keyframes for those pins after 1:27, and then delete the keyframes.

The animation for the other pins remains, but you've removed the keyframes that animate the pincers. Depending on where you placed Starch pins, the pincers may move slightly in response to other pins' movements.

5 Select the Puppet Position Pin tool (✱) in the Tools panel.

6 In the Timeline panel, select Puppet to see the pins in the Composition panel, if they're not already visible.

7 Select the Left Pincer pin in the Composition panel, and press Ctrl (Windows) or Command (macOS) to activate the Puppet Sketch tool. (A clock icon appears next to the pointer.)

8 Continue to hold down Ctrl or Command as you drag the Left Pincer pin into different positions for the length of the video. Release the mouse button when you've finished. The current-time indicator returns to 1:27.

● **Note:** The Puppet Sketch tool records changes in position, but not rotation or size.

9 Press Ctrl or Command, and drag the Right Pincer pin into different positions. Use the outline of the crab and the other pincer's movements to guide you. Release the mouse button to stop recording.

10 Preview the final animation.

You've used the Puppet tools to create a realistic, engaging animation. Remember that you can use the Puppet tools to deform and manipulate many kinds of objects.

Extra credit

Act it out with Adobe Character Animator

If you identify strongly with your characters, you might want to use Adobe Character Animator instead of creating cumbersome keyframes. It's especially useful if you're creating a long scene or you need to match the character's mouth to speech. It's also a lot of fun.

Character Animator is included in an Adobe Creative Cloud membership. With it, you can import a character you've created in Photoshop or Illustrator, and then act out facial gestures and head movements in front of your webcam; your character mirrors your gestures on the screen. If you speak, the character's mouth moves to match your words.

You can move other body parts, such as legs and arms, using keyboard shortcuts or your mouse or tablet. And you can set up dangling behavior so that, for example, if a rabbit's head moves to the left, its ears dangle with it.

Character Animator includes some entertaining interactive tutorials to help you get started. To learn more, go to https://www.adobe.com/products/character-animator.html.

Tips for a smooth animation experience

- Create different layers for different moving parts: draw the mouth on one layer, the right eye on another, and so on.

- Name layers so Character Animator will recognize them. Certain words, such as "pupil," help map the character to the image in the camera.

- Practice facial and other gestures before recording. Once you've set your Rest Pose, try different mouth shapes, eyebrow raises, head waggles, and other movements to see how subtle or exaggerated movements translate for your character.

- Speak into the microphone as you record. Many mouth shapes are triggered by audio cues, such as "uh-oh," and the character's mouth movements will be synced to your words automatically.

- Especially at first, consider using an existing character file as a template. It'll be easier to get the layer names right.

- Try animating objects that don't have faces and bodies. For example, you can use Character Animator to animate clouds floating, a flag waving, or flowers opening. Be creative and have fun!

Review questions

1 What's the difference between the Puppet Position Pin tool and the Puppet Advanced Pin tool?

2 When would you use the Puppet Starch Pin tool?

3 Describe two methods of animating pin positions.

Review answers

1 The Puppet Position Pin tool creates Position pins, which define the position of a portion of the image as the image is deformed. The Puppet Advanced Pin tool creates Advanced pins, which define the scale and rotation, as well as the position, of a portion of the image.

2 Use the Puppet Starch Pin tool to add Starch pins to an area that you want to remain more rigid while other areas of the object are distorted.

3 You can manually animate pin positions by changing the position for each pin in the Timeline panel. To animate pin positions more quickly, use the Puppet Sketch tool: With the Puppet Position Pin tool selected, press Ctrl or Command, and drag a pin to record its movement.

9 USING THE ROTO BRUSH TOOL

Lesson overview

In this lesson, you'll learn how to do the following:

- Extract a foreground object from the background using the Roto Brush tool.

- Correct the segmentation boundary across a span of frames.

- Touch up a matte with the Refine Edge tool.

- Freeze a matte across a clip.

- Replace a background.

- Animate properties for creative effects.

- Track a face in footage.

 This lesson will take about an hour to complete. If you haven't already done so, download the project files for this lesson from peachpit.com/ AfterEffectsCIB2024, following the instructions in the Getting Started section under "Accessing the lesson files and Web Edition."

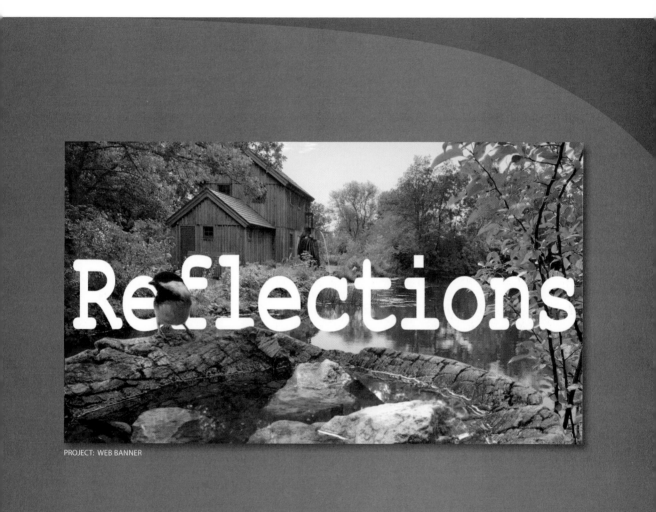

Reflections

With the Roto Brush tool, you can quickly separate a foreground object from a background across many frames. You can achieve professional results in a fraction of the time you'd spend performing the same task with traditional rotoscoping.

About rotoscoping

When you draw or paint on the frames of a movie, you're *rotoscoping*. For example, a common use of rotoscoping is to trace an object, using the path as a mask to isolate it from the background so you can work with it separately. You could draw masks, animate the mask paths, and then use the masks to define a matte. (A *matte* is a mask used to hide part of an image so that another image can be superimposed.) While effective, this is a time-intensive, tedious process, especially if the object moves a great deal or the background is complex.

If a background or foreground object is a consistent, distinct color, you could use color keying to separate the object from the background. If the subject was shot against a green or blue background (green screen or blue screen), keying is usually much easier than rotoscoping. However, keying is less efficient when you're working with complex backgrounds.

The Roto Brush tool in After Effects, powered by an AI model, is much faster than conventional rotoscoping. You use the Roto Brush tool to define the foreground and background elements. Then After Effects creates a matte, and tracks the movement of the matte over time. The Roto Brush tool does much of the work for you, leaving only a little cleanup work to be done.

Getting started

In this lesson, you'll use the Roto Brush tool to isolate a bird and rock pool so you can replace the background. To finish up the project, you'll add an animated title.

First, you'll preview the final movie and set up your project.

1 Make sure the following files are in the Lessons/Lesson09 folder on your hard disk, or download them from peachpit.com now:

- In the Assets folder: Chickadee.mov, Facetracking.mov, MillPond.mov

- In the Sample_Movie folder: Lesson09.mp4

2 Open and play the Lesson09.mp4 sample movie in Windows Movies & TV or QuickTime Player to see what you will create in this lesson. When you are done, close Windows Movies & TV or QuickTime Player. You may delete the sample movie from your hard disk if you have limited storage space.

When you begin this lesson, restore the default application settings for After Effects. See "Restoring default preferences" on page 3.

3 Start After Effects, and then immediately hold down Ctrl+Alt+Shift (Windows) or Command+Option+Shift (macOS). In the Startup Repair Options dialog box, click Reset Preferences.

4 Click New Project in the Home window.

After Effects opens to display an empty, untitled project.

5 Choose File > Save As > Save As.

6 In the Save As dialog box, navigate to the Lessons/Lesson09/
Finished_Project folder.

7 Name the project **Lesson09_Finished.aep**, and then click Save.

Creating the composition

You'll import a footage file and create a composition from it.

1 Click New Composition From Footage in the Composition panel.

2 Navigate to the Lessons/Lesson09/Assets folder, select the Chickadee.mov file, and
then click Import or Open.

After Effects creates a composition
named Chickadee, based on the settings
in the Chickadee.mov file. The composi-
tion is two and one half seconds long,
with a frame size of 1920 x 1080. The
movie file was shot at a rate of 29.97
frames per second.

3 Choose File > Save to save the project
so far.

Creating a segmentation boundary

You use the Roto Brush tool to specify which parts of the clip are in the foreground and which are in the background. You add strokes to distinguish the two, and then After Effects creates a segmentation boundary between the foreground and background.

Creating a base frame

To use the Roto Brush tool to isolate a foreground object, you start by adding strokes to a base frame to identify foreground and background areas. You can start on any frame in the clip, but in this exercise, you'll use the first frame as the base frame. First, you'll add the strokes that identify the bird and the rock pool as the foreground objects.

1 Move the current-time indicator across the time ruler to preview the footage.

2 Press the Home key to move the current-time indicator to the beginning of the time ruler.

3 Select the Roto Brush tool (🖌) in the Tools panel.

You use the Roto Brush tool in the Layer panel, which you'll open now.

4 Double-click the Chickadee.mov layer in the Timeline panel to open the clip in the Layer panel.

5 Choose Fit from the Magnification Ratio pop-up menu at the bottom of the Layer panel if you don't see the entire image clearly.

By default, the Roto Brush tool creates green foreground strokes. You'll start by adding strokes to the foreground—the rock pool and the bird. Generally, it's most efficient to start with broad strokes and then use smaller brushes to refine the border.

6 Choose Window > Brushes to open the Brushes panel. Set up a hard round 100-pixel brush. (You may need to resize the Brushes panel to see the options.)

When you're drawing strokes to define the foreground object, follow the skeletal structure of the subject. Unlike traditional rotoscoping, you don't need to define a precise boundary around the object. Start with broad strokes, and work down to small regions as After Effects determines where the boundary is supposed to be.

7 Draw a green stroke horizontally across the rock pool.

▶ **Tip:** You can quickly zoom in and out of the Layer panel using the scroll wheel on your mouse, if it has one.

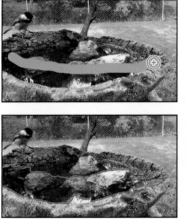

Roto Brush tool properties appear in the Effect Controls panel. In the Layer panel, a magenta outline identifies the boundaries After Effects created for the foreground object. After Effects recognized only about half of the pool, because you initially sampled only a small area of the subject. You'll help After Effects find the boundary by adding some more foreground strokes. First, you'll make sure you're using version 3 of the Roto Brush tool.

8 In the Effect Controls panel, make sure 3.0 is selected for the Version.

9 Still using a large brush, continue to draw green strokes along the inside edges of the pool. Do not include the branches directly behind the pool and the bird.

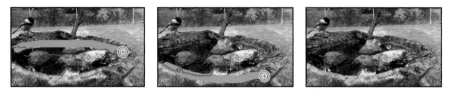

10 Zoom to 200% and use the Hand tool (✋) to pan to the bird.

11 Select the Roto Brush tool again. Then select a smaller brush, and draw a green stroke across the bird's body.

It can be tricky to get some areas without accidentally adding background as well. It's okay if you haven't captured every detail in the foreground. You'll use background strokes to remove any extraneous areas of the matte.

12 Press Alt (Windows) or Option (macOS) to switch to the red background stroke brush. Add red strokes to background areas you want to exclude from the matte.

13 Switch back and forth between the foreground and background brushes and brush sizes to fine-tune the matte. Don't forget to deselect the branches directly behind the bird and the pool. In some cases, one click may be all it takes to exclude an object or area from the matte.

14 When you're happy with the bird's matte, zoom back out and fine-tune any remaining areas that need to be addressed with the rock pool.

Editing Adobe Premiere Pro clips with After Effects

You can work with a clip in both Adobe Premiere Pro and After Effects, moving easily between the two applications as you edit your project.

To edit an Adobe Premiere Pro clip in After Effects, do the following:

1. Right-click or Control-click the clip in Adobe Premiere Pro, and choose Replace With After Effects Composition.

After Effects starts, and opens the Adobe Premiere Pro clip.

2. Save the project when you're prompted by After Effects. Then, work in the composition just as you'd work in any other After Effects project.

3. When you're finished, save the project, and return to Adobe Premiere Pro.

Your changes are automatically reflected in the timeline.

Don't worry about being exact about your brush strokes. Just make sure the matte is within 1 to 2 pixels of the edge of the foreground object. You'll have an opportunity to refine the matte later. However, After Effects uses the information on the base frame to adjust the matte for the rest of the span, so you want the matte to be accurate.

15 Click the Toggle Alpha button (⬛) at the bottom of the Layer panel. The selected area is white against a black background, so you can see the matte clearly.

16 Click the Toggle Alpha Overlay button (⬛) at the bottom of the Layer panel. The foreground area appears in color, and the background has a red overlay.

17 Click the Toggle Alpha Boundary button (⬛) at the bottom of the Layer panel to see the outline around the bird and rock pool again.

As you use the Roto Brush tool, the Alpha Boundary is the best way to see how accurate your boundary is, because you can see everything in the frame. However, the Alpha and Alpha Overlay options let you see your matte without the distraction of the background.

Refining the boundary across the span

You used the Roto Brush tool to create a base frame, which includes a segmentation boundary that divides the foreground from the background. The Roto Brush span appears below the time ruler at the bottom of the Layer panel. When After Effects has propagated the current boundary for a frame, the bar beneath that frame on the time ruler is green.

As you move forward and backward through the footage, the segmentation boundary moves with the foreground object (in this case, the bird and the rock pool). You'll step through the frames in the span and make adjustments to the segmentation boundary as necessary.

Because the rock pool is stationary, its track matte is consistent throughout the span. Given that, we'll focus on the bird, which moves around a lot.

1 Zoom in on the bird, and then make sure the Roto Brush tool is selected in the Tools panel.

2 Press the 2 key on your main keyboard (not the numeric keypad) to move forward one frame.

▶ **Tip:** To move forward one frame, press the 2 key on your keyboard; to move back one frame, press the 1 key.

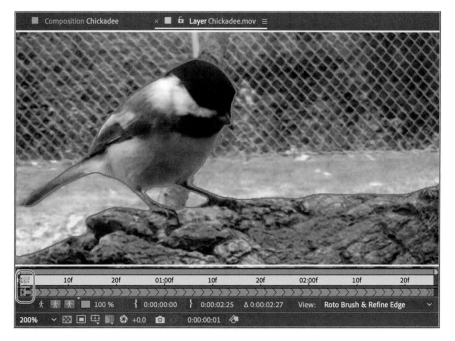

Working from the base frame, After Effects tracks the edge of the object and attempts to follow its movement. Depending on how complex your foreground and background elements are, the boundary may or may not conform exactly to the area you hoped it would.

3 Using the Roto Brush tool, paint foreground and background strokes to refine the matte for this frame. If the matte is accurate, you don't need to paint any strokes.

Note: As it propagates the segmentation boundary for a frame, After Effects caches that frame. Cached frames have a green bar in the time ruler. If you jump ahead to a frame further along the span, After Effects may take longer to calculate the boundary.

As you progress through this clip, you'll notice changes to the segmentation boundary with the bird's beak. Likewise, you may need to refine the segmentation boundary around the feet and legs.

4 Press the 2 key again to move forward to the next frame.

5 Use the Roto Brush tool to add to the foreground or subtract from the background as necessary to refine the boundary.

If you make a stroke you don't like, you can always undo the stroke and try again. As you move through the span, each change you make affects the frames after it. The more you refine your selection, the better the overall results will be. You may find it useful to move forward a few frames to see how changes affect the boundary.

When the bird is moving quickly (such as 0:14 –0:19), you'll notice that the segmentation boundary becomes more vague, but then "catches up" once the bird slows down again. When a frame displays rapid movement, focus on removing areas that should be excluded (such as the branch behind the bird), rather than adding blurry areas of the bird.

6 Repeat steps 4 and 5 until you reach the end of the layer.

7 Once you're satisfied with the bird, zoom out to fit the entire screen, and scroll though the span, making any adjustments as needed.

8 When you have completed refining the segmentation boundary for the entire layer, choose File > Save to save your work so far.

Fine-tuning the matte

Roto Brush does a pretty good job, but there may be stray bits of background in the matte, or foreground areas that weren't included. You'll clean those up by refining the edge.

Adjusting the Roto Brush & Refine Edge effect

When you use the Roto Brush tool, After Effects applies the Roto Brush & Refine Edge effect to the layer. You can modify the effect using settings in the Effect Controls panel. You'll use those settings to further refine the edge of the matte.

1 Press the spacebar to play the clip in the Layer panel. Press the spacebar again to end the preview when you've seen the whole clip.

As you preview the clip, you may notice that the segmentation boundary jumps around a bit. You'll adjust the Reduce Chatter and Contrast settings to make it smoother.

2 In the Effect Controls panel, decrease the Contrast to **40%** and increase Reduce Chatter to **20%**.

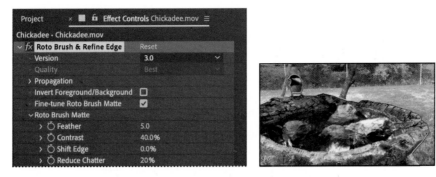

The Reduce Chatter value determines how much influence the current frame has when performing a weighted average across adjacent frames. Contrast affects how tight the boundary is.

3 Preview the clip again.

Using the Refine Edge tool

When an object isn't smooth, the Roto Brush may not pick up the nuanced edge. The Refine Edge tool lets you include fine details such as wisps of hair in designated areas of the segmentation boundary.

Though it might be tempting to use the Refine Edge tool immediately after creating the base frame, it's best to wait until you've refined the segmentation boundary across the entire clip. Because of the way After Effects propagates the segmentation boundary, using the Refine Edge tool too early results in a matte that is difficult to use.

1 Go to the base frame, which is the first frame of the clip, and then zoom in so that you can see the edges of the bird's tail clearly. Use the Hand tool if necessary to move the layer so you can see the entire bird.

2 Select the Refine Edge tool (✐), hidden beneath the Roto Brush tool in the Tools panel.

The tail is relatively soft, so a small brush size will work well. For a fuzzier object, you might have better results with a much larger brush. The brush needs to overlap the stray edges that emerge from the object.

3 Change the brush size to **5** pixels.

When you use the Refine Edge tool, draw strokes along the edges of the matte.

4 In the Layer panel, move the Refine Edge tool over the edge of the tail straddling the segmentation boundary and including the variations in the feathers. You can use multiple strokes if needed.

When you release the mouse, After Effects switches to the Refine Edge X-ray view so that you can see how the Refine Edge tool changes the matte, capturing the detail in the edges.

5 Move the current-time indicator across the time ruler to view the edge. At 0:15, Refine Edge breaks away from the tail as the bird moves away rapidly.

6 Change the brush size to **19** pixels.

7 At 0:15, press Alt (Windows) or Option (macOS) and erase the artifact from the Refine Edge tool, as it's no longer useful going forward.

8 Continue to move forward and backward through the scene, applying the Refine Edge tool wherever the matte's edge doesn't capture the fuzziness of the bird's feathers, and removing it wherever it strays from the tail.

● **Note:** Use the Refine Edge tool only after you have cleaned up the matte across the entire clip.

9 Zoom out to see the entire scene, resize the Layer panel if you enlarged it, and then choose File > Save to save your work.

Freezing your Roto Brush tool results

You've put a fair amount of time and effort into creating the segmentation boundary across the entire clip. After Effects has cached the segmentation boundary so it can recall it without having to make the calculations again. To keep that data easily accessible, you'll *freeze* it. This reduces the processing demands on your system so you can work faster in After Effects.

Once the segmentation is frozen, you cannot edit it unless you unfreeze it. Refreezing the segmentation is time-consuming, so it's best to refine the segmentation boundary as much as possible before freezing.

1 Click the Freeze button in the lower right area of the Layer panel.

Depending on your system, this may take a while.

After Effects displays a progress bar as it freezes the Roto Brush and Refine Edge tool data. Freezing may take a few minutes, depending on your system. As After Effects freezes the information for each frame, the cache line turns blue. When it has finished freezing, a blue warning bar appears above the time ruler in the Layer panel, reminding you that the segmentation is frozen.

2 Click the Toggle Alpha Boundary button (▦) in the Layer panel to see the matte. Then click the Toggle Transparency Grid button (▨). Move the time marker across the time ruler to see the subject without the distractions of the background.

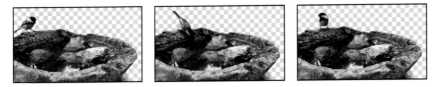

3 Click the Toggle Alpha Boundary button again to see the boundary.

4 Choose File > Save.

After Effects saves the frozen segmentation information with the project.

Changing the background

There are many reasons to isolate a foreground image from a background. You may want to replace the background entirely, moving the subject to a different setting. Or you could simply want to change the foreground or background without modifying the other. In this lesson, you'll remove the fenced in area of the background, and replace it with a different background, which you'll enhance with color correction tools.

1 Close the Layer panel to return to the Composition panel, and then move the current-time indicator to the beginning of the timeline. Choose Fit from the Magnification Ratio pop-up menu at the bottom of the Composition panel.

2 Hide the properties for the Chickadee.mov layer, if they're visible.

The Composition panel displays the composition, which includes only the Chickadee.mov layer, consisting only of the foreground you isolated from the clip.

3 Click the Project tab to display the Project panel, and double-click an empty area in the Project panel. Navigate to the Lessons/Lesson09/Assets folder, select the MillPond.mov file, and click Import or Open.

4 Drag the MillPond.mov clip from the Project panel to the Timeline panel, and place it below the original Chickadee.mov layer.

5 Click the new layer, press Enter or Return, and rename the layer **Mill Pond Start**. Then press Enter or Return again.

6 Select the Chickadee layer. Then, using the Selection tool (▶), drag the layer to the lower half of the Composition panel. Your values should be similar to ours.

7 Select the Mill Pond Start layer, and choose Effect > Color Correction > Hue/Saturation.

You'll use the Hue/Saturation effect in two different ways, so you'll create a duplicate layer for the second effect.

8 With the Mill Pond Start layer selected, choose Edit > Duplicate. Rename the bottom layer **Mill Pond End**. Then rename the top layer to remove the number 2 from the name (so that its name is Mill Pond Start).

9 Select the Mill Pond Start layer, and then, in the Effect Controls panel, do the following:

- Select Colorize.

- Change Colorize Hue to **56** degrees.

- Change Colorize Saturation to **19**.

- Change Colorize Lightness to **−25**.

10 In the Properties panel, click the stopwatch icon for the Opacity value to create an initial keyframe at 100%.

11 Go to 1:10, and change the Opacity to **0**.

12 Still at 1:10, select the Mill Pond End layer.

13 In the Effect Controls panel, click the stopwatch icon for the Channel Range property to create an initial keyframe.

14 Go to the end of the footage (2:25), and change the Master Hue to **-30**.

15 Press the spacebar to preview the project. Press the spacebar again when you've finished.

The background transitions from a monochromatic dusk to a full summer day and then again to the beginning of fall as the leaves change.

16 Choose File > Increment And Save.

If you save incrementally, you can return to earlier versions of your project to make adjustments later. This can be very useful if you're experimenting or want to try alternative effects. The Increment And Save feature preserves the previously saved version of the project and creates a new project with the same name, with an increasing number added to the filename.

Adding animated text

You're nearly done. All you need to do is to add the animated title between the bird and the background.

1 Deselect all layers, and then move the current-time indicator to the beginning of the time ruler.

2 Select the Type tool (T), and then type **Reflections** in the Composition panel.

A new text layer named Reflections appears in the Timeline panel at the top of the layer stack.

3 Select the Reflections layer, and then do the following in the Text section of the Properties panel:

- Choose Courier New for the font.

- Choose Bold for the font style.

- Type **300** px for the font size.

- Choose Optical from the Kerning menu.

- Select white for the Fill color.

- Deselect the Stroke checkbox.

4 Click the More button, and then type **140**% for the vertical scale.

5 Use the Selection tool (▶) to reposition the text to rest along the top edge of the rock pool, and then move the Reflections layer below the Chickadee layer.

You'll animate the text so that it appears on the screen in a liquid motion.

6 Make sure you're at the beginning of the timeline and the Reflections layer is selected. In the Effects & Presets panel, type **blur** in the search box. Under Text, double-click the Blur And Fade In preset.

7 Deselect all layers in the Timeline panel, and move the current-time indicator to the beginning of the time ruler. Press the spacebar to preview the clip.

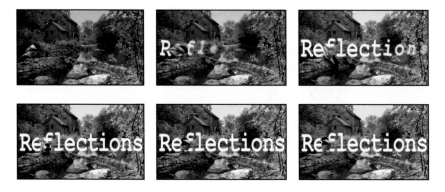

8 Choose File > Save to save your work.

Outputting your project

You'll render your movie to complete the project.

1 Choose File > Export > Add To Render Queue.

2 In the Render Queue panel, click the blue words *Best Settings*.

3 In the Render Settings dialog box, choose Half from the Resolution menu, and make sure Use Comp's Frame Rate is selected in the Frame Rate area. Then click OK.

4 Click the blue text next to Output Module. Then, at the bottom of the Output Module Settings dialog box, choose Audio Output Off, and click OK.

5 Click the blue text next to Output To. In the Output Movie To dialog box, navigate to the Lessons/Lesson09/Finished_Project folder, and click Save.

6 Click Render in the top right corner of the Render Queue panel.

7 When the project has rendered, save and close it.

Congratulations! You've separated a foreground object from the background, replaced and modified the background, and animated some text to complete the movie. You're ready to use the Roto Brush tool on your own projects.

Extra credit

Tracking faces

The face-tracking feature in After Effects makes it easier to track a face or specific facial features, such as lips or eyes. Previously, tracking a face required roto brushing or complex keying.

● **Note:** If you open the Lesson09_extra_credit.aep file, you may need to relink the Facetracking.mov asset.

1 Choose File > New > New Project.

2 Click the New Composition From Footage button in the Composition panel, and then navigate to the Lessons/Lesson09/Assets folder. Select the Facetracking.mov file, and click Import or Open.

3 Select the Facetracking.mov layer in the Timeline panel. Then, select the Ellipse tool, hidden by the Rectangle tool in the Tools panel.

4 Drag an elliptical mask roughly covering the face.

5 Right-click the Mask 1 layer, and choose Track Mask.

6 In the Tracker panel, choose Face Tracking (Outline Only) from the Method menu.

The Face Tracking (Outline Only) option tracks the entire face. The Face Tracking (Detailed Features) option tracks the outline plus the lips, eyes, and other distinctive facial features. You can export detailed facial data for use in Character Animator, or you can use it in After Effects to apply effects or to match it with another layer, such as an eye patch or a hat.

(continued on next page)

Extra credit (continued)

7 Click the Track Forward button in the Tracker panel.

The Tracker tracks the face, changing the mask's shape and position as the face moves.

8 Press the Home key to return to the beginning of the timeline, and then move the current-time indicator across the time ruler to see how the mask moves with the face.

9 In the Effects & Presets panel, search for **Bright**. Then drag the Brightness & Contrast effect onto the Facetracking.mov layer in the Timeline panel.

10 Expand Effects > Brightness & Contrast > Compositing Options in the Timeline panel.

11 Click the + icon next to Compositing Options. Choose Mask 1 from the Mask Reference 1 menu, and increase Brightness to **50**.

The masked area of the face brightens, but nothing else does. This setting is too bright, and the edge of the mask is too abrupt. You'll make it more subtle.

12 Reduce the Brightness to **20**.

13 Expand the Mask 1 properties. Change the Mask Feather property to **70**, **70** pixels.

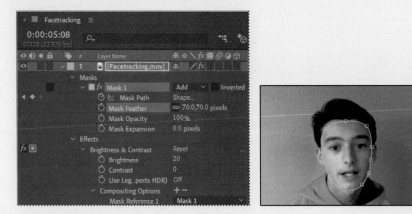

14 Save the project to the Lessons/Lesson09/Finished_Project folder. Then close the file.

You can use the face tracker to blur a face, brighten it, or add any other effect. You can also invert the mask to affect everything but the face.

Review questions

1 When should you use the Roto Brush tool?

2 What is the segmentation boundary?

3 When should you use the Refine Edge tool?

Review answers

1 Use the Roto Brush tool any time you would have used traditional rotoscoping. It's particularly useful for removing a foreground element from the background.

2 The segmentation boundary is the boundary between the foreground and background. The Roto Brush tool adjusts the segmentation boundary as you progress through the frames in the Roto Brush span.

3 Use the Refine Edge tool when you need to rotoscope objects with fuzzy or wispy edges. The Refine Edge tool creates partial transparency for areas of fine detail, such as hair. Use the Refine Edge tool only after you've adjusted the segmentation boundary across the entire clip.

10 ADJUSTING COLOR AND MOOD

Lesson overview

In this lesson, you'll learn how to do the following:

- Use Scene Edit Detection to create separate layers from a clip.

- Adjust hue and saturation to correct color.

- Track part of a scene using the mask tracker.

- Use the Auto-Contrast effect to adjust brightness and contrast.

- Copy an object in the scene with the Clone Stamp tool.

- Create an artistic colorization.

- Use freeze frames to pause action.

- Add transitions between scenes.

 This lesson will take about an hour to complete. If you haven't already done so, download the project files for this lesson from peachpit.com/ AfterEffectsCIB2024, following the instructions in the Getting Started section under "Accessing the lesson files and Web Edition."

ART GLASS

PROJECT: PRODUCTS ADVERTISEMENT

Most shots require some degree of color correction and color grading. With Adobe After Effects, you can easily remove color casts, brighten images, and change the mood of a clip.

Getting started

Color influences the way viewers see and respond to your movie. After Effects provides several features that let you alter or adapt the color of a captured image. Strictly speaking, *color correction* is the act of adjusting the color in a shot to correct errors in white balance and exposure, and to ensure color consistency from one shot to another. However, you can use the same color-correction tools and techniques to perform *color grading*, which is the subjective manipulation of color to focus attention on a key element in a shot or to create a color palette for a specific visual look.

In this lesson, you will adjust saturation, hue, and other color components to enhance the color in three clips. First, you'll separate the clips from a video file into three individual layers that you can manipulate separately. Then, you'll apply a variety of color-correction effects to enhance the images and alter the mood. You'll also use mask tracking and motion tracking to replace the unremarkable background of one image with stylish drapery.

First, you'll preview the final movie and set up your project.

1 Make sure the following files are in the Lessons/Lesson10 folder on your hard disk, or download them from your Account page at peachpit.com now:

 • In the Assets folder: Collectibles.mp4, drapes.jpg, and TrinketsText.psd

 • In the Sample_Movie folder: Lesson10.mp4

2 Open and play the Lesson10.mp4 sample movie in Windows Movies & TV or QuickTime Player to see what you will create in this lesson. When you are done, close Windows Movies & TV or QuickTime Player. You may delete the sample movie from your hard disk if you have limited storage space.

When you begin this lesson, restore the default application settings for After Effects. See "Restoring default preferences" on page 3.

3 Start After Effects, and then immediately hold down Ctrl+Alt+Shift (Windows) or Command+Option+Shift (macOS). In the Startup Repair Options dialog box, click Reset Preferences.

4 Click New Project in the Home window.

After Effects opens to display an empty, untitled project.

5 Choose File > Save As > Save As.

6 In the Save As dialog box, navigate to the Lessons/Lesson10/Finished_Project folder. Name the project **Lesson10_Finished.aep**, and then click Save.

Creating the composition

You'll create a new composition based on the Collectibles movie file.

1 Choose File > Import > File.

2 Navigate to the Lessons/Lesson10/Assets folder. Select the Collectibles.mp4 file, and select Create Composition.

3 Click Import or Open.

After Effects creates a composition named Collectibles and opens it in the Composition and Timeline panels.

Previewing your project on a video monitor

If possible, perform color correction for projects intended for broadcast on a video monitor instead of a computer monitor. The gamma values between a computer monitor and a broadcast monitor vary greatly. What may look good on a computer screen may be too bright and washed out on a broadcast monitor. Always be sure your video or computer monitor is properly calibrated before performing color correction. For instructions on calibrating a computer monitor, see After Effects Help.

Mercury Transmit is a software interface that Adobe digital video applications use to send video frames to external video displays. Video device manufacturers AJA, Blackmagic Design, Bluefish444, and Matrox provide plug-ins that route the video frames from Mercury Transmit to their hardware. The same Mercury Transmit plug-ins work in Adobe Premiere Pro, Prelude, and After Effects. Mercury Transmit can also use monitors connected to your computer's video card and FireWire-connected DV devices without an additional plug-in.

1 With a video monitor connected to your computer system, start After Effects.

2 Choose Edit > Settings > Video Preview (Windows) or After Effects > Settings > Video Preview (macOS). Then select Enable Mercury Transmit.

3 Choose a device from the list. Devices with names such as AJA Kona 3G or Blackmagic Playback represent video devices connected to your computer. Adobe Monitor devices are the computer monitors connected to your video card. Adobe DV requires a DV device connected to a FireWire port on your computer.

4 To change the options for your video device, click Setup next to its name. More options may be available in the device's control panel or management application.

5 Click OK to close the Preferences dialog box.

4 Press the spacebar to preview the footage. Notice that there are three distinct scenes. Depending on your computer's volume, you may also hear some static noise for most of the footage.

Detecting scenes in a composition

The video includes three scenes, which you need to edit independently. You'll rearrange the order of the scenes, change the length of each, apply different color corrections, replace the background in one, and clone an object in the final scene. All of these edits are much easier to perform in separate layers. You'll use Scene Edit Detection to split the layers, but first, you'll mute the composition's audio to remove the static noise so it doesn't carry over to the new scenes.

1 Press the Home key or move the current-time indicator to the beginning of the composition.

2 Click the Audio switch for the Collectibles.mp4 layer to mute its sound.

3 With the Collectibles layer selected, choose Layer > Scene Edit Detection.

4 In the Scene Edit Detection dialog box, select Split Layer At Scene Edit, and click OK.

After Effects splits the footage into three layers, each with the same name as the original file. Notice that all three layers are muted. The footage begins with the bottom layer (layer 3) and ends with the top layer (layer 1). You'll reorganize the layers.

5 Select the top layer, press Enter or Return, and rename the layer **Trinkets**. Press Enter or Return again to accept the new name.

6 Repeat step 5 to rename the middle layer **Ceramics** and the bottom layer **Art Glass**.

7 In the Timeline panel, drag the Ceramics layer to the top of the layer stack. Drag the Trinkets layer to the bottom.

8 Drag the footage to match the layer order: Drag the Ceramics layer to the beginning of the timeline (0:00); drag the Art Glass layer to 2:05; and make sure the Trinkets layer starts at 3:20.

9 Choose File > Save to save your work so far.

Making color enhancements

You'll use color-correction effects to make some subtle enhancements to the Ceramics clip, punching up the color and increasing the contrast.

Adjusting saturation

The hue is the actual color of an image, while saturation is the purity of that image. With the Hue/Saturation effect, you can adjust the hue, saturation, or lightness of an image.

You'll start by adjusting the saturation in the Ceramics clip.

1 Press the Home key or move the current-time indicator to the beginning of the composition.

2 Select the Ceramics layer in the Timeline panel.

3 Choose Effect > Color Correction > Hue/Saturation.

The Hue/Saturation effect options appear in the Effect Controls panel.

First, you'll punch up the color by adjusting the saturation.

4 Increase the Master Saturation to **25**.

All of the colors are slightly more intense, particularly the pink cloth. Now you'll enhance the shimmer in the metallic finishes by increasing just the yellow value.

5 From the Channel Control menu, choose Yellows.

6 Increase the Yellow Saturation to **25**.

7 Hide the Hue/Saturation properties in the Effect Controls panel.

Adjusting contrast

The Auto Contrast effect adjusts the overall contrast and mixture of colors. It maps the lightest and darkest pixels in the image to white and black, and then redistributes the intermediate pixels so that highlights appear lighter and shadows appear darker.

You'll adjust the contrast so that the details of the ceramic birds are more pronounced.

1 With the Ceramics layer selected, choose Effect > Color Correction > Auto Contrast.

After Effects applies the default settings to adjust the contrast in the image, and it opens the Auto Contrast effect options in the Effect Controls panel.

The default settings are a nice start, but you'll animate the settings to increase the contrast over time.

2 Make sure the current-time indicator is at the beginning of the time ruler. Then click the stopwatch icon (🕒) for the Black Clip property in the Effect Controls panel to create an initial keyframe.

3 Go to 2:02, where the text is in its final position.

4 Increase the Black Clip value to **2.00**.

The background darkens, making the text more pronounced.

5 Hide the Auto Contrast options in the Effect Controls panel.

6 Choose File > Save to save your work.

Adding a colorized effect

The Colorize option in the Hue/Saturation effect adds color to an image. It's an easy way to create a stylized duotone. To add some visual interest, you'll create a transition from a duotone to full color at the beginning of the clip.

1 Press the Home key or move the current-time indicator to the beginning of the time ruler.

2 Select the Ceramics layer, and choose Edit > Duplicate.

3 Select the Ceramics 2 layer, press Enter or Return, and rename the layer **Ceramics Intro**. Press Enter or Return to accept the new name.

4 Select the Ceramics Intro layer. Then, in the Effect Controls panel, delete the Auto Contrast effect.

5 In the Effect Controls panel, open the Hue/Saturation effect, if it isn't already open. Then, select Colorize.

6 Increase the Colorize Hue value to **25°**.

7 Increase the Colorize Lightness value to **30**.

8 In the Properties panel, click the stopwatch icon (⏱) for the Opacity property to create an initial keyframe.

9 Go to 0:15, and change the Opacity to **0**.

10 Drag the current-time indicator from 0:00 to 2:04 to preview the entire clip.

11 Hide the properties for all layers, and save your work.

Replacing a background

The background footage for the art glass is bland and there's an unsightly outlet in the corner. To resolve this, you'll replace the background with an image of drapery.

You'll start by masking the background and tracking the mask.

Using the mask tracker

The mask tracker transforms a mask so that it follows the motion of an object or objects in a movie. It's similar to the face tracker you used in the Extra Credit project in Lesson 9. You can use it to mask a moving object so that you can apply a special effect to it, for example. In this case, you'll use it to track the art glass as the camera moves through the scene.

1 Select the Art Glass layer, and go to 2:05, the beginning of the art glass footage.

2 In the Composition panel, zoom out to see the pasteboard outside the frame.

3 Select the Pen tool (✐) from the Tools panel.

4 Draw a mask around the pieces and the table, extending the top and side boundaries beyond the edge of the clip as in the image below.

5 Press the M key to display the Mask properties.

6 Choose None from the Mask Mode menu.

Mask modes (blending modes for masks) control how masks within a layer interact with one another. By default, all masks are set to Add, which combines the transparency values of any masks that overlap on the same layer. While Add is chosen, areas outside the mask disappear. Choosing None from the Mask Mode menu reveals the entire clip in the Composition panel, not just the masked area, so it's easier to edit.

7 Right-click (Windows) or Control-click (macOS) Mask 1, and choose Track Mask.

After Effects opens the Tracker panel. The mask tracker does not alter the shape of the mask to follow a shape; the mask remains the same shape but the tracker can change its position, rotation, or scale based on the motion in the clip. You'll use it to track the edges of the bottles and table without having to manually adjust and track the mask. Because the glass objects curve along the round table edge, you'll track the perspective of the mask.

8 In the Tracker panel, choose Perspective from the Method menu. Click the Track Selected Masks Forward button (▶) to begin tracking forward from 2:05.

9 When the tracking is complete, manually preview the clip to see the mask. If it slips out of place, adjust the mask on individual frames. You can shift the entire mask or reposition individual points, but don't delete any points, as that will change the mask for all the frames that follow.

● **Note:** If the mask requires adjustment on more than a few frames, delete it and draw the mask again.

Adding a new background

With the mask tracked, you're ready to add drapery to the scene.

1 Choose Add from the Mask Mode menu, and select Inverted next to Mask 1 in the Timeline panel.

2 Hide the properties for the Art Glass layer, and then go to 2:05, the beginning of the scene.

3 Double-click an empty area in the Project panel to open the Import File dialog box, and navigate to the Lessons/Lesson10/Assets folder. Select the drapes.jpg file, deselect Create Composition, and click Import or Open.

4 Drag the drapes.jpg file from the Project panel to the Timeline panel, placing it below the Art Glass layer.

5 Drag the ends of the drapery footage in the Timeline panel so that its duration matches the Art Glass layer.

6 With the drapes.jpg file selected in the Timeline panel, choose Layer > Transform > Fit to Comp Width.

7 Use the Selection tool (▶) to reposition the image, aligning it with the top of the composition.

Color-correcting using Auto Contrast

Although the background is now less bland, the contrast of the drapes doesn't quite match the foreground elements. You'll use the Auto Contrast effect to correct that.

1 Select the Art Glass layer in the Timeline panel, and then choose Effect > Color Correction > Auto Contrast.

2 In the Effect Controls panel, change Temporal Smoothing (seconds) to **2.00**.

3 Change the White Clip value to **3.00%** to brighten the foreground elements.

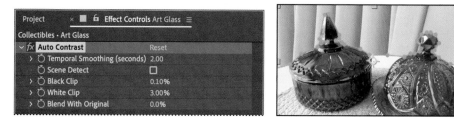

The Black Clip and White Clip values determine how much of the shadows and highlights (respectively) are clipped to the new extreme shadow and highlight colors in the image. Set the clipping values only as high as you need to as excessive clipping can reduce detail in the shadows or highlights.

4 Choose File > Save to save your work.

Cloning an object in a scene

Cloning in After Effects is similar to cloning in Photoshop, but in After Effects, you can clone across the entire timeline, rather than in a single image. When you add an object, you can use motion tracking to ensure it remains in sync with the rest of the scene.

You'll use the Clone Stamp tool to place an additional pawn on the other side of the queen in the Trinkets layer.

1 Go to the beginning of the Trinkets footage at 3:20.

2 Double-click the Trinkets layer to open it in the Layers panel. Then zoom in on the queen and pawn chess pieces in the lower right.

3 Select the Clone Stamp tool (⊥) in the Tools panel.

The Clone Stamp tool samples the pixels on a source layer and applies the sampled pixels to a target layer; the target layer can be the same layer or a different layer in the same composition. You use painting tools, including the Clone stamp tool, in the Layers panel.

When you select the Clone Stamp tool, After Effects adds the Brushes and Paint panels to the stack.

4 Scroll down, if necessary, to see the entire Paint panel. Make sure the Mode is set to Normal and the Duration to Constant. The source should be set to Current Layer. Select Aligned and Lock Source Time, and make sure the Source Time is set to 0 frames.

● **Note:** If the Brushes panel is dimmed, select the Brush tool in the Tools panel to activate it, and then select the Clone Stamp tool again.

5 In the Brushes panel, set up a brush with a Diameter of **21** pixels and Hardness of **80**.

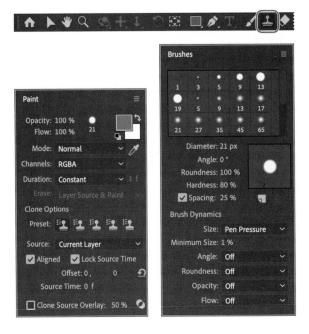

The Constant setting applies the Clone Stamp effect from the current time forward. Because you're starting at the beginning of the timeline, the changes you make will affect every frame in the layer.

When Aligned is selected in the Paint panel, the position of the sample point—the clone position—changes for subsequent strokes to match the movement of the Clone Stamp tool in the target Layer panel so you can use multiple strokes to paint the entire cloned object. The Lock Source Time option lets you clone a single source frame.

6 In the Layer panel, position the cursor at the top of the pawn. Alt-click (Windows) or Option-click (macOS) to designate a source point for cloning.

7 Click next to the left side of the queen midway between the queen and the owl. Continually pressing the mouse, drag back and forth to paint the new pawn. Be careful not to clone too much of the wooden table in the process. If you make a mistake, undo and start over with a new source point.

● **Note:** Painting the pawn without lifting the mouse makes it easier to ensure the entire pawn will move with the video later.

8 When the second pawn is in place, scrub through the clip. The cloned pawn is stationary while the rest of the scene moves; it isn't in sync with the other objects. You'll use tracking data to fix the problem.

9 Go to 3:20. With the Trinkets layer selected, open the Tracker panel, and click Track Motion.

The cloned pawn disappears. Don't worry; it's still there.

10 Select the Selection tool, and then drag the track point (the empty portion of the inner box) to the top of the queen's head for the best tracking results.

11 Select Raw for Track Type, and then click the Analyze Forward button.

● **Note:** You'll learn more about using track points in Lesson 14.

12 In the Timeline panel, go to 3:20, the beginning of the footage.

13 Expand the Trinkets layer > Motion Trackers > Tracker 1 > Track Point 1.

14 In the Trinkets layer, expand Effects > Paint > Clone 1 > Transform Clone 1.

● **Note:** If you used
multiple strokes to paint
the cloned pawn, you'll
need to drag the pick
whip from the Position
property for each clone
(Clone 1, Clone 2, etc.)
to the Track Point 1
Attach Point.

15 Drag the pick whip for the Transform: Clone 1 Position property to the Track Point 1: Attach Point property, and release it. (You may need to enlarge the Timeline panel to see both properties at once.)

The expression you created ties the position of the cloned pawn to the tracking data you created for the clip earlier in the lesson. The pawn will travel with the image.

16 Click the Composition: Collectibles tab to bring the Composition panel forward so you can see the cloned pawn.

The pawn is in the wrong place. You can correct its relationship to the other objects by adjusting its anchor point.

17 Adjust the Transform: Clone 1: Anchor Point property until the pawn is positioned next to the queen. We used 80, -50.

You might need to zoom out to see where the pawn is while adjusting the anchor point values. Your values will probably be different from ours.

18 Choose Fit from the Magnification Ratio pop-up menu so that you can see the whole composition.

19 Scrub through the clip to verify that the pawn is positioned properly. When you're satisfied that it is, close the Layer panel, hide the properties for all layers in the Timeline panel, and restore the Timeline panel to its original size.

20 Choose File > Save to save your work.

Darkening a scene

The third scene is looking pretty good. You'll add an image of the business logo and adjust the brightness of the footage to make the text stand out clearly.

Adding a title image

You'll import a Photoshop file of the business logo to add to the third scene.

1 Select the Trinkets layer, and go to 3:20, where the clip begins.

2 Double-click an empty area in the Project panel to open the Import File dialog box, and navigate to the Lessons/Lesson10/Assets folder. Select the TrinketsText.psd file. Choose Footage from the Import As menu, and click Import or Open.

3 In the TrinketsText.psd dialog box, accept Merged Layers for the Layer Options, and click OK.

4 Drag the TrinketsText.psd file from the Project panel into the Timeline panel, placing it directly above the Trinkets layer.

5 With the TrinketsText layer selected, press Alt+[(Windows) or Option+[(macOS) to set the In point to 3:20, so that it starts at the same time as the Trinkets footage.

The text sits nicely in the middle of the frame, but the brightness of the scene makes it difficult to read. You'll fix that.

Adding a vignette

You'll use a new solid layer to create a vignette, which will emphasize the text in the center as a focal point.

1 Select the Trinkets layer, and go to 3:20, the beginning of the clip.

2 Choose Layer > New > Solid.

3 In the Solid Settings dialog box, do the following:

- Name the layer **Vignette**.

- Click the Make Comp Size button.

- Change the color to black (R=**0**, G=**0**, B=**0**).

- Click OK.

4 Select the Ellipse tool (⬤), hidden beneath the Rectangle tool (⬛) in the Tools panel, and then double-click the Ellipse tool to add an elliptical mask that is automatically sized to fit the layer.

▶ **Tip:** Press Shift while you double-click the Ellipse tool or Rectangle tool to create a perfect circle or square, respectively.

5 In the Timeline panel, select the Vignette layer, and press Alt+[(Windows) or Option+[(macOS) to set the In point to match the Trinkets clip.

6 Expand the Mask 1 properties. Change the Mask Mode to Subtract, and change the Mask Feather value to **600** pixels.

7 Change the Mask Opacity to **50%**.

8 Hide the properties for all layers and then save the file.

Adjusting the brightness

The vignette helped, but the Trinkets layer remains a little too bright. You'll use the Brightness and Contrast effect to reduce the brightness over time. Then, you'll animate the opacity of the layer so that the business name shines at the end of the clip.

1 Select the Trinkets layer, make sure you're at 3:20, and choose Effect > Color Correction > Brightness & Contrast.

After Effects open the Brightness & Contrast controls in the Effect Controls panel.

2 In the Effect Controls panel, click the stopwatch icon for the Brightness property to create an initial keyframe at its current value.

3 Go to 5:17, the end of the clip.

4 Change the Brightness value to **−150**.

5 Drag the current-time marker across the time ruler to preview the clip.

The business name is much more readable at the end of the footage. Now you'll animate the TrinketsText layer so that it fades in as the footage gets darker.

6 Go to 5:17, and select the TrinketsText.psd layer.

7 In the Properties panel, click the stopwatch icon for the Opacity property to create an initial keyframe at 100%.

8 Go to 3:20, the beginning of the layer. Change the Opacity to **0**.

9 Hide the properties for all layers, and then preview the Trinkets clip. The text now fades in as the scene darkens, making it more pronounced and legible.

Freezing the action

After Effects includes features that let you freeze a frame, stopping the action until you start it again or through the end of a layer. You'll freeze the last frame in each scene to give the viewer a chance to read the text and take in the image. First, though, you'll precompose the scenes and expand the composition to make room for the extra time.

Precomposing the scenes

First, you'll simplify the timeline elements by precomposing the individual scenes.

1 Press the Home key or move the current-time indicator to the beginning of the time ruler. Then, press the spacebar to preview the entire composition. Press the spacebar again to stop the playback.

Overall things look good, but each scene is too short; the viewer doesn't have enough time to read the titles.

2 In the Timeline panel, Shift-select the Ceramics Intro and Ceramics layers.

3 Choose Layer > Pre-compose.

4 In the Pre-compose dialog box, name the composition **Ceramics Comp**.

5 Select Adjust Composition Duration To The Time Span Of The Selected Layers, and then click OK.

6 Shift-select the Art Glass and drapes layers.

7 Choose Layer > Pre-compose.

8 In the Pre-compose dialog box, name the composition **Art Glass Comp**.

9 Select Adjust Composition Duration To The Time Span Of The Selected Layers, and then click OK.

10 Shift-select the TrinketsText.psd, Vignette, and Trinkets layers.

11 Choose Layer > Pre-Compose.

12 In the Pre-compose dialog box, name the composition **Trinkets Comp**,

13 Select Adjust Composition Duration To The Time Span Of The Selected Layers, and then click OK.

Expanding the composition time

Before you add the freeze frames, you'll increase the duration of the composition to accommodate them.

1 In the Project panel, select the Collectibles composition, and choose Composition > Composition Settings.

2 In the Composition Settings dialog box, increase the Duration to 8:18.

You've increased the duration by three seconds, one second for each scene.

3 Click OK.

4 In the Timeline panel, drag the Time Navigator End tab to the right to see the entire duration of the composition.

Adding the freeze frames

Now you're ready to freeze the action and extend each scene.

1 Right-click or Control-click the Ceramics Comp layer, and choose Time > Freeze On Last Frame.

After Effects enables time remapping and places a hold keyframe at the position of the last frame in the layer.

2 Move the current-time indicator to 3:04. With the Ceramics Comp layer selected, press Alt+] (Windows) or Option+] (macOS) to set the Out point for the layer at 3:04.

3 Shift the Art Glass Comp and Trinkets Comp layers to the right, so that the Art Glass Comp layer now begins where the Ceramics Comp layer ends.

4 Right-click or Control-click the Art Glass Comp layer, and choose Time > Freeze On Last Frame.

5 Move the current-time indicator to 5:18. With the Art Glass Comp layer selected, press Alt+] (Windows) or Option+] (macOS) to set the Out point for the layer at 5:18.

6 Shift the Trinkets Comp layer to the right so that it begins where the Art Glass Comp layer ends.

7 Right-click or Control-click the Trinkets Comp layer, and choose Time > Freeze On Last Frame.

The Trinkets Comp layer extends to the end of the composition, at 8:18.

8 Press Home or move the current-time indicator to the beginning of the time ruler. Press the spacebar to preview the entire composition. Press the spacebar again to stop playback.

9 Hide the properties for all layers, and choose File > Save to save your work.

Adding transitions

The composition is almost done. The lighting and color look great and the text remains on screen long enough for the viewer to read it. But the scenes change abruptly. You'll add transitions to make that change just a little more gradual.

1 In the Timeline panel, Shift-select the Ceramics Comp and Art Glass Comp layers.

The Art Glass Comp layer follows the Ceramics Comp layer; you'll add a transition between them.

2 Choose Animation > Keyframe Assistant > Sequence Layers.

3 In the Sequence Layers dialog box, select Overlap. Then enter a Duration of **:03**, and choose Dissolve Front Layer from the Transition menu. Click OK.

4 Scroll through the transition to preview the result.

After Effects overlaps the layers by the duration you specify so that the first clip dissolves into the second.

5 In the Timeline panel, Shift-select the Art Glass Comp layer and the Trinkets Comp layer.

6 Choose Animation > Keyframe Assistant > Sequence Layers.

7 In the Sequence Layers dialog box, select Overlap. Then enter a Duration of **:03**, and choose Dissolve Front Layer from the Transition menu. Click OK.

Overlapping the layers shortened the overall length of the clips. You'll extend the Trinkets Comp layer to the end of the composition

8 Press End or move the current-time indicator to the end of the time ruler (8:17).

9 Select the Trinkets Comp layer, and then press Alt+] (Windows) or Option+] (macOS) to extend the layer to 8:17.

10 Preview the entire composition. Make any additional adjustments you want to make, and then save your work!

Review questions

1 What's the difference between color correction and color grading?

2 How can you colorize a scene?

3 When would you use the mask tracker?

Review answers

1 Color correction is performed to correct errors in white balance and exposure or to ensure color consistency from one shot to another. Color grading is more subjective; its goals are to optimize the source material, to focus attention on a key element in the shot, or to create a color palette to match the visual look the director prefers.

2 Select Colorize in the Hue/Saturation effect controls to colorize a scene. The effect makes it easy to create a duotone effect.

3 Use the mask tracker when you need to track a mask that does not change shape, but that does change position, scale, or rotation through a clip. For example, you can use it to track a person in an action shot, a wheel, or an area of the sky.

11 CREATING MOTION GRAPHICS TEMPLATES

Lesson overview

In this lesson, you'll learn how to do the following:

- Add controls to the Essential Graphics panel.

- Protect portions of a project from time-stretching.

- Export a Motion Graphics template (.mogrt) file.

- Allow image replacement in a .mogrt file.

- Create essential properties for layers in nested compositions.

- Work with a Motion Graphics template in Adobe Premiere Pro.

 This lesson will take about an hour to complete. If you haven't already done so, download the project files for this lesson from peachpit.com/ AfterEffectsCIB2024, following the instructions in the Getting Started section under "Accessing the lesson files and Web Edition."

SHOT IN THE DARK

EPISODE 3: A NEW DAY DAWNS

PROJECT: MOTION GRAPHICS TEMPLATE FOR TV SHOW TITLE SEQUENCE

With Motion Graphics templates, you can preserve the style and settings for a project while giving colleagues control over specific editorial decisions in Adobe Premiere Pro.

Getting started

Using the Essential Graphics panel in After Effects, you can create Motion Graphics templates that let your colleagues edit aspects of the composition in Adobe Premiere Pro. You decide which properties are editable as you create the template, and then you can share the template using Creative Cloud libraries or by sending your colleague the Motion Graphics template (.mogrt) file. You can also use the Essential Graphics panel to create essential properties within nested compositions.

You'll create a Motion Graphics template for the title sequence of a noir television show in which the main title text needs to remain constant but the episode subtitle, background images, and effect settings can change.

First, you'll preview the sample movie and then set up the project.

1 Make sure the following files are in the Lessons/Lesson11 folder on your hard disk, or download them from peachpit.com now:

 • In the Assets folder: Embrace.psd, Holding_gun.psd, Man_Hat.psd, and Stylized_scene.psd

 • In the Sample_Movie folder: Lesson11.mp4

2 Open and play the Lesson11.mp4 sample movie in Windows Movies & TV or QuickTime Player to see what you will create in this lesson. When you are done, close Windows Movies & TV or QuickTime Player. You may delete the sample movie from your hard disk if you have limited storage space.

When you begin this lesson, restore the default application settings for After Effects. See "Restoring default preferences" on page 3.

3 Start After Effects, and then immediately hold down Ctrl+Alt+Shift (Windows) or Command+Option+Shift (macOS). In the Startup Repair Options dialog box, click Reset Preferences. Click New Project in the Home window.

After Effects opens to display an empty, untitled project.

4 Choose File > Save As > Save As.

5 In the Save As dialog box, navigate to the Lessons/Lesson11/Finished_Project folder. Name the project **Lesson11_Finished.aep**, and click Save.

Preparing a master composition

To create a template, you first need to create an After Effects composition upon which the template will be based. You'll create a master composition that contains the background image assets and an animated title and subtitle.

Creating the composition

First, import an asset, and create the composition.

1 Double-click an empty area of the Project panel to open the Import File dialog box.

2 Navigate to the Lessons/Lesson11/Assets folder on your hard disk, and then select the Embrace.psd file. Click Import or Open, and click OK in the Embrace.psd dialog box.

3 Click the New Composition button in the Composition panel.

4 In the Composition Settings dialog box, do the following, and then click OK:

• Name the composition **Title sequence**.

• Choose HD • 1920x1080 • 25fps from the Preset menu.

• Enter **10:00** for the Duration.

• Select black for the Background Color.

5 Drag the Embrace.psd file into the Timeline panel.

Displaying a background file will make it easier to position your text.

Adding animated text

The project includes a series title that appears at the top of the screen and moves down as it grows larger, and an episode title that appears letter by letter and then later explodes off the screen. You'll create both layers and animate them.

1 Select the Horizontal Type tool (T) in the Tools panel, and click an insertion point in the Composition panel.

After Effects adds a new layer to the Timeline panel and displays text attributes in the Properties panel.

2 Type **Shot in the Dark** in the Composition panel.

▶ **Tip:** For more information about installing fonts, see "Installing a font using Adobe Fonts" in Lesson 3.

3 In the Properties panel, click next to the font name to open the font menu. If you do not already have Calder Dark Grit Shadow and Calder Dark fonts on your system, click Add Adobe Fonts, and then activate the fonts using Adobe Fonts. Or choose a different font in the following step.

4 Select the text in the Composition panel, and then select the following settings in the Properties panel:

- Font Family: Calder
- Font Style: Dark Grit Shadow
- Fill Color: White
- Stroke: None
- Font Size: **140** px
- Tracking: **10**

5 Select the Selection tool (▶), and then position the title in the center of the top half of the scene in the Composition panel.

6 Go to 2:00. With the Shot in the Dark layer selected, click the stopwatch icons next to the Position and Scale properties in the Properties panel to create initial keyframes.

7 Press the Home key to go to the beginning of the time ruler. Change the Scale to **50**%. With the Selection tool, drag the title so that it is centered at the top of the Composition panel. After Effects creates keyframes for the Scale and Position properties.

8 Deselect all layers, and go to 2:10. Then select the Horizontal Type tool in the Tools panel again, and type **Episode 3: A Light in the Distance** in the Composition panel.

● **Note:** If you didn't activate Calder Dark from Adobe Fonts in step 3, activate it now, or choose a different font in step 9.

9 Select the text in the Composition panel, and then make the following changes to settings in the Properties panel (click More to see Horizontal Scale):

- Font Family: Calder

- Font Style: Dark

- Font Size: **120** px

- Horizontal Scale: **50**%

10 Go to 9:00. In the Effects & Presets panel, type **explosion** in the search bar. Then select the Explosion 2 animation preset, and drag it onto the Episode 3 layer in the Timeline panel.

11 Go back to 2:10. In the Effects & Presets panel, type **typewriter** in the search bar. Then select the Typewriter animation preset, and drag it onto the Episode 3 layer in the Timeline panel.

12 Go to 9:00 again. Select the Selection tool in the Tools panel, and then center the text in the bottom third of the screen.

13 Press the Home key or move the current-time indicator to the beginning of the time ruler. Then press the spacebar to preview the movie. Press the spacebar again to stop playback.

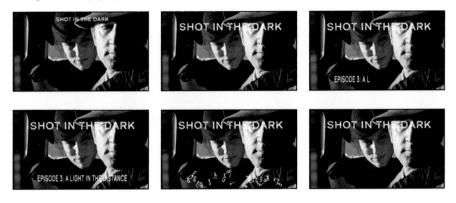

14 Hide the properties for both text layers, and then choose File > Save to save your work so far.

Animating a background image

You've animated the text, but the background image just sits there. Because this is a noir series, you'll add an unsettling effect. You'll use an adjustment layer to apply the effect only after the text has appeared on the screen.

1 Select the Embrace.psd layer in the Timeline panel.

2 Choose Layer > New > Adjustment Layer. Rename the layer **Background effect**.

After Effects creates a new adjustment layer immediately above the layer you selected. The adjustment layer will affect all layers below it.

3 Go to 5:00. Then press Alt+[(Windows) or Option+[(macOS) to trim the layer so that its in point is at 5 seconds.

4 In the Effects & Presets panel, type **bad TV** in the search bar. Then select the Bad TV 3 - weak animation preset, and drag it onto the Background effect layer in the Timeline panel.

5 Press the Home key or move the current-time indicator to the beginning of the time ruler. Then press the spacebar to preview the movie. Press the spacebar again to stop playback.

The series title slides down, the episode title appears, and then the image becomes distorted. Near the end of the time ruler, the episode title explodes off the screen. The image is challenging to see once the effect is applied. You can change a setting in the effect to make the image clearer.

6 In the Effect Controls panel, choose Smooth Noise from the Wave Type menu. Then preview the sequence again to see the difference.

7 Choose File > Save to save your work so far.

Setting up a template

You use the Essential Graphics panel to build custom controls and share them as Motion Graphics templates. Drag properties into the panel to add controls you want to make editable. In the panel, you can customize the names of controls, and you can group them to help others understand their function. You can open the Essential Graphics panel separately, or select the Essential Graphics workspace to open the panels you're most likely to use in creating a template, including the Effects & Presets panel.

1 Choose Window > Workspace > Essential Graphics.

2 In the Essential Graphics panel, choose Title sequence from the Primary menu. Your template will be based on the Title sequence composition.

3 Type **Shot in the Dark sequence** for the template name.

Adding properties to the Essential Graphics panel

You can add the controls for most effects, transform properties, and text properties to Motion Graphics templates. You'll give your colleagues options to replace the episode title and adjust it, adjust the settings of the Bad TV 3- weak effect, and replace the background image.

Making the text editable

The episode title for this title sequence will change for each episode, so the editor needs to be able to edit the text. For every text layer, there is a source text property that you can add to the Essential Graphics panel.

1 In the Timeline panel, expand the Text properties for the Episode 3 layer.

2 Drag the Source Text property into the Essential Graphics panel.

Note: You can add dropdown menus to motion graphics templates for some properties. Dropdown boxes require some scripting. See After Effects Help for more information.

3 Click the Episode 3 label on the left in the Essential Graphics panel, select the text, and then type **Episode name**.

4 Click Edit Properties next to the Episode name property, select Enable Font Size Adjustment, and click OK.

A text size slider appears beneath the Episode title property in the Essential Graphics panel.

5 In the Timeline panel, select the Episode 3 layer, and press P to display the Position property. Then, drag the Position property into the Essential Graphics panel.

6 Click the Episode 3 property label on the left, select the text, and type **Position**.

The episode title text, font size, and position will be editable to Motion Graphics template users; other attributes are protected from editing.

Adding effects properties

Many effects properties can be included in Motion Graphics templates. You can see which properties in a composition are compatible with the Essential Graphics panel by clicking Solo Supported Properties. You'll add properties to change the appearance of the effect, which may need to be lighter or darker depending on the background image selected.

1 In the Essential Graphics panel, click Solo Supported Properties to display only the properties you can add in the Timeline panel.

2 In the Timeline panel, hide the properties for the Shot in the Dark and Episode 3 layers, because you don't need to add any more text properties to the template.

3 Under the Color Balance properties for the Background effect layer, drag Lightness into the Essential Graphics panel. Then, drag Saturation into the Essential Graphics panel.

4 Under the Noise properties for the Background effect layer, drag Amount of Noise into the Essential Graphics panel.

5 Go to 6:00 so you can see the effect. Then, drag the sliders in the Essential Graphics panel to see how the appearance of the effect changes. Press Ctrl+Z or Command+Z to undo any changes you made.

Grouping properties

It's hard to tell what the properties currently in the Essential Graphics panel affect. You could change each of their names to make their effect clear, but it's easier to group them. You'll create groups for properties related to the episode title and those related to the background effect.

1 Choose Add Group from the menu at the bottom of the Essential Graphics panel. (By default, it says Add Formatting.)

2 Name the group **Episode title**, and then drag the Episode name and Position properties into the Episode title group. The Size slider travels with the Episode name property.

3 Deselect all properties, choose Add Group from the menu again, and then name the new group **Background effect**.

4 Drag the Color Balance (HLS) Saturation, Color Balance (HLS) Lightness, and Noise Amount of Noise properties into the Background effect group.

5 Hide the properties for all layers in the Timeline panel, and then choose File > Save to save your work so far.

Enabling image replacement

For this template, you want editors to be able to replace the background image with one that is appropriate for the episode. You can easily add a placeholder image to a motion graphics template that can be replaced in Premiere Pro.

1 Drag the Embrace.psd layer from the Timeline panel to the Essential Graphics panel.

2 Click Embrace.psd, select the text, and type **Episode image**.

3 Choose File > Save to save your work so far.

Protecting the timing of a section

The Responsive Design features in After Effects and Premiere Pro let you author adaptive motion graphics. The Responsive Design – Time feature, specifically, preserves the duration of time in a particular region of a composition in a Motion Graphics template while enabling time stretching in unprotected regions. You can preserve the timing of specific areas in compositions you export as Motion Graphics templates or in nested compositions within After Effects.

You'll protect the duration of the episode title's transition. That way, an editor in Premiere Pro will be able to shift the timing of other areas, such as shortening the time before the text explodes, but speeding up or slowing down time elsewhere won't affect the protected area.

1 In the Timeline panel, drag the Work Area Start marker to 2:00.

2 Drag the Work Area End marker to 5:00.

You've reduced the work area to the area that you want to protect from time-stretching.

3 Choose Composition > Responsive Design – Time > Create Protected Region From Work Area.

The protected area is shaded in the Timeline panel.

4 Choose File > Save.

Exporting the template

▶ **Tip:** If you don't have the original project file available, you can open a .mogrt file as a project file in After Effects. When you select the .mogrt file in the Open Project dialog box, you'll be prompted to select a folder for the extracted files. After Effects extracts the components and re-creates the project file.

You've added properties to the Essential Graphics panel, renamed them to make sense to an editor in Adobe Premiere Pro, and tested their effects. Now you're ready to export the template so that your colleagues can use it. You can share it through a Creative Cloud library or save it to a local drive as a Motion Graphics template (.mogrt) file to distribute yourself. The template includes all the source images, videos, and properties.

1 Click Export Motion Graphics Template in the Essential Graphics panel.

2 In the Export As Motion Graphics Template dialog box, make sure Local
 Templates Folder is selected, and click OK.

By default, Premiere Pro looks for Motion Graphics templates in the Motion
Graphics Templates folder on your local computer. However, you can choose
to save the template to a different folder on your computer or to a Creative
Cloud library, which you can access from other devices.

3 Choose File > Save, and then close the project.

Creating essential properties

The Essential Graphics panel lets you create Motion Graphics templates. However, you can also use it to create essential properties, which give you access to specific properties within nested compositions. Using essential properties, you can retain quick access to properties you need to edit frequently without having to open the nested composition and find the properties for a specific layer.

To specify essential properties, open the nested composition. In the Essential Graphics panel, choose the nested composition from the Primary menu. Then drag properties from layers in the composition to the Essential Graphics panel. You can rename them and group them just as you do when creating a template.

To use the essential properties, just select the nested composition in the Timeline panel, and then make changes to the Essential Properties section of the Properties panel.

Extra credit

Using a Motion Graphics template in Adobe Premiere Pro

You can use the template to edit the title sequence in Premiere Pro.

1 Open Premiere Pro. Click New Project in the Home window.

2 Name the project **Shot in the Dark opening**, and save it in the Lessons/Lesson11/Finished_ Project folder. Click OK or Create.

3 Choose Window > Workspaces > Captions And Graphics to open the Essential Graphics panel and other panels you're likely to use with it.

4 Choose File > New > Sequence, select the HDV > HDV 1080p25 preset, and click OK.

5 Make sure Local Templates Folder is selected in the Essential Graphics panel, and scroll to the template you created. Premiere Pro includes several standard templates in the Local Templates folder.

(continued on next page)

Extra credit (continued)

6 Drag your template from the Essential Graphics panel onto the new sequence in the Timeline panel. If prompted, click Change Sequence Settings to match the clip.

As the template loads, Premiere Pro displays a media offline message.

7 When the template has loaded, press the spacebar to preview the clip, and then scroll through the time ruler until you can see the episode title text and the effect.

8 Double-click an empty area in the Project panel. Then, navigate to the Lessons/Lesson 11/Assets folder, Shift-select all four PSD files, and click Open or Import. Click OK in the dialog box that appears for each file.

9 Click the Edit tab in the Essential Graphics panel. Double-click the Program Monitor panel if you don't see the template controls in the Essential Graphics panel, and then make changes to the episode title and effect settings in the Essential Graphics panel.

10 Drag an image from the Project panel onto the Episode image thumbnail in the Essential Graphics panel. Premiere Pro changes the background image in the Program panel and in the thumbnail.

11 Press the spacebar to preview the movie again.

12 In the Timeline panel, drag the layer to extend it, and then preview again. The title animation at the beginning is extended, as is the timing of the effect on the image. But the episode title animation timing is preserved.

13 Make any other changes you like, save the file, and close Premiere Pro.

Review questions

1 Why would you save a Motion Graphics template from After Effects?

2 How do you add controls to the Essential Graphics panel?

3 How can you organize controls in the Essential Graphics panel?

4 How can you share a Motion Graphics template?

Review answers

1 Saving a Motion Graphics template lets you give your colleagues the ability to edit specific attributes of a composition without sacrificing stylistic control.

2 To add a control to the Essential Graphics panel, drag a property from the Timeline panel.

3 To organize controls, group them. Choose Add Group from the menu at the bottom of the Essential Graphics panel, name the group, and drag controls into it. You can also add comments to help users understand your intention.

4 You can share a Motion Graphics template by exporting it to a shared Creative Cloud library, the local templates folder on the same computer, or a .mogrt file that you distribute to your colleagues.

12 USING 3D FEATURES

Lesson overview

In this lesson, you'll learn how to do the following:

- Create a 3D environment in After Effects.

- Import 3D objects.

- Rotate and position layers along x, y, and z axes.

- Use the 3D Transform Gizmo.

- Look at a 3D scene from multiple views.

- View a 3D ground plane.

- Animate a camera layer.

- Add lights to create shadows and depth.

- Extrude 3D text and shapes in After Effects.

- Use Cinema 4D with After Effects.

 This lesson will take about an hour to complete. If you haven't already done so, download the project files for this lesson from peachpit.com/ AfterEffectsCIB2024, following the instructions in the Getting Started section under "Accessing the lesson files and Web Edition."

PROJECT: AD FOR A FICTITIOUS BEVERAGE COMPANY

By clicking a single switch in the Timeline panel in After Effects, you can turn a 2D layer into a 3D layer, opening up a whole new world of creative possibilities. Maxon Cinema 4D Lite, included with After Effects, gives you even greater flexibility.

Getting started

Adobe After Effects can work with layers in two dimensions (x, y) or in three dimensions (x, y, z). So far in this book, you've worked primarily in two dimensions. When you specify a layer as three-dimensional (3D), After Effects adds the z axis, which lets you move the object forward and backward in space. By combining this depth with a variety of lights and camera angles, you can create animated 3D projects that take advantage of the full range of natural motion, lighting and shadows, perspective, and focusing effects. In this lesson, you'll explore how to import, create, and animate 3D layers as you create a simple ad for a fictional beverage company.

First, you'll preview the final movie and set up the project.

1 Make sure the following files are in the Lessons/Lesson12 folder on your hard disk, or download them from peachpit.com now:

- In the Assets folder: Bottle.glb, Trees.jpg, and Wineglass.glb

- In the Sample_Movie folder: Lesson12.mp4

2 Open and play the Lesson12.mp4 sample movie in Windows Movies & TV or QuickTime Player to see what you will create in this lesson. When you're done, close Windows Movies & TV or QuickTime Player. You may delete the sample movie from your hard disk if you have limited storage space.

When you begin this lesson, restore the default application settings for After Effects. See "Restoring default preferences" on page 3.

3 Start After Effects, and then immediately hold down Ctrl+Alt+Shift (Windows) or Command+Option+Shift (macOS). In the Startup Repair Options dialog box, click Reset Preferences. Click New Project in the Home window.

4 Choose File > Save As > Save As.

5 In the Save Project As dialog box, navigate to the Lessons/Lesson12/Finished_Project folder. Name the project **Lesson12_Finished.aep**, and click Save.

6 Click New Composition in the Composition panel.

7 In the Composition Settings dialog box, do the following and then click OK:

- Name the composition **Cider Ad**.

- Choose HD 1920x1080 29.97fps from the Preset menu.

- Type **5:00** for the Duration.

- Select a pale blue color (we used R=194, G=200, B=236).

Creating a 3D shape in After Effects

You can create a 3D object from a standard shape layer in After Effects. All you need to do is select the 3D layer switch to make the transformation.

You'll create a platform for the bottle and wineglasses to sit on.

1 Select the Rectangle tool in the Tools panel.

2 Draw a rectangle approximately 410 x 78 pixels. You can drag the rectangle to the right size, or draw an initial rectangle, and then enter the dimensions in the Shape Properties section of the Properties panel. (Click the Link icon to unlink the height and width.)

3 In the Properties panel, change the Roundness to **38** to create rounded corners.

4 Change the Fill Color to black, and the Stroke color to None.

Now you'll make the shape layer 3D and extrude the layer to create depth.

5 In the Timeline panel, change the layer's name to **Platform**.

6 Select the 3D Layer switch (⬡) for the Platform layer in the Timeline panel.

The Platform layer becomes a 3D layer. When a 3D layer is selected, the 3D Transform Gizmo appears over the layer's anchor point in the Composition panel. The red controls manipulate the x axis, the green controls manipulate the y axis, and the blue controls manipulate the z axis. The letter x, y, or z appears when you position the Selection tool over the corresponding controls. When you move or rotate the layer while the pointer is over a particular axis, the layer's movement is restricted to that axis.

Three 3D Rotation properties, as well as an Orientation property, appear in the Transform property group for the layer, and properties that previously supported only two dimensions now display a third value for the z axis.

● **Note:** The Advanced 3D renderer won't be available if your system doesn't have enough dedicated video memory (VRAM). You can use the Cinema 4D renderer to extrude text and shapes, but won't be able to import 3D models.

7 In the Timeline panel, click Change Renderer next to Geometry Options.

8 In the Composition Settings dialog box, choose Advanced 3D from the Renderer menu, and click OK.

Geometry Options settings become available in the Timeline panel.

9 Expand Geometry Options, and then change the Extrusion Depth to **250.**

The platform is extruded, though only some of the extrusion is visible from this angle. The platform isn't tall enough. You'll scale it.

10 In the Layer Transform section of the Properties panel, click the link icon for the Scale property to unlink the values. Then type **475%** for the Y Scale value.

11 Select the Selection tool (▶), and then drag the platform to the lower left corner. Your Position values will differ from ours, depending on where you drew the original rectangle.

12 Hide the properties for all layers in the Timeline panel, and save your work so far.

Viewing the 3D ground plane

A ground plane represents the ground relative to the 3D objects. Viewing the ground plane can make it easier to align objects and determine their relationships to each other. In After Effects, you can view the 3D ground plane when the Real-time Draft 3D preview mode is enabled. Real-time Draft 3D preview mode speeds up real-time playback in heavy scenes; it's intended only for draft quality and not final output.

1 Click the Draft 3D button at the bottom of the Composition panel to enable Draft 3D mode.

2 Click the 3D Ground Plane button if it isn't already enabled.

How much of the ground plane is visible depends on the camera angle. Currently, the camera is facing the front of the scene, so the ground plane isn't visible.

When After Effects is in Draft 3D mode, if Extended View is selected, items on the pasteboard are visible. Keep the composition borders in mind so that you know what will be visible to viewers.

Using the 3D Transform Gizmo

The 3D Transform Gizmo lets you manipulate the position, scale, and rotation of a 3D layer on the x, y, and z axes. The x axis is red, the y axis is green, and the z axis is blue.

To change the layer's position, move the arrow for the appropriate axis. For example, to move a layer along the x axis, drag the red arrow.

To change the layer's scale, move the square for the appropriate axis. For example, to change the scale on the y axis, drag the green square. Press Shift while scaling to scale uniformly in all directions.

To change the layer's rotation, drag the cursor along the arc for the appropriate axis. For example, to change the rotation on the z axis, drag along the blue arc. By default, rotation moves in increments of one degree.

Importing 3D objects

You can import 3D objects in GLB, GLTF, or OBJ file formats into After Effects projects. Materials applied to those objects in other applications are included with the imported objects, though you cannot edit the materials in After Effects. However, you can modify the position, size, and orientation of 3D objects in After Effects.

1 Choose File > Import > File.

2 Navigate to the Lessons/Lesson12/Assets folder, and select the Bottle.glb file. Click Import or Open.

A folder containing the Bottle.glb file appears in the Project panel.

3 Drag the Bottle.glb file into the Timeline panel.

The Model Settings dialog box opens. When Preview is selected in this dialog box, you can see how changes affect the object you're adding to the composition.

4 In the Model Settings dialog box, change the Object Scale to **165%**, and click OK.

● **Note:** When you add an imported 3D object to a composition, After Effects automatically changes the renderer to Advanced 3D if it isn't already selected.

5 Make sure the Bottle layer is selected in the Timeline panel.

6 Using the Selection tool (▶) and the 3D Transform Gizmo, drag the bottle so that it is resting atop the platform.

7 Double-click an empty area in the Project panel to open the Import File dialog box again. Select the Wineglass.glb file in the Assets folder, and click Import or Open.

8 Drag the Wineglass.glb file into the Timeline panel.

9 In the Model Settings dialog box, change the Object Scale to **230%**, and click OK.

10 In the Timeline panel, select the Wineglass layer, and choose Edit > Duplicate.

11 Move the wineglasses next to the bottle on top of the platform. Your values will probably differ from ours.

12 Hide the properties for all layers, and save your work.

About importing 3D objects

You can import 3D models in OBJ, GLB, or GLTF format into After Effects. Several applications can create these formats, including Adobe Substance 3D and Adobe Illustrator.

When you import a 3D model into a project, After Effects creates a new folder with the model's name. If the file has dependent files (such as texture image files), they are included in the folder with the model file itself.

When you prepare a model in another application, specify PNG or JPEG formats for included texture files for the best results in After Effects.

If you're working with imported 3D models, it's a good idea to work in Draft 3D mode to access the ground plane and to see accurate previews quickly.

Creating 3D text

The company name should appear on the platform. You'll create 3D text to make it appear that the name is mounted to the front of the platform.

1 Select the Horizontal Type tool (T) in the Tools panel.

2 Click an insertion point in the Composition panel, and type **Birch's Sparkling Cider**, pressing Enter or Return after each word to create three lines.

3 Select the text you just typed in the Composition panel. Then, in the Text section of the Properties panel, select the following settings:

 • Font: Noteworthy Light or another script font

 • Stroke: None

 • Font Size: **72** px

 • Fill Color: White

● **Note:** If a script font is not available, install one using Adobe Fonts. Choose File > Add Fonts From Adobe, select Script from the Classification filters, and activate the font. You may need to close the Properties panel and reopen it to see a newly activated font.

4 In the Paragraph section of the Properties panel, select Center Text.

5 In the Timeline panel, select the 3D Layer switch (⬡) for the Birch's Sparkling Cider layer.

Geometry Options and Material Options are now available for the layer, just as they are for the 3D shape layer you created earlier. Likewise, three Rotation properties and an Orientation property appear in the Transform properties for the layer.

Tip: When a 2D layer is between 3D layers in the Timeline panel, you create separate 3D bins. Layers in one 3D bin render and interact separately from layers in another 3D bin. Bins are indicated by dotted lines around the included layers' 3D switches in the Timeline panel.

6 In the Timeline panel, expand the Geometry Options for the Birch's Sparkling Cider layer.

7 Change the Extrusion Depth to **27**.

8 Choose Convex from the Bevel Style menu, and make sure the Bevel Depth is 2.0.

The text is three-dimensional, ready to position.

9 Move the Birch's Sparkling Cider layer to the top of the layer stack if it isn't already there.

10 Select the Selection tool. Then, use the 3D Transform Gizmo to move the text to the front of the platform.

11 Hide properties for all layers, and save your work.

Converting 2D objects to 3D

You can convert almost any 2D layer to 3D simply by selecting the 3D Layer switch. The resulting 3D layer can be manipulated on three axes; it can cast and receive shadows; and it can have other material options settings applied to it. However, only shape and text layers can be extruded. When you convert most 2D layers to 3D, they remain two-dimensional objects manipulated in 3D space. For example, a video clip can be rotated, but its edge will be flat, as if it were a postcard.

Using 3D views

Sometimes the appearance of 3D layers can be deceptive. For example, a layer might appear to be scaling smaller along its x and y axes when it's actually moving along the z axis. You can't always tell from the default view in the Composition panel. The Select View Layout pop-up menu at the bottom of the Composition panel lets you divide the panel into different views of a single frame, so you can see your work from multiple angles. You specify different views using the 3D View pop-up menu. You'll view the scene from different angles so you can verify that everything is positioned correctly.

1 At the bottom of the Composition panel, click the Select View Layout pop-up menu, and choose 4 Views, if your screen is large enough to display them. Otherwise, choose 2 Views. (You may need to extend the width of the Composition panel to see the menu.)

With 4 Views selected, you can view the scene from four different perspectives. The Top view displays the scene along the y axis. There, you can see the z axis, and it's clear that the layer has depth, but it just looks like a rectangle from here. The Active Camera view displays what the camera sees, which is currently the same as the Front view. The Right view shows the scene as if you were observing it along the x axis. Like the Top view, the depth appears rectangular.

2 If you chose 4 Views, click the Front view to make it active; if you chose 2 Views, click the view on the left to make it active. (Blue corner tabs appear around the active view.) Then, from the 3D View pop-up menu, choose Custom View 1 to see the scene from a different perspective.

Viewing your 3D scene from different perspectives can help you align elements more accurately, view how layers are interacting with each other, and understand how objects, lights, and cameras are positioned in 3D space. You may see, for example, that the bottle and wineglasses overlap each other. Or one or more of them may hang off the edge of the platform.

Using the camera tools

● **Note:** Because the camera tools change the perspective, they work only in custom views, not in fixed views, such as Front or Top.

When you create a 3D layer, the camera tools become available in the Tools panel. You can use the camera tools to change the perspective on the scene and to manipulate existing cameras.

- The Orbit tools (◔) orbit around the cursor, scene, or camera point of interest.
- The Pan tools (✛) pan the camera under the cursor or in the center of the screen.
- The Dolly controls (↓) move the camera toward the cursor, to the cursor, or to the point of interest.

You'll experiment with each tool to see how it changes your perspective.

1 Select the Orbit Around Cursor tool (◔) in the Tools panel.

2 Drag the Orbit Around Cursor tool across the Custom View 1 window to change the angle from which you're viewing the scene.

3 Select the Pan Under Cursor tool (✛), and drag it across the Custom View 1 window to see its effect.

4 Select the Dolly Towards Cursor tool (⬇), and drag it around the Custom View 1 window to see its effect.

As you use the camera tools, the view in each of the other windows is unchanged. The layers themselves haven't moved at all; only your perspective of them has changed. It's as if you were able to fly around the stage and view the scene from different angles.

5 Use the camera tools to verify the position of the objects on the platform.

6 Select 1 View from the Select View Layout menu.

7 Use the Orbit Around Cursor tool to see the scene from all angles.

8 If you notice any issues with any of the objects, make adjustments while you're viewing the angle that revealed the issue. Use the Selection tool and the 3D Transform Gizmo to adjust the bottle, wineglasses, or text. The bottle and glasses should be on the platform, not descending into it or hovering above it. The text should be in front of the platform, with its extrusion apparent.

9 After you've made your changes, choose View > Reset Default Camera to return the camera to the original view.

Adding a background

The light blue background isn't very interesting. You'll add a stylized image of birch trees to complement the company name.

1 Double-click an empty area in the Project panel to open the Import File dialog box again. Select the Trees.jpg file in the Assets folder, and click Import or Open.

2 Drag the Trees.jpg file to the Timeline panel, placing it at the bottom of the layer stack.

Lighting a scene

In After Effects, a *light* is a type of layer that shines light on other layers. You can choose from among five different types of lights—Parallel, Spot, Point, Ambient, and Environment—and modify them with various settings. Lights, by default, are directed toward a point of interest, which is the focus area of the scene. After Effects creates a default light when you create a 3D layer, but you have more control over lights you create yourself. Lights affect only 3D objects so won't have any effect on the background.

You'll add lighting and adjust the material properties to make the scene more sophisticated.

Adding a spotlight

First, you'll add a spotlight to add some depth to the scene.

1 Go to 4:29, the last frame in the time ruler.

2 Deselect all layers, and then choose Layer > New > Light.

3 In the Light Settings dialog box, do the following:

- Name the layer **Spotlight**.

- Choose Spot from the Light Type menu.

- Set Color to a white tint (we used R=248, G=249, B=242).

- Make sure Intensity is set to **100%** and Cone Angle to **90** degrees.

- Make sure Cone Feather is set to **50%**.

- Click OK to create the light layer.

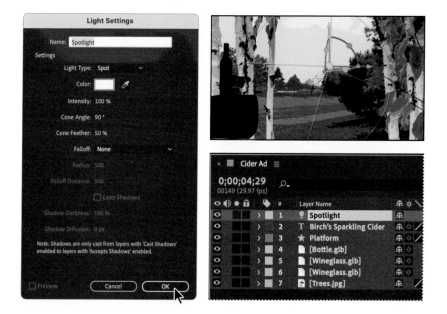

In the Timeline panel, the light layer is represented by a light bulb icon (💡).

In the Composition panel, a wireframe illustrates the light's position, with a cross-hairs icon (⊕) representing the point of interest.

4 Make sure the Spotlight layer is selected in the Timeline panel.

5 In the Properties panel, do the following:

 • Change the Point of Interest to **52, 677, 347**.

 • Change the Position to **665, 310, -510**.

 • Change the Orientation to **5, 359, 90**.

Creating an ambient light

The spotlight adds some drama, but it isn't enough on its own. When you created a light, the default light was disabled. You'll add an ambient light to light the entire scene.

1 Choose Layer > New > Light.

2 In the Light Settings dialog box, do the following:

 • Name the layer **Fill Light**.

 • Choose Ambient from the Light Type menu.

 • Set the Color to a light blue (we used R=179, G=221, B=244).

 • Set Intensity to **65%**.

 • Click OK to create the light layer.

3 Choose File > Save.

Casting shadows and setting material properties

The scene is looking better, but you can make it more obviously three-dimensional still. You'll change the Material Options properties to determine how the 3D layers interact with the lights and shadows.

1 Select the Birch's Sparkling Cider layer, and expand the Material Options settings.

The Material Options property group defines the surface properties of a 3D layer. You can also set shadow and light transmission values.

2 Make sure On is selected for Casts Shadows.

The text layer casts shadows based on the lights in the scene.

3 Change the Specular Intensity to **35%** so that the text reflects less of the light in the scene.

4 Increase the Specular Shininess to **15%** to give the surface a slightly more metallic shine.

5 Decrease the Ambient value to **25%** to reduce the ambient layer's effect on the text.

6 Hide the properties for all layers. Deselect all layers.

7 Choose File > Save to save your work.

Using HDR images as lights

You can create interesting lighting effects using an HDR or HDRI format image layer as an environment map for an environment light. Environment maps surround 3D layers to create realistic lighting, reflections, and shadows.

To add an HDR-based environment light, do the following:

1 Choose Layer > New > Light, and set the Light Type to Environment.

2 Import an HDR (Radiance HDR) file into your project, and add it to the composition.

3 Expand the environment light's properties in the Timeline panel.

4 Set the light's Source property to the HDR layer.

When you choose an HDR layer as the light's source, the HDR layer itself will no longer be visible.

Environment maps must be single HDR frame layers, not sequences. Effects and animation applied to the environment map are ignored.

To learn more, see Adobe After Effects Help.

Adding a camera

You've seen that you can view a 3D scene from different perspectives. You can also view 3D layers from various angles and distances using layers called *cameras*. When you set a camera view for your composition, you look at the layers as though you were looking through that camera. You can view a composition through the active camera or through a named, custom camera. If you have not created a custom camera, then the active camera is the same as the default composition view.

If you've used the camera tools to create a custom view, you can create a camera from that view by choosing View > Create Camera From 3D View.

For this project, you'll create a custom camera.

1 Deselect all layers, and then choose Layer > New > Camera.

2 In the Camera Settings dialog box, choose 35mm from the Preset menu, and click OK.

The Camera 1 layer appears at the top of the layer stack in the Timeline panel (with a camera icon next to the layer name), and the Composition panel updates to reflect the new camera layer's perspective. The view should change slightly, because the 35mm preset shows a wider field of view than the default. If you didn't notice the scene change, toggle the visibility of the Camera 1 layer to see it, and then make sure it's visible.

▶ **Tip:** After Effects displays the wireframes for cameras by default. To see wireframes only when cameras (or spotlights) are selected, or not at all, choose View Options from the Composition panel menu, and then choose the options you want from the Camera Wireframes and Spotlight Wireframes menus. Then click OK.

3 Choose 2 Views from the Select View Layout pop-up menu at the bottom of the Composition panel.

4 Change the view on the left to Right, and set the view on the right to Active Camera (Camera 1).

Like light layers, camera layers have a *point of interest* that can be used to determine what the camera looks at. By default, the camera's point of interest is the center of the composition.

You've set the objects' position and the camera for the final view. In the next exercise, you'll animate the text, the camera, and the lights to complete the video. It's much easier to animate a camera than to coordinate the movements of multiple objects in a 3D scene.

Animating objects in a 3D scene

You've put together several 3D components—imported objects, a 3D shape, 3D text, lights, and a camera—but everything has been static so far. Now you'll create animations to move from the initial image with centered text to the final scene.

1 Go to 4:29, the last frame in the composition, if you're not already there.

First, you'll animate the opacity of the platform, bottle, and glasses.

2 In the Timeline panel, Shift-select the Platform, Bottle, and both Wineglass layers.

3 In the Properties panel, click the stopwatch icon (🕚) for the Opacity property to create keyframes for each selected layer.

Wait, the top image is the timeline panel. Let me place properly.

							#	Layer Name			
0;00;04;29											
00149 (29.97 fps)											

Cider Ad ≡

0;00;04;29
00149 (29.97 fps)

●	◐ ● 🔒		#	Layer Name	
●		> ■	1	🎥 Camera 1	
●		> ■	2	💡 Fill Light	
●		> ■	3	💡 Spotlight	
●		> ■	4	T Birch's Sparkling Cider	
●		∨ ■	5	★ Platform	
				Ō 📈 Opacity	100%
●		∨ ■	6	📄 [Bottle.glb]	
				Ō 📈 Opacity	100%
●		∨ ■	7	📄 [Wineglass.glb]	
				Ō 📈 Opacity	100%
●		∨ ■	8	📄 [Wineglass.glb]	
				Ō 📈 Opacity	100%
●		> ■	9	📄 [Trees.jpg]	

Properties: 4 layers selected ≡

Layer Transform Reset

Ō	Anchor P...	0	0	0	
Ō	Position	–	–	–	
Ō	Scale	–	–%	–%	–%
Ō	Orientation	–°	–°	–°	
Ō	X Rotation	0x+0°			
Ō	Y Rotation	0x+0°			
Ō	Z Rotation	0x+0°			
	Opacity	100%			

4 Go to 3:00. Then click the Add Or Remove Keyframe At Current Time icon for the Opacity property to add another keyframe for each layer, at full opacity.

5 Press the Home key or move the current-time indicator to the beginning of the composition.

6 With all four layers still selected, change the Opacity to **0%**.

7 Select the Trees layer in the Timeline panel, and change its Opacity to **50%**. Then click the stopwatch icon for the Opacity property to create an initial keyframe at the beginning of the scene.

8 Go to the end of the time ruler again (4:29), and change the Opacity to **100%**.

9 Select the Birch's Sparkling Cider layer. Click the stopwatch icon next to the Scale and Position properties in the Properties panel to create keyframes for each property.

10 Go to 3:00, and click the Add Or Remove Keyframe At Current Time icon for the Scale and Position properties to create additional keyframes at the current values.

11 Go to 0:15. Drag the Birch's Sparkling Cider layer to the center of the screen, facing forward. Change its Scale to **350%**.

Cider Ad ≡

0;00;00;15
00015 (29.97 fps)

●	◐ ● 🔒		#	Layer Name	
●		> ■	1	🎥 Camera 1	
●		> ■	2	💡 Fill Light	
●		> ■	3	💡 Spotlight	
●		∨ ■	4	T Birch's Sparkling Cider	
				Ō 📈 Position	976.0,352.0,0.0
				Ō 📈 Scale	350.0,350.0,350.0%

Properties: Birch's Sparkling Cider ≡

Layer Transform Reset

Ō	Anchor P...	0	0	0
	Position	976	352	0
	Scale	350%	350%	350%

12 In the Timeline panel, expand the Material Options for the Birch's Sparkling Cider layer. Go to 4:29, and click the stopwatch icon next to the Ambient property to create a keyframe with a value of **25%**.

13 Press the Home key or move the current-time indicator to the beginning of the composition. Change the Ambient value to **50%**.

14 Hide the properties for all layers, and save your work.

15 Press the spacebar to preview the animation. Press the spacebar again to stop the preview.

Animating a camera

You're ready to animate the camera. You'll use the camera tools to position the camera at different points in the composition.

1 Press the Home key or move the current-time indicator to the beginning of the composition. Select the Camera 1 layer. In the Properties panel, click the stopwatch icon for both the Position and Point of Interest properties to set keyframes at their current values.

2 Go to 0:20. Select the Orbit Around Scene tool, hidden beneath the Orbit Around Cursor tool.

3 Use the Orbit Around Scene tool to move the camera so that the platform appears to be facing to the right.

4 Go to 4:20. Use the Orbit, Pan, and Dolly tools to position the camera so that the platform and other objects appear larger, centered, and facing to the left, as in the following image.

Now the camera swoops around to focus on the platform, bottle, and glasses.

5 Hide the properties for all layers.

6 Press the spacebar to preview the entire scene. Press the spacebar again when you've finished.

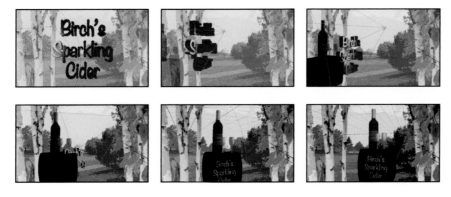

7 If you want to change the way the camera angles shift over time, make adjustments to the existing keyframes or create new ones.

8 Save your work.

3D channel effects

Several 3D channel effects (3D Channel Extract, Depth Matte, Depth of Field, and Fog 3D) can extract the image depth data (called z-depth) from a nested 3D composition to apply special effects. First, precompose 3D layers if they're not already nested. Then apply the effect to the nested composition, and make adjustments in the Effect Controls panel. You can learn more about depth passes and 3D channel effects in After Effects Help.

Working with Cinema 4D Lite

After Effects includes a version of Maxon Cinema 4D that lets motion graphics artists and animators insert 3D objects directly into an After Effects scene without pre-rendering passes and potentially complicated file exchanges. You can continue to edit 3D objects in Cinema 4D Lite after you've added them to your After Effects composition.

If Cinema 4D Lite isn't installed, open the Creative Cloud app, find After Effects in the list of installed apps, choose Add-ons from the More Actions menu, and then click Add next to Cinema 4D. To use Cinema 4D Lite, you must register with Maxon. You can use the Cinema 4D renderer in After Effects without registering.

● **Note:** In After Effects, the upper left corner of the composition is considered 0, 0. In many 3D applications, including Maxon Cinema 4D, the center of the world (often the screen) is the origin, or 0, 0, 0 point. Additionally, the Y distance increases as the cursor moves down the screen in After Effects.

When you add a Cinema 4D layer to a composition, After Effects opens Cinema 4D Lite so you can create your 3D scene in a new C4D file. Save the file in Cinema 4D, and it updates automatically in After Effects.

To add a layer, choose Layer > New > Maxon Cinema 4D File. After Effects adds a layer to the Timeline panel, and Cinema 4D opens with an empty scene, displaying only the 3D grid.

To learn more about using Cinema 4D Lite, see Cinema 4D Help.

Review questions

1 What happens to a layer when you select its 3D Layer switch?

2 Why is it important to look at multiple views of a composition that contains 3D layers?

3 What is a camera layer?

4 What is a 3D light in After Effects?

Review answers

1 When you select a layer's 3D Layer switch in the Timeline panel, After Effects adds a third axis, the z axis, to the layer. You can then move and rotate the layer in three dimensions. In addition, the layer takes on new properties that are unique to 3D layers, such as the Materials Options property group.

2 The appearance of 3D layers can be deceptive, depending on the view in the Composition panel. By enabling 3D views, you can see the true position of a layer relative to other layers in the composition.

3 You can view After Effects 3D layers from any number of angles and distances using layers called *cameras*. When you set a camera view for your composition, you look at the layers as though you were looking through that camera. You can animate a camera's position and angle.

4 In After Effects, a light is a type of layer that shines light on other layers. You can choose from among five different types of lights—Parallel, Spot, Point, Ambient, and Environment—and modify them with various settings.

13 WORKING WITH THE 3D CAMERA TRACKER

Lesson overview

In this lesson, you'll learn how to do the following:

- Track footage using the 3D Camera Tracker.

- Add camera and text elements to a tracked scene.

- Set a ground plane and origin.

- Create realistic shadows for new 3D elements.

- Lock elements to planes using solid objects.

- Remove rolling shutter distortions from DSLR footage.

 This lesson will take about an hour and a half to complete. If you haven't already done so, download the project files for this lesson from peachpit.com/AfterEffectsCIB2024, following the instructions in the Getting Started section under "Accessing the lesson files and Web Edition."

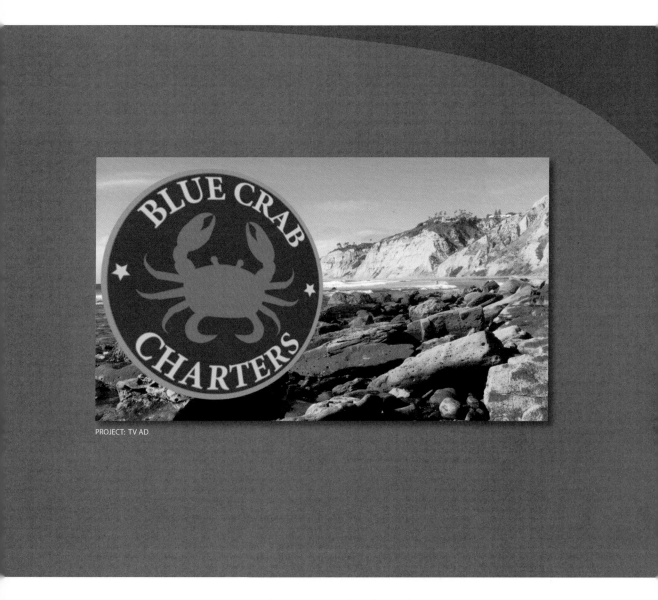

PROJECT: TV AD

The 3D Camera Tracker effect analyzes two-
dimensional footage to create a virtual 3D camera
that matches the original. You can use this data
to add 3D objects that merge realistically with
your scene.

About the 3D Camera Tracker effect

The 3D Camera Tracker effect automatically analyzes the motion present in existing 2D footage, extracts the position and lens type of the real camera that shot the scene, and creates a new 3D camera in After Effects to match it. The effect also overlays 3D track points onto the 2D footage, so you can easily attach new 3D layers onto the original footage.

These new 3D layers have the same movement and perspective changes as the original footage. The 3D Camera Tracker effect even helps create "shadow catchers," so your new 3D layers can appear to cast realistic shadows and reflections onto the existing footage.

The 3D Camera Tracker performs its analysis in the background. Therefore, you can work on other compositions while the footage is being analyzed.

Getting started

In this lesson, you'll create a short ad for a tourism company. You'll begin by importing the footage and tracking it with the 3D Camera Tracker effect. Then you'll add 3D text elements that track precisely with the scene. You'll add images using similar techniques. Finally, you'll use an effect to quickly add more character to the scene.

First, you'll preview the final movie and set up your project.

1 Make sure the following files are in the Lessons/Lesson13 folder on your hard disk, or download them from peachpit.com now:

 • In the Assets folder: BlueCrabLogo.psd, Quote1.psd, Quote2.psd, Quote3.psd, Shoreline.mov

 • In the Sample_Movie folder: Lesson13.mp4

2 Open and play the Lesson13.mp4 sample movie in Windows Movies & TV or QuickTime Player to see what you will create in this lesson. When you are done, close Windows Movies & TV or QuickTime Player. You may delete the sample movie from your hard disk if you have limited storage space.

When you begin this lesson, restore the default application settings for After Effects. See "Restoring default preferences" on page 3.

3 Start After Effects, and then immediately hold down Ctrl+Alt+Shift (Windows) or Command+Option+Shift (macOS). In the Startup Repair Options dialog box, click Reset Preferences. Click New Project in the Home window.

After Effects opens to display an empty, untitled project.

4 Choose File > Save As > Save As.

5 In the Save As dialog box, navigate to the Lessons/Lesson13/ Finished_Project folder.

6 Name the project **Lesson13_Finished.aep**, and then click Save.

Importing the footage

You'll import five assets for this lesson.

1 Choose File > Import > File.

2 Navigate to the Lessons/Lesson13/Assets folder. Shift-click to select the Quote1.psd, Quote2.psd, Quote3.psd, and Shoreline.mov files, and then click Import or Open.

3 Double-click an empty area in the Project panel to open the Import File dialog box again.

4 Select the BlueCrabLogo.psd file, and click Import or Open.

5 In the BlueCrabLogo.psd dialog box, select Merged Layers, and then click OK.

Creating the composition

Now, you will create a new composition based on the aspect ratio and duration of the Shoreline.mov file.

1 Drag the Shoreline.mov item onto the Create A New Composition button (🖾) at the bottom of the Project panel. After Effects creates a new composition named Shoreline and displays it in the Composition and Timeline panels.

2 Drag the current-time indicator across the time ruler to preview the shot.

The camera moves around a beach scene, with a close-up of some scurrying crabs before it zooms back out to a shot of the ocean and rocks. You'll add text, quotes for the crabs, and the company logo.

3 Choose File > Save to save the file.

Repairing rolling shutter distortions

Digital cameras with CMOS sensors—including video-capable DSLRs, popular for the creation of films, commercials, and television shows—typically have what is commonly known as a "rolling" shutter, which captures a frame of video one scan line at a time. Due to time lag between scan lines, not all parts of the image are recorded at exactly the same time, causing motion to ripple down the frame. If the camera or the subject is moving, the rolling shutter can cause distortions, such as leaning buildings and other skewed images.

The Rolling Shutter Repair effect attempts to correct this problem automatically. To use it, select the problem layer in the Timeline panel, and choose Effect > Distort > Rolling Shutter Repair.

Due to a rolling shutter distortion, the pillars of the building appear to be leaning.

After applying the effect, the building looks much more stable.

The default settings usually do the trick, but you may need to change the Scan Direction or the Method being used to analyze the footage.

If you plan to use the 3D Camera Tracker effect with footage on which you've used the Rolling Shutter Repair effect, precompose the footage first.

Tracking the footage

The 2D footage is in place. Now you'll have After Effects track it and interpolate where a 3D camera should be placed.

1 Press the Home key or move the current-time indicator to the beginning of the time ruler.

2 Right-click (Windows) or Control-click (macOS) the Shoreline.mov layer in the Timeline panel, and choose Track & Stabilize > Track Camera.

After Effects begins tracking the camera and displays messages as it analyzes the footage in the background. When the analysis is complete, many tracking points appear in the Composition panel. The size of a tracked point indicates its proximity to the virtual camera: Larger points are closer, and smaller points are further away.

► **Tip:** The default analysis is usually sufficient, but you can perform a more detailed analysis to better solve the camera position. The Detailed Analysis option is in the Advanced area of the Effect Controls panel.

3 When the analysis is complete, choose File > Save to save your work so far.

Creating a ground plane, a camera, and the initial text

You have a 3D scene, but it needs a 3D camera. You'll add a camera when you create the first text element.

● **Note:** You can also add a camera by clicking the Create Camera button in the Effect Controls panel.

1 Press the Home key or move the current-time indicator to the beginning of the time ruler.

2 In the Composition panel, hover the cursor over the water next to the large rocks until you see a flat target similar to the one in the image following step 3 on the next page. (If you don't see the track points and target, click the 3D Camera Tracker effect in the Effect Controls panel to make it active.) Your track points and targets may look different from ours.

► **Tip:** You can Shift-select track points to determine which ones are used to create a plane and target.

When you hover the cursor between three or more neighboring track points that can define a plane, a semitransparent triangle appears between the points. Additionally, a red target shows the orientation of the plane in 3D space.

3 Right-click (Windows) or Control-click (macOS) the plane, and choose Set Ground Plane And Origin.

The ground plane and origin provide a reference point, setting a point where the coordinates are (0, 0, 0). Though nothing appears to change in the Composition panel using the Active Camera View, the ground plane and origin make it easier to change the camera's rotation and position.

4 Right-click (Windows) or Control-click (macOS) the same plane, and choose Create Text And Camera.

After Effects displays a large text item lying flat in the Composition panel. It also adds two layers to the Timeline panel: Text and 3D Tracker Camera. The 3D switch is enabled for the Text layer, but the Shoreline.mov layer remains 2D. Because the text elements are the only ones that need to be positioned in 3D space, there is no reason to make the background footage layer a 3D layer.

5 Move the current-time indicator along the time ruler. The text remains in position, tracking with the camera. Return the current-time indicator to the beginning of the time ruler.

6 Double-click the Text layer in the Timeline panel to open the text attributes
 in the Properties panel.

7 Change the font to Impact Regular and the font size to **48** px. Select the check
 box next to Stroke, set the stroke width to **.5** px, and the stroke type to Stroke
 Over Fill. Make sure the fill color is white and the stroke color is black (the
 default colors), and that Tracking is set to **0**.

The text looks great, but you want it to stand on end. You'll change its location
in space, and then replace it with the advertisement text.

8 Select the Text layer in the Timeline panel to exit text-editing mode. Then,
 in the Properties panel, change the Orientation values so the text is upright.
 (We used 12, 30, 350 degrees, but yours will likely be different.)

● **Note:** If you
selected a different
target for your ground
plane, you will need
to use different values.
Instead of entering
values, you could use
the 3D Transformation
Gizmo to adjust the
individual axes in the
Composition panel.

Any new 3D layer you create uses the ground plane and origin to orient the layer
in the scene. When you change the Orientation values, the text changes its orienta-
tion in space.

9 Double-click the Text layer in the Timeline panel to make it active in the Composition panel.

When the text is editable, it appears to have a light red mask surrounding it.

10 With the text selected in the Composition panel, type **THE OTHER GUYS** to replace it. Then select the THE OTHER GUYS layer to exit text-editing mode.

So far, so good. But you want the text to be centered in the scene. You'll reposition the text.

11 Using the Selection tool, drag the text up the screen, so that it is over the water. Or, if your ground plane matches ours, you can type **−6270, −1740, 1188** for the Position property.

If the text stays in the same position, it won't be visible as the camera moves away. You'll animate it to remain visible a bit longer.

12 Click the stopwatch icon (⟳) to create an initial keyframe for the Position property.

13 Go to 2:03. Change the Position property to **−7115, 1800, −1150**, or use the Selection and Rotation tools to position it as it appears in the image below.

14 Manually scroll through the timeline to preview the text. Then close any open properties, and choose File > Save to save your work so far.

Creating additional text elements

You created the initial text for the advertisement. Now you need to perform the same tasks to create the rest of the ad. You'll use the same steps to create each label, but because the text appears in different places in the video and needs to shift in relationship to the scene, you'll need to use different position, orientation, and scaling values.

1 Go to 2:03.

2 In the Timeline panel, select the Shoreline.mov layer, and press E to reveal its effects. Then select the 3D Camera Tracker to make it active.

● **Note:** Make sure you select the 3D Camera Tracker effect in the Shoreline.mov layer, not the 3D Tracker Camera layer.

3 In the Effect Controls panel, change the Track Point Size value to 50% so you can see the track points more clearly.

4 Make sure the Selection tool is selected. Then, in the Composition panel, hover over an area so that the red target lies flat across the rocks, right-click or Control-click the target, and choose Create Text.

5 Select the Text layer in the Timeline panel and then rotate the text as shown. (Our Orientation values are 0, 45, 0.)

6 Double-click the Text layer to make it editable, and then type **ARE** in the Composition panel. Click the ARE layer to exit text-editing mode.

7 Click the stopwatch icon (⏱) for the Position property to create an initial keyframe.

8 Go to 2:29, and use the Selection tool to move the text so that its position is similar to the text in the image below. Your values probably differ from ours.

9 Go to 4:14. Use the Selection tool to drag the composition so that the bottom of the text is visible, as shown in the image below. (Use the Hand tool (✋) to move it so that you can see the text box outside the frame, if necessary.) Or, you can adjust the Position values. Your values will be different than ours.

10 Hide the properties for the layer. If you used the Hand tool to reposition the image, move it back now. Then select the Selection tool, and manually preview the text animation.

11 Go to 4:14, and activate the 3D Camera Tracker track points again by selecting the Shoreline.mov layer in the Timeline panel, and then selecting either 3D Camera Tracker under the Shoreline.mov layer or 3D Camera Tracker in the Effect Controls panel.

12 With the Selection tool (▶), select a target for a flat plane against the large rock on the right. Then right-click the target, and choose Create Text.

13 Select the Text layer in the Timeline panel. Rotate the text so it's upright and angled slightly, as shown below. (Our Orientation values are 0, 45, 10.) Change the Scale property to **2000%**.

14 Double-click the Text layer, and then type **SCRAMBLING** in the Composition panel.

15 Go to 3:10, where this text should first be visible. Use the Selection tool to drag the text so that it starts below "ARE" and continues offscreen. You can also use the Rotation tool or the 3D Gizmo. When you're satisfied with its position, click the stopwatch icon (🕑) to create an initial keyframe for the Position property.

16 Go to 4:21, and use the Selection tool to move the text as it appears in the image below. Then do the same at 6:05 and 7:04, so that the text continues to move down and toward the left.

4:21 6:05 7:04

The text is in position, but you want it to appear suddenly on the screen. You'll trim the layers to stagger their appearance.

17 Go to 2:03, select the ARE layer, and then press Alt+[(Windows) or Option+[(macOS). Then go to 3:10, select the SCRAMBLING layer, and press Alt+[or Option+[again.

18 Hide the properties for all layers, and then choose File > Save to save your work.

19 Press the spacebar to preview the text animation. Press the spacebar again to stop playback.

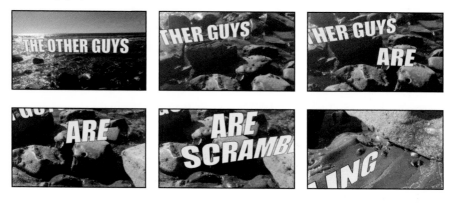

Locking an image to a plane with a solid layer

You created the advertising copy in After Effects, but the crabs' expressions are in quotation bubbles, which are easier to include as images. You'll attach the PSD files to solid layers in After Effects to lock them to specific planes.

1 Go to 6:06, select the Shoreline.mov layer in the Timeline panel, and select the 3D Camera Tracker effect in the Effect Controls panel.

2 With the Selection tool, move the cursor so that the target is on a vertical plane as in the image below. Right-click the target, and choose Create Solid.

After Effects creates a Track Solid 1 layer, and a colorful solid square appears in the Composition panel. The color of the solid square you see may be different from ours.

3 Right-click or Control-click the Track Solid 1 layer in the Timeline panel, and choose Pre-compose. Then, in the Pre-compose dialog box, name the layer **Crab Quote 1**, and click OK.

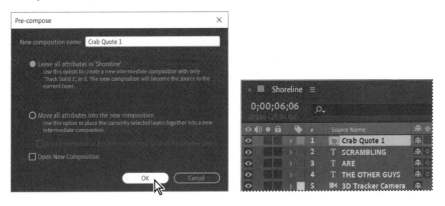

After Effects creates the Crab Quote 1 composition, which contains the Track Solid 1 layer.

4 Double-click the Crab Quote 1 composition to open it. In the Timeline panel, delete the Track Solid 1 layer.

5 Drag the Quote1.psd file from the Project panel into the Timeline panel.

6 Choose Layer > Transform > Fit to Comp Width.

7 Select the Shoreline Timeline panel.

After Effects displays the Quote1.psd image where you created a solid layer.

8 Use the Selection tool and the 3D Gizmo to position and scale the quote so that it appears to relate to a cluster of crabs.

9 Go to 7:15, select the Shoreline.mov layer in the Timeline panel, and select the 3D Camera Tracker effect again. In the Effect Controls panel, reduce the Track Point Size to **25%** so you can see the track points more clearly. Then, find a vertical plane against the rock, right-click the target, and choose Create Solid.

10 Right-click or Control-click the Track Solid 1 layer, and choose Pre-compose. In the Pre-compose dialog box, name the composition **Crab Quote 2**, and then click OK.

11 Double-click the Crab Quote 2 composition to open it. Delete the Track Solid 1 layer, drag the Quote2.psd file from the Project panel to the Timeline panel, and choose Layer > Transform > Fit To Comp.

12 Return to the Shoreline Timeline panel, and then adjust the position, rotation, and scale of the quote to match the crabs' position.

13 Go to 9:01, select the Shoreline.mov layer, and select the 3D Camera Tracker effect again. In the Effect Controls panel, reduce the Target Size to **50%**. Right-click a target on a vertical plane, and choose Create Solid.

14 Right-click or Control-click the Track Solid 1 layer, choose Pre-compose, name the composition **Crab Quote 3**, and click OK. Then, double-click the Crab Quote 3 composition to open it, delete the Track Solid 1 layer, drag the Quote3.psd file into the Timeline panel, and choose Layer > Transform > Fit To Comp.

15 Select the Shoreline Timeline panel, and then adjust the position, rotation, and scale of the quote to match the position of the crabs.

16 Choose File > Save to save your work so far.

Tidying the composition

You've done some complex work to create a scene that merges the added components with an existing tableau. You'll preview it to see it in action.

1 Press the Home key or move the current-time indicator to the beginning of the time ruler.

2 Press the spacebar to preview the movie. Let it play through completely once to cache the video and audio; once it's cached, it should play in real time.

3 Press the spacebar again to stop playback.

It's looking pretty good, but the word *ARE* may show up unexpectedly toward the end, and the crab quotes all appear at once. You'll adjust layers to ensure they appear when you want them to.

4 Go to 5:00, select the ARE layer, and press Alt+] or Option+].

5 Go to 6:06, select the Crab Quote 1 layer, and press Alt+[or Option+[.

6 Go to 7:15, select the Crab Quote 2 layer, and press Alt+[or Option+[.

7 Go to 9:01, select the Crab Quote 3 layer, and press Alt+[or Option+[.

8 Press the spacebar to preview the movie again. Now the text and quotes appear when you expect them to.

9 Press the spacebar again to stop playback.

10 Choose File > Save to save your work so far.

Adding a final object

Without the company logo, no one will know who has the competition scrambling. You'll add the logo to the end of the movie using another solid layer.

1 Go to 11:15, select the Shoreline.mov layer, and select the 3D Camera Tracker effect in the Effect Controls panel again. Change the Track Point Size and Target Size back to **100%**.

2 Find a plane that is relatively flat on a rock, right-click the target, and choose Create Solid.

3 Right-click or Control-click the Track Solid 1 layer, choose Pre-compose, name the composition **Logo**, and click OK.

4 Double-click the Logo composition to open it. Delete the Track Solid 1 layer, and then drag the BlueCrabLogo.psd file into the Timeline panel. With the BlueCrabLogo.psd layer selected, choose Layer > Transform > Fit To Comp.

5 Select the Shoreline Timeline panel, and then select the Logo layer.

6 Use the 3D Transformation Gizmo to rotate the logo as shown. (Our Orientation values are 0, 60, 0.) Then, use the Selection tool (▶) to drag the logo up to rest on the rock.

7 In the Properties panel, click the stopwatch icons (⏱) to create initial keyframes for the Position, Scale, and Orientation properties.

8 Go to 12:03, and increase the Scale value (we used 190.5%). Adjust the position and orientation as needed to match the image below.

9 Go to 13:04, and increase the Scale value again (we used 249%). Adjust the position if necessary to match the image below.

10 Go to 13:25, and increase the Scale value again (we used 285.2%). Adjust the orientation so that the logo faces forward; adjust the position to match the image below.

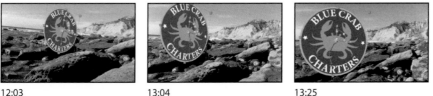

12:03 13:04 13:25

11 Go to 14:29, and adjust the position for the final shot. Hide all layer properties.

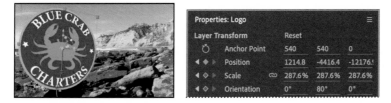

Creating realistic shadows

You've set up your elements, but unlike true 3D objects, they aren't casting any shadows. You'll create a shadow catcher and a light to add depth to your video.

1 Go to 5:00, select the Shoreline.mov layer in the Timeline panel, and select the 3D Camera Tracker effect in the Effect Controls panel.

2 Select the Selection tool in the Tools panel. Then, in the Composition panel, hover until you find a plane that is horizontal against the rocks.

3 Right-click or Control-click the target, and choose Create Shadow Catcher And Light.

● **Note:** Be sure to select the 3D Camera Tracker effect in the Shoreline.mov layer, not the 3D Tracker Camera layer.

After Effects adds a light source to the scene. The default settings are applied, so a shadow appears in the Composition panel. However, you'll need to reposition the light to match the light in the source footage. The Shadow Catcher 1 layer that After Effects adds to the Timeline panel is a shape layer that has its material options set so that it accepts shadows only from the scene.

4 Select the Light 1 layer in the Timeline panel. In the Properties panel, enter the following values for the Position property to reposition the light:
 939.6, **169.7**, **23.7**.

Properties: Light 1			≡
Layer Transform	Reset		
○ Point of Interest	0	0	0
○ Position	939.6	169.7	23.7

5 Choose Layer > Light Settings.

You can change the intensity, color, and other attributes of the light in the Light Settings dialog box.

Light Settings	×
Name: Light 1	
Settings	
Light Type: Spot ⌄	
Color: [] ✏	
Intensity: 100 %	
Cone Angle: 90 °	
Cone Feather: 50 %	
Falloff: None ⌄	
☑ Casts Shadows	
Shadow Darkness: 15 %	
Shadow Diffusion: 100 px	
Note: Shadows are only cast from layers with 'Cast Shadows' enabled to layers with 'Accepts Shadows' enabled.	
☑ Preview (OK) (Cancel)	

6 Choose Spot from the Light Type menu. Make sure the light color is white. Then change the Shadow Darkness to **15%** and the Shadow Diffusion to **100** px. Click OK.

7 Select the Shadow Catcher 1 layer in the Timeline panel, and change its Scale value to **340%**.

Scaling the Shadow Catcher 1 layer changes the area in which shadows can appear for the light that was created with it.

Adding ambient light

The shadow looks better after the adjustments you made to the light, but it's now causing the text to appear black. You'll add ambient light to address this. Unlike a spotlight, ambient light creates a more diffuse light throughout the scene.

1 Deselect all layers, and then choose Layer > New > Light.

2 Choose Ambient from the Light Type menu, and change its Intensity value to **80%**. Make sure the light color is white, just like the spotlight.

3 Click OK to add the light to the scene.

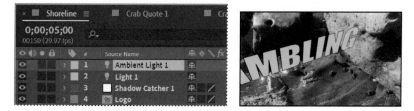

Adding an effect

The 3D elements, camera, and lighting are all complete, but you can make the video more interesting by adding a ripple effect to the quotes.

1 Go to 6:06.

2 Choose Window > Effects & Presets to open the panel. In the Effects & Presets panel, type **Ripple** in the search menu.

3 Select the Dissolve-Ripple effect from the Transitions-Dissolves category, and drag it onto the Crab Quote 1 layer in the Timeline panel.

The crab quote disappears, but it will gradually appear and ripple on the screen.

4 Go to 7:15, and repeat step 3 for the Crab Quote 2 layer.

5 Go to 9:01, and repeat step 3 for the Crab Quote 3 layer.

Previewing the composition

All of the elements are in place, along with cameras, lighting, and effects. You'll preview the composition to see the results of your work.

1 Press the Home key or move the current-time indicator to the beginning of the time ruler.

2 Press the spacebar to preview the movie. Let it play through completely once to cache the video and audio; once it's cached, it should play in real time.

3 Press the spacebar again to stop playback.

4 Choose File > Save to save the final project!

Review questions

1 What does the 3D Camera Tracker effect do?

2 How can you make an added 3D element look like it is the same size as elements that are farther from the camera?

3 What is the Rolling Shutter Repair effect?

Review answers

1 The 3D Camera Tracker effect automatically analyzes the motion present in existing 2D footage, extracts the position and lens type of the real camera that shot the scene, and creates a new 3D camera in After Effects to match it. The effect also overlays 3D track points onto the 2D footage, so you can easily attach new 3D layers onto the original footage.

2 To make an added 3D element appear to recede, so that it looks like it's farther from the camera, adjust its Scale property. Adjusting the Scale property keeps its perspective locked with the rest of the composition.

3 The Rolling Shutter Repair effect attempts to correct the "rolling" shutter problem that commonly occurs when you use digital cameras with CMOS sensors, which capture a frame of video one scan line at a time. Due to time lag between scan lines, not all parts of the image are recorded at exactly the same time, causing motion to ripple down the frame. If the camera or the subject is moving, the rolling shutter can cause distortions, such as leaning buildings and other skewed images. To use the effect, select the problem layer in the Timeline panel, and choose Effect > Distort > Rolling Shutter Repair.

14 ADVANCED EDITING TECHNIQUES

Lesson overview

In this lesson, you'll learn how to do the following:

- Stabilize a shaky camera shot.

- Use single-point motion tracking to track one object in a shot to another object in a shot.

- Remove unwanted objects from video using content-aware fill.

- Create a particle system.

- Use the Timewarp effect to create slow-motion video.

 This lesson will take about two hours to complete. If you haven't already done so, download the project files for this lesson from peachpit.com/ AfterEffectsCIB2024, following the instructions in the Getting Started section under "Accessing the lesson files and Web Edition."

PROJECT: SPECIAL EFFECTS AND EDITING TECHNIQUES

After Effects provides advanced motion stabilization, motion tracking, high-end effects, and other features for the most demanding production environments.

Getting started

In previous lessons, you've used many of the essential 2D and 3D tools you need for motion graphics design. But Adobe After Effects also offers motion stabilization, motion tracking, advanced keying tools, distortion effects, the capability to retime footage using the Timewarp effect, support for high dynamic range (HDR) color images, network rendering, and much more. In this lesson, you will learn how to use Warp Stabilizer VFX to stabilize a handheld camera shot, how to track one object to another in an image so that their motion is synchronized, and how to remove unwanted objects using content-aware fill. Finally, you will explore two of the high-end digital effects available in After Effects: a particle system generator and the Timewarp effect.

This lesson includes multiple projects. Take a peek at all of them before beginning.

1 Make sure the following files are in the Lessons/Lesson14 folder on your hard disk, or download them from peachpit.com now:

 • In the Assets folder: cat.psd, koala.mov, snowday.mov, spinning_dog.mov, ticktock.mov

 • In the Sample_Movies folder: Lesson14_Content-Aware.mp4, Lesson14_Particles.mp4, Lesson14_Stabilize.mp4, Lesson14_Timewarp.mp4, and Lesson14_Tracking.mp4.

● **Note:** You can view these movies all at once or, if you don't plan to complete these exercises in one session, you can watch each sample movie just before you are ready to complete the associated exercise.

2 Play the sample movies in Windows Movies & TV or QuickTime Player to see the projects you will create in this lesson.

3 When you're done, quit Windows Movies & TV or QuickTime Player. You may delete these sample movies from your hard disk if you have limited storage space.

Stabilizing a shot

If you shoot footage while holding a phone or camera, you will probably end up with shaky shots. Unless this look is intentional, you'll want to stabilize your shots to eliminate unwanted motion.

Warp Stabilizer VFX in After Effects automatically removes extraneous jitters. When played back, the motion appears smooth, because the layer itself is scaled and moves incrementally to offset the unwanted movement.

Bicubic scaling

When you scale video footage or an image to a larger size, After Effects must sample data to add information where none existed before. You can choose which sampling method After Effects uses when scaling a layer. For details, see After Effects Help.

Bilinear sampling may be a better option for sharp-edged graphics. However, bicubic sampling uses a more complex algorithm that typically provides better results when color transitions are more gradual, as in nearly all real-world photographic images.

To choose a sampling method for a layer, select the layer, and choose Layer > Quality > Bicubic or Layer > Quality > Bilinear. Bicubic and bilinear sampling are available only for layers that are set to Best quality. (To change a layer's quality setting to Best, choose Layer > Quality > Best.) You can also use the Quality and Sampling layer switch to toggle between the Bilinear and Bicubic sampling methods.

If you need to scale an image by a large amount while preserving details, use the Detail-Preserving Upscale effect instead. The effect preserves the sharpness of sharp lines and curves. For example, you can scale up from SD frame sizes to HD frame sizes, or from HD frame sizes to digital cinema frame sizes. This effect is very closely related to the Preserve Details resampling option in the Image Size dialog box in Photoshop. Note that using the Detail-Preserving Upscale effect is slower than using either bilinear or bicubic scaling for the layer.

Setting up the project

As you start After Effects, restore the default application settings for After Effects. See "Restoring default preferences" on page 3.

1 Start After Effects, and then immediately hold down Ctrl+Alt+Shift (Windows) or Command+Option+Shift (macOS) to restore default preferences settings. In the Startup Repair Options dialog box, click Reset Preferences.

2 Click New Project in the Home window.

After Effects opens to display a new, untitled project.

3 Choose File > Save As > Save As.

4 In the Save As dialog box, navigate to the Lessons/Lesson14/Finished_ Projects folder.

5 Name the project **Lesson14_Stabilize.aep**, and then click Save.

Creating the composition

You'll start by importing footage and creating the composition.

1 Click New Composition From Footage in the Composition panel.

2 Navigate to the Lessons/Lesson14/Assets folder. Select the snowday.mov file, and click Import or Open.

After Effects creates a new composition named snowday with the same pixel size, aspect ratio, frame rate, and duration of the source clip.

3 Click in the Timeline panel to make it active. Then, click the Play button in the Preview panel to preview the footage. Press the spacebar to stop the preview when you've seen the whole clip.

This clip was shot with a smartphone camera. A dog runs toward the camera, but the camera moves, too, resulting in an unsteady shot. Before you apply stabilization, you'll remove the unnecessary section of the video that occurs after the dog leaves the frame.

4 Move the Work Area End bracket to 5:00.

5 Choose Composition > Trim Comp To Work Area, and then save the file.

Warp Stabilizer VFX settings

This is a summary of the Warp Stabilizer VFX settings to help you get started. To learn more about the settings, and to read more tips for using the effect successfully, see After Effects Help.

- **Result** controls the intended result. Smooth Motion makes camera movement smoother, but doesn't eliminate it; use the Smoothness setting to control how smooth the movement becomes. No Motion attempts to remove all of the camera motion.

- **Method** specifies the most complex operation the Warp Stabilizer VFX performs on the footage to stabilize it: Position, which is based on position data only; Position, Scale, Rotation, which uses these three types of data; Perspective, which effectively corner-pins the entire frame; or Subspace Warp (the default), which attempts to warp various parts of the frame differently to stabilize the entire frame.

- **Borders** settings adjust how borders (the moving edges) are treated for footage that is stabilized. Framing controls how the edges appear in a stabilizing result, and determines whether the effect crops, scales, or synthesizes edges using material from other frames.

- **Auto-scale** displays the current auto-scale amount and allows you to set limits on the amount of auto-scaling.

- **Advanced** settings give you even greater control over the actions of the Warp Stabilizer VFX effect.

Applying Warp Stabilizer VFX

Warp Stabilizer VFX starts analyzing footage as soon as you apply it. Stabilization is a background process, so you can work on other compositions while it finishes. How long it takes depends on your system. After Effects displays a blue banner while it analyzes the footage and an orange banner while it applies stabilization.

1 Select the snowday.mov layer in the Timeline panel, and choose Animation > Warp Stabilizer VFX. The blue banner appears immediately.

2 When Warp Stabilizer VFX has finished stabilizing and the orange banner has disappeared, press the spacebar to preview the changes.

3 Press the spacebar to stop the preview.

The clip is still shaky, but it's smoother than it was initially.

4 Choose Window > Effect Controls to open the Effect Controls panel if it's not already open.

Warp Stabilizer VFX moved and repositioned the footage using its default settings. To see how it applied changes, view the effects in the Effect Controls panel. For example, the clip's borders were scaled up (to about 140%) to hide black gaps that occur when the image is repositioned in the stabilization process. You'll change the Framing setting to see how stabilization affects the image without scaling.

5 Choose Stabilize Only from the Framing menu in the Effect Controls panel.

6 Press the spacebar to preview the clip. The border shifts throughout the clip. Press the spacebar again to stop the preview.

7 Choose Stabilize, Crop, Auto-Scale from the Framing menu again.

Removing motion blur

If there are moments of blurriness after you stabilize the shot, try applying the Camera Shake Deblur effect. This effect analyzes frames on either side of the blurry frames for apparent sharpness and then blends the non-motion-blurred frames into the blurry frames.

The effect works best on brief moments of blur caused by wind or camera bumps.

Adjusting the Warp Stabilizer VFX settings

You'll change the settings in the Effect Controls panel to make the shot smoother.

1 In the Effect Controls panel, choose No Motion from the Result menu.

With this setting, Warp Stabilizer VFX attempts to lock the camera in position. This requires even more scaling. When No Motion is selected, the Smoothness option is dimmed.

Warp Stabilizer VFX immediately begins stabilizing again. It doesn't need to analyze the footage, because the initial analysis data is stored in memory.

2 When the orange banner disappears, preview the changes again. Press the spacebar to stop the playback.

The camera is much steadier. But in order to achieve this effect, Warp Stabilizer VFX had to scale the clip considerably and it warps the clip in some distracting ways. You'll manually adjust the settings to have more control.

3 In the Effect Controls panel, choose Smooth Motion from the Result menu. Then increase the Smoothness amount to **100%**.

Again, Warp Stabilizer VFX begins stabilizing the image immediately.

4 When Warp Stabilizer VFX has finished, preview the changes again.

Fine-tuning the results

The default analysis works well most of the time, but sometimes you may need to massage the end results even further. You'll change the method that Warp Stabilizer VFX uses for an even smoother result.

1 In the Effect Controls panel, choose Position from the Method menu.

2 Choose Stabilize, Crop from the Framing menu, and then increase the Additional Scale to **155%**.

● **Note:** Scaling a video layer up degrades the image. Scale only as much as you need to in order to hide black gaps that appear from stabilization.

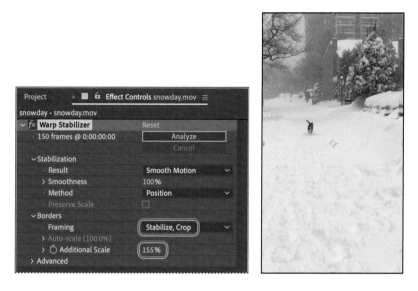

3 Preview the changes one more time, and press the spacebar to stop the playback when you're done.

4 Choose File > Save to save your work, and then choose File > Close Project.

As you have discovered, stabilizing a shot can have drawbacks. To compensate for the movement or rotation data applied to the layer, the frames must be scaled, which could ultimately degrade the footage. However, if you must use a shaky shot in your production, this may be the best compromise.

Using single-point motion tracking

When productions incorporate digital elements into final shots, compositors need an easy way to synchronize computer-generated effects with film or video backgrounds. After Effects lets you do this with the capability to follow, or track, a defined area in the shot, and to apply that movement to other layers. These layers can contain text, effects, images, or other footage. The resulting visual effect precisely matches the original moving footage.

When you track motion in an After Effects composition that contains multiple layers, the default tracking type is Transform. This type of motion tracking tracks position and/or rotation to apply to another layer. When tracking position, this option creates one track point and generates Position keyframes. When tracking rotation, this option creates two track points and produces Rotation keyframes.

In this exercise, you will track an object layer (the cat face) to the pendulum weight as it swings. This will be a little challenging, as there aren't distinctive characteristics within the pendulum weight itself.

Setting up the project

If you've just completed the first project, and After Effects is open, skip to step 3. Otherwise, restore the default application settings for After Effects. See "Restoring default preferences" on page 3. You'll start by importing assets and creating the composition.

1 Start After Effects, and then immediately hold down Ctrl+Alt+Shift (Windows) or Command+Option+Shift (macOS) to restore default preferences settings. In the Startup Repair Options dialog box, click Reset Preferences.

2 Click New Project in the Home window.

After Effects opens to display a new, untitled project.

3 Choose File > Save As > Save As.

4 In the Save As dialog box, navigate to the Lessons/Lesson14/Finished_ Projects folder.

5 Name the project **Lesson14_Tracking.aep**, and then click Save.

6 Click New Composition From Footage in the Composition panel.

7 Navigate to the Lessons/Lesson14/Assets folder. Select the ticktock.mov file, and click Import or Open.

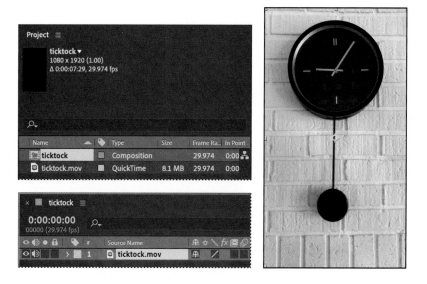

After Effects creates a new composition named ticktock with the same pixel size, aspect ratio, frame rate, and duration of the source clip.

8 Click the Play button in the Preview panel to preview the footage. Press the spacebar to stop the preview when you've seen the whole clip.

9 Double-click an empty area of the Project panel to open the Import File dialog box, and then navigate to the Lessons/Lesson14/Assets folder.

10 Select the cat.psd file, and then click Import or Open.

11 Drag the cat.psd file into the Timeline panel, and place it at the top of the layer stack.

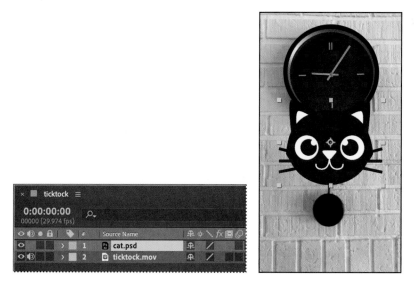

12 With the cat.psd layer selected, change its Scale property to **50%** in the
Properties panel.

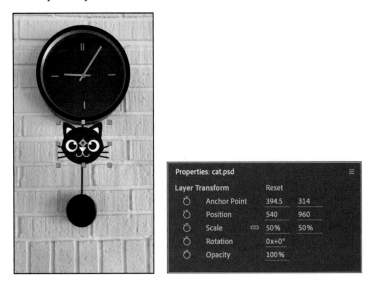

Positioning the track point

After Effects tracks motion by matching pixels from a selected area in a frame to
pixels in each succeeding frame. You create track points to specify the area to track.
A track point contains a feature region, a search region, and an attach point. After
Effects displays the track point in the Layer panel as it tracks.

You will track the pendulum by placing tracking regions around the area that you'll
track another layer to. The key to successful tracking is to position the feature region
over an area with distinct characteristics. The cat layer is above the ticktock layer in the
composition, so you are ready to position the track point.

1 Press the Home key or move the current-time indicator to the beginning
of the time ruler.

2 Select the ticktock layer, and choose Animation > Track Motion. The Tracker
panel opens; increase its size if you can't see all the options.

Moving and resizing the track points

In setting up motion tracking, it's often necessary to refine a track point by adjusting its feature region, search region, and attach point. You can resize or move these items independently or in groups by dragging with the Selection tool. The pointer icon changes to reflect one of many different activities.

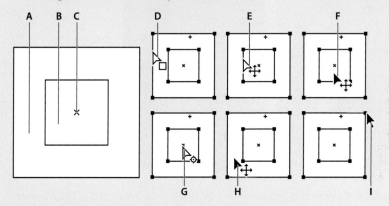

Track point components (left) and Selection tool pointer icons (right):
A. Search region **B.** Feature region **C.** Attach point **D.** Moves search region
E. Moves both regions **F.** Moves entire track point **G.** Moves attach point
H. Moves entire track point **I.** Resizes region

- To turn feature region magnification on or off, choose Magnify Feature When Dragging from the Tracker panel menu. A check mark appears next to the option when it's on.

- To move only the search region, using the Selection tool, drag the edge of the search region; the Move Search Region pointer (⊳▯) appears (D, above).

- To move just the feature and search regions together, Alt-drag (Windows) or Option-drag (macOS) with the Selection tool inside the feature or search region; the Move Both Regions pointer (⊳⊹) appears (E, above).

- To move only the attach point, using the Selection tool, drag the attach point; the Move Attach Point pointer (⊳◇) appears (G, above).

- To resize the feature or search region, drag a corner handle (I, above).

- To move the feature region, search region, and attach point together, drag with the Selection tool inside the track point area (avoiding the region edges and the attach point); the Move Track Point pointer (⊳⊹) appears.

For more information about track points, see After Effects Help.

After Effects opens the selected layer in the Layer panel. The Track Point 1 indicator is in the center of the image.

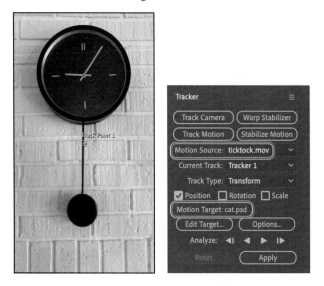

Notice the settings in the Tracker panel: ticktock.mov is selected in the Motion Source menu. The Current Track is Tracker 1, and the Motion Target is cat.psd, because After Effects automatically sets the Motion Target to the layer immediately above the source layer.

Now, you'll position your track point.

3 Choose 200% from the Magnification Ratio menu at the bottom of the Composition panel so you can see the track point clearly.

4 Select the Hand tool (✥), and shift the image up so you can see both the pendulum weight and the track point. You may also need to resize the Composition panel.

5 Select the Selection tool (▶), and then move the Track Point 1 indicator (drag the empty portion of the inner box) in the Composition panel to the top of the pendulum weight, as in the image on the next page.

6 Enlarge the search region (the outer box) to encompass the entire pendulum weight and part of the leader.

Analyzing and applying tracking

Now that the search and feature regions are defined, you can apply the tracker.

1 Click the Analyze Forward button (▶) in the Tracker panel. Watch the analysis to ensure the track point stays with the pendulum. If it doesn't, press the spacebar to stop the analysis, and reposition the feature region. (See the sidebar "Checking for drift.")

2 When the analysis is complete, click the Apply button.

The tracking analysis may take quite a while. The larger the search and feature regions, the longer After Effects takes to analyze tracking.

3 In the Motion Tracker Apply Options dialog box, click OK to apply the tracking to the x and y dimensions.

The motion-tracking data is added to the Timeline panel, where you can see that the track data is in the ticktock layer, but the results are applied to the Position property of the cat layer.

4 Choose Fit from the Magnification Ratio menu in the Composition panel, and resize it if you enlarged it earlier. The Composition panel should be active again.

5 Go to the beginning of the time ruler, and preview the movie.

The cat head moves with the pendulum, but it's too high. You want it to cover the pendulum weight. You'll adjust the cat layer's anchor point.

6 Select the cat layer in the Timeline panel, and then select the Pan Behind (⬚) tool in the Tools panel.

7 Drag the anchor point to the top of the cat's head.

8 Select the Selection tool (▸), and move the cat's head so it covers the pendulum weight.

9 Preview the movie again. The cat's head covers the pendulum weight as it swings. Where the anchor point should be depends on the precise location of your track point. If the head doesn't cover the weight as it swings, undo steps 7 and 8, and reposition the anchor point.

10 Hide the properties for both layers in the Timeline panel, choose File > Save, and then choose File > Close Project.

Checking for drift

As an image moves in a shot, the lighting, surrounding objects, and angle of the object can all change, making a once-distinct feature no longer identifiable at the subpixel level. It takes time to develop an eye for choosing a trackable feature. Even with careful planning and practice, you may often find that the feature region drifts away from the desired feature. Readjusting the feature and search regions, changing the tracking options, and trying again are all standard parts of digital tracking. When you notice drifting occurring, try the following:

1 Immediately stop the analysis by pressing the spacebar.

2 Move the current-time indicator back to the last good tracked point. You can see this in the Layer panel.

3 Reposition and/or resize the feature and search regions, being careful not to accidentally move the attach point. Moving the attach point will cause a noticeable jump in your tracked layer.

4 Click the Analyze Forward button to resume tracking.

Removing unwanted objects

It can be frustrating and tedious to remove unwanted objects from video, especially if the object moves between frames. The Content-Aware Fill feature in After Effects makes it possible to remove distractions such as microphones or other filming equipment, incongruous landscape elements, or even people. The feature removes the area you select, and then it analyzes frames over time to synthesize new pixels from other frames. You can adjust settings in the Content-Aware Fill panel to help the new fill blend seamlessly with the rest of the image. For information about the options available in the panel and techniques to use for different types of video, see After Effects Help.

You'll remove a bolt from the tree in a video of a koala so that the koala's environment appears to be a more natural setting. If you haven't already watched the sample movie for this exercise, do so now.

Setting up the project

Start by launching After Effects and creating a new project.

1 If it's not already open, start After Effects, and then immediately hold down Ctrl+Alt+Shift (Windows) or Command+Option+Shift (macOS) to restore default preferences settings. In the Startup Repair Options dialog box, click Reset Preferences, and then click New Project in the Home window.

After Effects opens to display an empty, untitled project.

2 Choose File > Save As > Save As.

3 In the Save As dialog box, navigate to the Lessons/Lesson14/ Finished_Projects folder.

4 Name the project **Lesson14_Content-Aware.aep,** and then click Save.

5 Double-click an empty area of the Project panel to open the Import File dialog box, and then navigate to the Lessons/Lesson14/Assets folder.

6 Select the koala.mov file, and then click Import or Open.

7 In the Project panel, drag the koala.mov file onto the New Composition button in the Composition panel.

8 In the Timeline panel, manually preview the footage. Notice the bolt in the tree.

9 Press the Home key or move the current-time indicator to the beginning of the time ruler.

Creating a mask

You'll start by identifying the area to be filled. You can use any technique you like to create a transparent area, but for this clip, it's easiest to create and track a mask.

1 Zoom in to see the bolt clearly.

2 Select the koala.mov layer in the Timeline panel. Selecting the layer ensures you'll draw a mask instead of creating a new shape layer.

3 Select the Ellipse tool (⬤), hidden behind the Rectangle tool (⬛) in the Tools panel.

4 Drag an ellipse so that it completely covers and is slightly larger than the bolt.

5 Choose Subtract from the Mask Mode menu in the Timeline panel.

6 Right-click or Control-click Mask 1, and choose Track Mask.

After Effects opens the Tracker panel.

7 In the Tracker panel, select Position from the Method menu. Click the Track Selected Masks Forward button.

8 Go to the beginning of the time ruler. Press the spacebar to preview the mask. Press the spacebar again to stop preview. If the mask slips from the bolt, adjust it as needed.

9 Choose File > Save to save your work so far.

Applying Content-Aware Fill

You're ready to replace the masked area with content-aware fill.

1 Select the koala.mov layer in the Timeline panel.

2 Choose Window > Content-Aware Fill. After Effects open the Content-Aware Fill panel in the panel dock.

3 In the Content-Aware Fill panel, do the following:

- Set Alpha Expansion to **10**.

- Choose Object from the Fill Method menu.

- Choose Entire Duration from the Range menu.

The Alpha Expansion setting increases the size of the area to fill. Content-Aware Fill often performs better when the selected area includes pixels outside the object you're removing. The Fill Method determines how the feature samples pixels and accommodates motion in the video. Range determines whether the fill layer is rendered for only the work area or for the entire composition.

4 Click Generate Fill Layer.

After Effects analyzes each frame and fills the transparent area. It places the sequence of images it analyzed in a Fill layer in the Timeline panel, with the name including the number of images in that sequence.

5 Deselect all layers, and choose Fit from the Magnification Ratio menu so you can see the full video.

6 Move the current-time indicator to the beginning of the timeline, and preview the movie to see the results of the fill.

7 When you're done watching the preview, press the spacebar to stop playback.

8 Hide the layer properties to keep the Timeline panel neat, and choose File > Save to save your work.

9 Choose File > Close Project.

Mocha AE

You've used the Tracker panel to track points in several videos in this book, with pretty good results. However, in many cases, you'll get better and more accurate tracking results using the Mocha AE plug-in from Boris FX. To track using Mocha, choose Animation > Track In Boris FX Mocha. You can access the full Mocha interface by choosing Effect > Boris FX Mocha > Mocha AE and launching Mocha AE.

One advantage of Mocha is that you don't have to accurately place track points to obtain a perfect track. Rather than using track points, Mocha uses a planar tracker, which attempts to track an object's translation, rotation, and scaling data based on the movement of a user-defined plane. Planes provide more detail to the computer than is possible with single-point and multipoint tracking tools.

When you work with Mocha, you need to identify planes that coincide with movement you want to track in a clip. Planes don't have to be tabletops or walls. For example, if someone is waving goodbye, you can use their upper and lower limbs as two planes. After you track the planes, you can export the tracking data for use in After Effects.

To learn more about Mocha, launch Mocha AE, and choose Help > Help.

Creating a particle simulation

After Effects includes several effects that do an excellent job of creating particle simulations. Two of them—CC Particle Systems II and CC Particle World—are based on the same engine. The major difference between the two is that Particle World enables you to move the particles in 3D space rather than in a 2D layer.

In this exercise, you'll learn how to use the CC Particle Systems II effect to create a supernova that could be used as the opening of a science program or as a motion background. If you haven't already watched the sample movie for this exercise, do so now before continuing.

Setting up the project

Start by launching After Effects and creating a new composition.

1 If it's not already open, start After Effects, and then immediately hold down Ctrl+Alt+Shift (Windows) or Command+Option+Shift (macOS) to restore default preferences settings. In the Startup Repair Options dialog box, click Reset Preferences, and click New Project in the Home window.

After Effects opens to display an empty, untitled project.

2 Choose File > Save As > Save As.

3 In the Save As dialog box, navigate to the Lessons/Lesson14/ Finished_Projects folder.

4 Name the project **Lesson14_Particles.aep**, and then click Save.

You don't need to import any footage items for this exercise. However, you do need to create the composition.

5 Click New Composition in the Composition panel.

6 In the Composition Settings dialog box, do the following, and then click OK:

- Type **Supernova** in the Composition Name field.
- Choose HD • 1920x1080 • 29.97 from the Preset pop-up menu.
- Set the Duration to **10:00**.

Creating a particle system

You will build the particle system from a solid layer, so you'll create that next.

1 Choose Layer > New > Solid to create a new solid layer.

2 In the Solid Settings dialog box, type **Particles** in the Name box.

3 Click Make Comp Size to make the layer the same size as the composition. Then click OK.

4 With the Particles layer selected in the Timeline panel, choose Effect > Simulation > CC Particle Systems II.

5 Go to 4:00 to see the particle system.

A large stream of yellow particles appears in the Composition panel.

Understanding Particle Systems II properties

Particle systems have a unique vocabulary. Some of the key settings are explained here for your reference. They're listed in the order in which they appear (top to bottom) in the Effect Controls panel.

Birth Rate Controls the number of particles generated per second. The value itself is arbitrary and does not equal the actual number of particles being generated. However, the higher the number, the more densely packed the particles become.

Longevity Determines how long the particles are visible.

Producer Position Controls the center point or origin of the particle system. The position is set based on the x, y coordinates. All particles emanate from this single point. You can control the size of the producer by making adjustments to the x and y radius settings. The higher these values, the larger the producer point will be. A high x value and a y value of zero (0) result in a line.

Velocity Controls the speed of particles. The higher the number, the faster the particles move.

Inherent Velocity % Determines how much of the velocity is passed along to the particles when the Producer Position is animated. A negative value causes the particles to move in the opposite direction.

Gravity Determines how fast particles fall. The higher the value, the faster the particles fall. A negative value causes particles to rise.

Resistance Simulates particles interacting with air or water, slowing over time.

Direction Determines which direction the particles flow. Use with the Direction Animation type.

Extra Introduces randomness into the movement of the particles.

Birth/Death Size Determines the size of the particles when they are created and when they expire.

Opacity Map Controls opacity changes for the particle over its lifetime.

Color Map Use with the Birth and Death colors to shade the particles over time.

Customizing the particle effect

You will turn this stream of particles into a supernova by customizing the settings in the Effect Controls panel.

1 If the Effect Controls panel isn't open, choose Window > Effect Controls to open it.

2 Expand the Physics property group in the Effect Controls panel. The Explosive Animation setting works fine for this project, but instead of the particles falling down, you want them to flow out in all directions, so change the Gravity value to **0.0**.

3 Hide the Physics property group, and expand the Particle property group. Then choose Faded Sphere from the Particle Type menu.

Now the particles look intergalactic. Don't stop there, though.

4 Change the Death Size to **1.50**, and increase the Size Variation to **100%**.

This allows the particles to change birth size randomly.

5 Reduce the Max Opacity to **55%** to make the particles semitransparent.

6 Click the Birth Color swatch, and change the color to R=**255**, G=**200**, B=**50** to give the particles a yellow hue at birth.

7 Click the Death Color swatch, and change the color to R=**180**, G=**180**, B=**180** to give the particles a light gray hue as they fade out.

● **Note:** Even though they're at the top of the Effect Controls panel, it is often easier to adjust the Longevity and Birth Rate settings after you have set the other particle properties.

8 To keep the particles from staying onscreen too long, decrease the Longevity value to **0.8** seconds.

The Faded Sphere particle type softens the look, but the particle shapes are still too sharply defined. You will fix that by blurring the layer to blend the particles with one another.

9 Hide the CC Particle Systems II effect properties.

10 Choose Effect > Blur & Sharpen > Gaussian Blur.

11 In the Gaussian Blur area of the Effect Controls panel, increase the Blurriness value to **10**. Then select Repeat Edge Pixels to keep the particles from being cropped at the edge of the frame.

Creating the sun

You will now create a bright halo of light that will go behind the particles.

1 Go to 7:00.

2 Press Ctrl+Y (Windows) or Command+Y (macOS) to create a new solid layer.

3 In the Solid Settings dialog box, do the following:

- Type **Sun** in the Name box.

- Click Make Comp Size to make the layer the same size as the composition.

- Click the color swatch, and make the layer the same yellow as the Birth Color of the particles (R=**255**, G=**200**, B=**50**).

- Click OK to close the Solid Settings dialog box.

4 Drag the Sun layer below the Particles layer in the Timeline panel.

5 Select the Ellipse tool (⬤), which may be hidden behind the Rectangle tool (■) in the Tools panel, and Shift-drag in the Composition panel to draw a circle with a radius of roughly 100 pixels, or one-fourth the width of the composition. You've created a mask.

6 Using the Selection tool (▶), click the mask shape and then drag it to the center of the Composition panel.

7 With the Sun layer selected in the Timeline panel, press the F key to reveal its Mask Feather property. Increase the Mask Feather amount to **100**, **100** pixels.

8 Press Alt+[(Windows) or Option+[(macOS) to set the In point of the layer to the current time.

9 Hide the properties for the Sun layer.

Lighting the darkness

Since the sun is bright, it should illuminate the surrounding darkness.

1 Make sure the current-time indicator is still at 7:00.

2 Press Ctrl+Y (Windows) or Command+Y (macOS) to create a new solid layer.

3 In the Solid Settings dialog box, name the layer **Background**, click the Make Comp Size button to make the layer the same size as the composition, and then click OK to create the layer.

4 In the Timeline panel, drag the Background layer to the bottom position in the layer stack.

5 With the Background layer selected in the Timeline panel, choose Effect > Generate > Gradient Ramp.

The Gradient Ramp effect creates a color gradient, blending it with the original image. You can create linear ramps or radial ramps, and vary the position and colors of the ramp over time. Use the Start Of Ramp and End Of Ramp settings to specify the start and end positions. Use the Ramp Scatter setting to disperse the ramp colors and eliminate banding.

6 In the Gradient Ramp area of the Effect Controls panel, do the following:

 • Change Start Of Ramp to **960**, **538** and End Of Ramp to **360**, **525**.

 • Choose Radial Ramp from the Ramp Shape menu.

 • Click the Start Color swatch, and set the start color to dark blue (R=**0**, G=**25**, B=**135**).

 • Set the End Color to black (R=**0**, G=**0**, B=**0**).

7 Press Alt+[(Windows) or Option+[(macOS) to set the In point of the layer to the current time.

Adding a lens flare

To tie all the elements together, you'll add a lens flare to simulate an explosion.

1 Press the Home key or move the current-time indicator to the beginning of the time ruler.

2 Press Ctrl+Y (Windows) or Command+Y (macOS) to create a new solid layer.

3 In the Solid Settings dialog box, name the layer **Nova**, click the Make Comp Size button to make the layer the same size as the composition, set the Color to black (R=**0**, G=**0**, B=**0**), and then click OK.

4 Drag the Nova layer to the top of the layer stack in the Timeline panel. Then, with the Nova layer selected, choose Effect > Generate > Lens Flare.

5 In the Lens Flare area of the Effect Controls panel, do the following:

- Change Flare Center to **960**, **538**.

- Make sure 50–300mm Zoom is selected in the Lens Type menu.

- Decrease Flare Brightness to **0%**, and then click the Flare Brightness stopwatch icon (⌚) to create an initial keyframe.

6 Go to 0:10.

7 Increase the Flare Brightness to **240%**.

8 Go to 1:04, and decrease the Flare Brightness to **100%**.

9 With the Nova layer selected in the Timeline panel, press the U key to see the animated Lens Flare property.

10 Right-click or Control-click the ending Flare Brightness keyframe, and choose Keyframe Assistant > Easy Ease In.

11 Right-click or Control-click the beginning Flare Brightness keyframe, and choose Keyframe Assistant > Easy Ease Out.

Finally, you need to make the layers under the Nova layer visible in the composition.

12 Press F2 to deselect all layers, and choose Columns > Modes from the Timeline panel menu. Then choose Screen from the Mode menu for the Nova layer.

13 Preview the movie. When you're done, press the spacebar to stop the preview.

14 Choose File > Save, and then choose File > Close Project.

About high dynamic range (HDR) footage

After Effects supports high dynamic range (HDR) color.

The dynamic range (ratio between dark and bright regions) in the physical world far exceeds the range of human vision and of images that are printed or displayed on a monitor. But while human eyes can adapt to very different brightness levels, most cameras and computer monitors can capture and reproduce only a limited dynamic range. Photographers, motion-picture artists, and others working with digital images must be selective about what's important in a scene, because they're working with a limited dynamic range.

HDR footage opens up a world of possibilities, because it can represent a very wide dynamic range through the use of 32-bit floating-point numeric values. Floating-point numeric representations allow the same number of bits to describe a much larger range of values than integer (fixed-point) values. HDR values can contain brightness levels, including objects as bright as a candle flame or the sun, that far exceed those in 8-bit-per-channel (bpc) or 16-bpc (non-floating-point) mode. Lower dynamic range 8-bpc and 16-bpc modes can represent RGB levels only from black to white, which comprises an extremely small segment of the dynamic range in the real world.

After Effects supports HDR images in a variety of ways. For example, you can create 32-bpc projects to work with HDR footage, and you can adjust the exposure, or the amount of light captured in an image, when working with HDR images in After Effects. For more information about support in After Effects for HDR images, see After Effects Help.

Retiming playback using the Timewarp effect

The Timewarp effect in After Effects gives you precise control over a wide range of parameters when changing the playback speed of a layer, including interpolation methods, motion blur, and source cropping to eliminate unwanted artifacts.

In this exercise, you will use the Timewarp effect to change the speed of a clip, slowing it down and speeding it up at different points. If you haven't already watched the sample movie for this exercise, do so now.

Setting up the project

Start by launching After Effects and creating a new project.

1 If After Effects isn't open, start it, and then immediately hold down Ctrl+Alt+Shift (Windows) or Command+Option+Shift (macOS) to restore default preferences settings. In the Startup Repair Options dialog box, click Reset Preferences, and then click New Project in the Home window.

After Effects opens to display an empty, untitled project.

2 Choose File > Save As > Save As.

3 In the Save As dialog box, navigate to the Lessons/Lesson14/ Finished_Projects folder.

4 Name the project **Lesson14_Timewarp.aep**, and then click Save.

5 Click New Composition From Footage in the Composition panel. Then navigate to the Lessons/Lesson14/Assets folder on your hard disk, select the spinning_ dog.mov file, and click Import or Open.

After Effects creates a new composition named for the source file, and displays it in the Composition and Timeline panels.

6 Choose File > Save to save the project.

Using Timewarp

In the source footage, a dog spins as she moves from room to room. At around 4 seconds, you'll slow the motion down to 10%, and then ramp up to twice the original speed before slowing back to full speed at the end of the clip.

1 With the spinning_dog.mov layer selected in the Timeline panel, choose Effect > Time > Timewarp.

2 If the Effect Controls panel isn't open, choose Window > Effect Controls.

3 In the Timewarp area of the Effect Controls panel, make sure Pixel Motion is selected in the Method menu and Speed is selected in the Adjust Time By menu.

With Pixel Motion selected, Timewarp creates new frames by analyzing the pixel movement in nearby frames and creating motion vectors. The Speed option controls the time adjustment by percentage rather than by a specific frame.

4 Go to 2:00.

5 In the Effect Controls panel, set the Speed to **100**, and click the stopwatch icon (⏱) to set a keyframe.

The Timewarp effect will keep the speed of the clip at 100% until the 2-second mark.

6 With the spinning_dog.mov layer selected in the Timeline panel, press the U key to see the animated Timewarp Speed property.

7 Go to 5:00, and set the Speed to **10**. After Effects adds a keyframe.

8 Go to 7:00, and set the Speed to **100**. After Effects adds a keyframe.

9 Go to 9:00, and set the Speed to **200.** After Effects adds a keyframe.

10 Go to 11:00, and set the Speed to **100**. After Effects adds a keyframe.

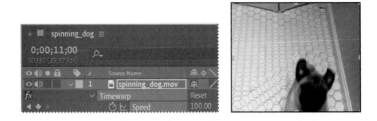

● **Note:** Be patient. The first time through, After Effects is caching information in RAM. The second time it plays, playback will be more accurate.

11 Press the Home key or move the current-time indicator to the beginning of the time ruler, and then press the spacebar to watch a preview of the effect.

The speed adjustments are rather abrupt—not the smooth, slow-motion curve you would expect to see in a professional effect. This is because the keyframes are linear instead of curved. You'll fix that next.

12 Press the spacebar to stop playback when you're ready.

13 Click the Graph Editor button in the Timeline panel to display the Graph Editor instead of the layer bars. Make sure the Speed property name for the spinning_ dog layer is selected. The Graph Editor displays its graph.

14 Click to select the first Speed keyframe (at 2:00), and then click the Easy Ease icon (🛶) at the bottom of the Graph Editor.

▶ **Tip:** Close columns in the Timeline panel to see more icons in the Graph Editor. You can also apply an Easy Ease adjustment by pressing the F9 key.

● **Note:** If you click the Speed property a second time, all the keyframes are selected and changes you make to one affect all of them.

This adjusts the influence into and out of the keyframe to smooth out sudden changes.

15 Repeat step 14 for the other Speed keyframes in the motion graph, at 5:00, 7:00, 9:00, and 11:00.

▶ **Tip:** You can tweak a motion graph by dragging the Bezier handles. You used Bezier handles in Lesson 7, "Working with Masks."

16 Preview the movie again. This time, the slow-motion Timewarp effect transitions are smoother.

17 Choose File > Save to save the project, and then choose File > Close Project.

You've now experimented with some of the advanced features in After Effects, including motion stabilization, motion tracking, particle systems, content-aware fill, and the Timewarp effect. To render and export any or all of the projects you completed in this lesson, see Lesson 15, "Rendering and Outputting," for instructions.

Review questions

1 What is Warp Stabilizer VFX, and when do you need to use it?

2 Why might drifting occur when you're tracking an image?

3 What is the birth rate in a particle effect?

4 What does the Timewarp effect do?

Review answers

1 Shooting footage using a handheld camera typically results in shaky shots. Unless this look is intentional, you will want to stabilize the shots to eliminate unwanted motion. Warp Stabilizer VFX in After Effects analyzes the movement and rotation of the target layer, and then makes adjustments to it. When played back, the motion appears smooth, because the layer itself moves incrementally to offset the unwanted motion. You can change the way Warp Stabilizer VFX crops, scales, and performs other adjustments by modifying settings for the effect.

2 Drifting occurs when the feature region loses the feature that's being tracked. As an image moves in a shot, the lighting, surrounding objects, and angle of the object can change, making a once-distinct feature unidentifiable at the subpixel level. Even with careful planning and practice, the feature region often drifts away from the desired feature. Readjusting the feature and search regions, changing the tracking options, and trying again are all standard procedures in digital tracking.

3 The birth rate in a particle effect determines how often new particles are created.

4 The Timewarp effect gives you precise control over a wide range of parameters to change the playback speed of a layer, including interpolation methods, motion blur, and source cropping to eliminate unwanted artifacts.

15 RENDERING AND OUTPUTTING

Lesson overview

In this lesson, you'll learn how to do the following:

- Output movies using the Render Queue.

- Create templates for the Render Queue.

- Receive notifications when rendering is complete.

- Output movies using Adobe Media Encoder.

- Select the appropriate compressor for your delivery format.

- Produce a test version of a composition.

- Create custom encoding presets in Adobe Media Encoder.

- Render and output a web version of the final composition.

 The total amount of time required to complete this lesson depends in part on the speed of your processor and the amount of RAM available for rendering. The amount of hands-on time required is less than an hour. If you haven't already done so, download the project files for this lesson from peachpit.com/AfterEffectsCIB2024, following the instructions in the Getting Started section under "Accessing the lesson files and Web Edition."

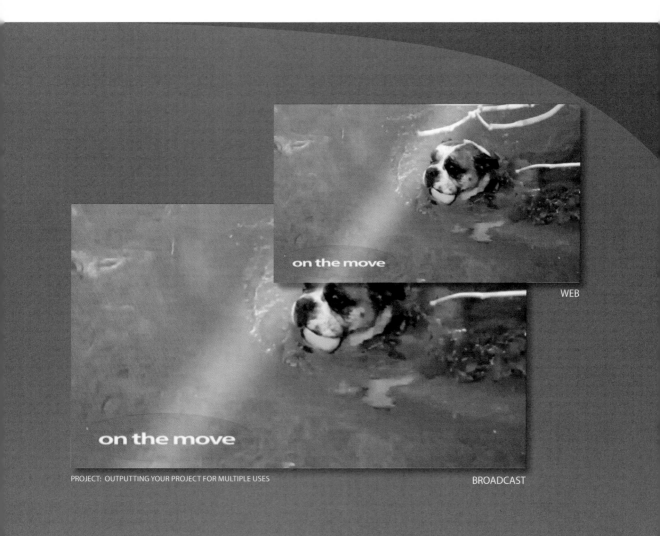

WEB

PROJECT: OUTPUTTING YOUR PROJECT FOR MULTIPLE USES

BROADCAST

The success of any project depends on your ability to deliver it in the format you need, whether it's for the web or broadcast output. Using Adobe After Effects and Adobe Media Encoder, you can render and export a final composition in a variety of formats and resolutions.

Getting started

This lesson continues from the point at which many of the preceding lessons end: when you're ready to output the final composition. In order to produce several versions of the animation for this lesson, you'll explore options available within the Render Queue panel and Adobe Media Encoder. For this lesson, we provide you with a starting project file that is essentially the final composition from Lesson 1 of this book.

1 Make sure the following files are in the Lessons/Lesson15 folder on your hard disk, or download them from peachpit.com now:

 • In the Assets folder: movement.mp3, swimming_dog.mp4, title.psd

 • In the Start_Project_File folder: Lesson15_Start.aep

 • In the Sample_Movies folder: Lesson15_Draft_RQ.mp4, Lesson15_Final_Web.mp4, Lesson15_HD-test_1080p.mp4, Lesson15_Lowres_YouTube.mp4

● **Note:** The Lesson15_HD_test_1080p.mp4 file includes only the first three seconds of the movie.

2 Open and play the sample movies for Lesson 15, which represent different final versions of the movie—rendered with different quality settings—that you created in Lesson 1. When you're done viewing the sample movies, quit Windows Movies & TV or QuickTime Player. You may delete the sample movies from your hard disk if you have limited storage space.

As always, when you begin the lesson, restore the default application settings for After Effects. See "Restoring default preferences" on page 3.

3 Start After Effects, and then immediately hold down Ctrl+Alt+Shift (Windows) or Command+Option+Shift (macOS). In the Startup Repair Options dialog box, click Reset Preferences.

4 Click Open Project in the Home window.

● **Note:** If you receive an error message about missing layer dependencies (Arial Narrow Regular), click OK. If you're missing footage, right-click a footage item, choose Replace Footage > File, navigate to the Lesson15/Assets folder, and double-click the file.

5 Navigate to the Lessons/Lesson15/Start_Project_File folder, select the Lesson15_Start.aep file, and click Open.

6 Choose File > Save As > Save As.

7 In the Save As dialog box, navigate to the Lessons/Lesson15/Finished_Project folder.

8 Name the project **Lesson15_Finished.aep**, and then click Save.

About rendering and output

Rendering a composition creates the frames of a movie from all the layers, settings, effects, and other information that makes up the model for that image. After Effects renders content every time it creates a preview, but this lesson focuses on the rendering process that occurs when you've completed your composition and are ready to share your movie. You can generate a final movie file using the Render Queue panel in After Effects or Adobe Media Encoder. (Render Queue uses an embedded version of Adobe Media Encoder to encode most movie formats, but doesn't include all the features of the separate application.)

When you use the Render Queue to create your final output, there are two steps to the process: After Effects renders the composition and then encodes the rendered frames into output files. In the Render Queue, the first step is governed by the render settings you've selected, and the second by the selected output module.

Adobe recommends that you use Adobe Media Encoder to create a high-quality movie file that is compressed for the web, DVD, or Blu-ray disc.

Exporting using the Render Queue

You can export a movie using the Render Queue at any stage in the process—whether you're creating a sample for a client to review, producing a low-res version to check the timing, or creating a final high-resolution movie. The settings you choose for each purpose are different, but the process is the same.

You'll export a draft version of the On the Move movie using the Render Queue.

1 Select the Movement composition in the Project panel, and choose Composition > Add To Render Queue.

▶ **Tip:** Alternatively, you can drag the composition from the Project panel onto the Render Queue panel.

After Effects opens the Render Queue panel. The Movement composition is in the queue. Note the default settings in the Render Settings and Output Module pop-up menus; by default, After Effects produces a full-size high-quality movie. You'll change the settings to create a low-resolution test file that will render quickly.

2 Click the arrow to the right of Render Settings, and choose Draft Settings. Then, click the words *Draft Settings*.

After Effects opens the Render Settings dialog box. You'll use most of the settings preselected in the Draft Settings template, but you'll reduce the resolution and ensure the entire composition is rendered.

3 In the Render Settings dialog box, choose Third for Resolution.

When you choose Third, After Effects renders one-ninth of the pixels in the composition: one-third of the rows and one-third of the columns.

4 In the Time Sampling area, choose Length of Comp for Time Span.

5 Click OK to close the Render Settings dialog box.

6 Choose H.264–Match Render Settings–5 Mbps from the Output Module pop-up menu.

7 Click the blue words next to Output To.

8 In the Output Movie To dialog box, locate the Lessons/Lesson15 folder, and create a new folder called **Final_Movies**:

 • In Windows, click New Folder, and then type the name for the folder.

 • In macOS, click the New Folder button, name the folder, and click Create.

9 Open the Final_Movies folder, if it's not already open.

10 Name the file **Draft_RQ.mp4**, and then click Save to return to the Render Queue panel.

The margin notes on the left:

Tip: Select Notify When Queue Completes...

Note: You do not need to render a movie...

Then the main body.

> **Tip:** Select Notify When Queue Completes in the lower-right area of the Render Queue panel to receive a notification when all jobs in the queue finish rendering.

> **Note:** You do not need to render a movie multiple times to export it to multiple formats with the same render settings. You can export multiple versions of the same rendered movie by adding output modules to a render item in the Render Queue panel.

11 Select the Notify checkbox in the Render Queue panel.

When Notify is selected, you'll receive notifications in the Creative Cloud Desktop (Windows and macOS) and Creative Cloud Mobile (iOS and Android) apps, as well as on Apple Watch or other connected devices.

12 Click the Render button in the Render Queue panel.

After Effects renders the movie. If there were additional movies—or the same movie with different settings—in the queue, After Effects would render those, too.

13 Navigate to the Lessons/Lesson15/Final_Movies folder, and then double-click your movie to preview it.

If you need to make any final changes to the movie, reopen the composition and make those adjustments now. Remember to save your work when you finish, and then output the test movie again using the appropriate settings. Next, you'll proceed with outputting the movie for full-resolution broadcast.

Preparing movies for mobile devices

You can create movies in After Effects for playback on mobile devices, such as tablets and smartphones. To render your movie, add the composition to the Adobe Media Encoder encoding queue, and choose an appropriate device-specific encoding preset.

For the best results, consider the limitations of mobile devices as you shoot footage and work with After Effects. For a small screen size, pay careful attention to lighting, and use a lower frame rate. See After Effects Help for more tips.

Creating templates for the Render Queue

When you output a composition, you can select individual render and output-module settings. However, you can also use templates to apply settings quickly. Templates are presets that streamline the setup process when you render items for the same type of delivery format. After you define templates, they appear in the Render Queue panel on the appropriate pop-up menu (Render Settings or Output Module). Then, when you're ready to render a composition, you can simply select the appropriate template for the delivery format that your job requires, and the template applies all the settings.

Creating a render-settings template

You can create render-settings templates for different circumstances. For example, you could create templates for rendering draft copies for review, high-res versions, or different frame rates.

To create a render-settings template, choose Edit > Templates > Render Settings. In the Settings area of the Render Settings Templates dialog box, click New to create a new template. Then select the appropriate settings for the template. For Settings Name, type a name that describes the template's purpose or use (for example, Test_ lowres). Click OK when you've made the changes.

Render-settings templates you've saved are available on the Render Settings pop-up menu in the Render Queue panel.

Creating templates for output modules

You can use a similar process to create a template for output-module settings. Each output-module template includes unique combinations of settings appropriate for a specific type of output.

To create a template, choose Edit > Templates > Output Module to open the Output Module Templates dialog box. In the Settings area, click New to create a new template. Then select the appropriate settings for the template. Name the template to indicate the output it will generate, and click OK to close the dialog box.

Output-module templates you've saved are available on the Output Module pop-up menu in the Render Queue panel.

Rendering movies with Adobe Media Encoder

● **Note:** If Adobe Media Encoder is not currently installed on your system, install it from Creative Cloud.

Your movie is ready for final output. Adobe Media Encoder, which is installed when you install After Effects, has the widest selection of codecs available for different delivery formats, including popular video services such as YouTube.

Rendering a broadcast-quality movie

First, you'll select settings to render your movie in a quality suitable for broadcast.

▶ **Tip:** You can also drag a composition into the Render Queue panel, and click Queue in AME to add it to the Adobe Media Encoder queue.

1 In the Project panel, select the Movement composition, and choose Composition > Add To Adobe Media Encoder Queue.

After Effects opens Adobe Media Encoder and adds your composition with default render settings. Your default settings may vary from ours.

2 Click the blue link in the Preset column.

▶ **Tip:** If you don't need to change anything else in the Export Settings dialog box, you can change the preset using the Preset pop-up menu in the Queue panel.

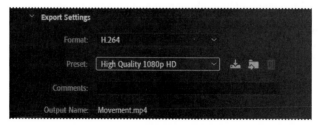

Adobe Media Encoder connects to the Dynamic Link server, which may take a few moments.

3 When the Export Settings dialog box appears, choose H.264 from the Format menu, and then choose High Quality 1080p HD from the Preset menu.

Rendering the full movie with the High Quality 1080p HD preset may take several minutes. You'll change the settings to render only the first three seconds of the movie so that you can preview the quality. You can change the range rendered using the time ruler at the bottom of the Export Settings dialog box.

4 Move the current-time indicator to 3:00, and then click the Set Out Point button (▶|) to the left of the Select Zoom Level pop-up menu.

▶ **Tip:** It's easy to create an animated GIF from just about any short movie. Just add the composition to the Adobe Media Encoder queue, and choose Animated GIF for the format.

5 Click OK to close the Export Settings dialog box.

6 Click the blue link in the Output File column. Name the movie **HD-test_1080p.mp4**, and specify the Lessons/Lesson15/Final_Movies folder. Then click Save or OK.

You're ready to output this movie, but you'll set up an additional movie option in the queue before you render it.

About compression

Compression is essential to reduce the size of movies so that they can be stored, transmitted, and played back effectively. When exporting or rendering a movie file for playback on a specific type of device at a certain bandwidth, you choose a compressor/decompressor (also known as an encoder/decoder), or *codec*, to compress the information and generate a file that is readable by that type of device at that bandwidth.

A wide range of codecs is available; no single codec is the best for all situations. For example, the best codec for compressing cartoon animation is generally not efficient for compressing live-action video. When compressing a movie file, you can fine-tune it for the best quality playback on a computer, a video playback device, the web, or from a DVD player. Depending on which encoder you use, you may be able to reduce the size of compressed files by removing artifacts that interfere with compression, such as random camera motion and excessive film grain.

The codec you use must be available to your entire audience. For instance, if you use a hardware codec on a capture card, your audience must have the same capture card installed, or a software codec that emulates it.

For more information about compression and codecs, see After Effects Help.

Adding another encoding preset to the queue

► **Tip:** If you render files frequently, consider setting up a watch folder. When you place a file in the watch folder, Adobe Media Encoder automatically encodes it using the settings you've specified in the Watch Folders panel.

Adobe Media Encoder comes with dozens of built-in presets suitable for output for traditional broadcast, mobile devices, and the web. You'll output a version of your composition ready for posting to YouTube.

1 In the Preset Browser panel, navigate to Web Video > Social Media > YouTube 480p SD Wide.

2 Drag the YouTube 480p SD Wide preset onto the Movement composition in the Queue panel.

Adobe Media Encoder adds another output item to the queue.

3 Click the blue link in the Output File column for the item you just added. Then name the file **Final_Web.mp4**, specify the Lessons/Lesson15/Final_Movies folder, and click Save or OK.

Rendering movies

You've set up two versions of your movie in the queue. Now you'll render and view them. Rendering is resource-intensive, and it can take a while, depending on your system, the complexity and length of the composition, and the settings you use.

1 Click the green Start Queue button (▶) in the upper right corner of the Queue panel.

Depending on your system, this may take a while.

Adobe Media Encoder encodes the movies in the queue simultaneously, displaying a status bar and reporting the estimated time remaining.

2 When Adobe Media Encoder has finished, navigate to the Final_Movies folder in the Finder or Explorer, and double-click your files to play them.

Creating custom presets for Adobe Media Encoder

In most cases, one of the default Adobe Media Encoder presets will be appropriate for your project. However, you can create your own encoding presets if you have specialized needs. In this case, you'll create a preset that renders a lower-resolution file for YouTube more quickly than the one you just encoded.

▶ **Tip:** If you forget where you saved your encoded movies, click the blue link in the Output File column next to the finished movie. Adobe Media Encoder opens a window to show you where your files were saved.

1 Click the Create New Preset Group button () at the top of the Preset Browser panel, and give the group a unique name, such as your name.

2 Click the Create New Preset button (**+**), and choose Create Encoding Preset.

3 Do the following in the Preset Settings dialog box:

- Name the preset **Low-res_YouTube**.
- Make sure H.264 is chosen from the Format menu.
- Choose YouTube 480p SD Wide from the Based On Preset menu.

- Select the Video tab, if it's not already selected.
- For Frame Rate, deselect Based On Source.

- Choose Baseline from the Profile menu. (You may need to scroll down to see it and the following options.)

- Choose 3.0 from the Level menu.

- Make sure VBR, 1 Pass is chosen from the Bitrate Encoding menu.

- Click the Audio tab, and choose 44100 Hz from the Sample Rate menu.

4 Click OK to close the Preset Settings dialog box.

5 Drag the Low-res_YouTube preset onto the Movement composition in the Queue panel.

6 Click the blue link in the Output File column. Then name the file **Lowres_YouTube**, specify the Lessons/Lesson15/Final_Movies folder, and click Save or OK.

7 Click the Start Queue button (▶).

With the settings in your new preset, the movie encodes more quickly. However, the quality isn't as high.

8 When Adobe Media Encoder has finished, navigate to the Final_Movies folder in Explorer or the Finder, and double-click the Lowres_YouTube movie to view it.

You have created both a web version and a broadcast version of the final composition.

Preparing a movie
for broadcast output

The project you're rendering in this lesson is already high-resolution and appropriate for broadcast output. However, you may need to adjust other compositions for your intended delivery format.

To change the composition size, create a new composition with the appropriate settings for your final format. Then drag the project composition into the new composition.

If you converted the composition from a square pixel aspect ratio to a nonsquare pixel aspect ratio, which is used in broadcasting, items in the Composition panel may appear wider than before. To view the video accurately, enable *pixel aspect ratio correction*. Pixel aspect ratio correction squeezes the view of the composition slightly to display the image as it will appear on a video monitor. By default, this feature is turned off, but you can easily turn it on by clicking the Toggle Pixel Aspect Ratio Correction button at the bottom of the Composition panel. The quality of the pixel aspect ratio correction for previews is affected by the Zoom Quality preference in the Previews category of the Preferences dialog box.

Congratulations! You have completed all the lessons in *Adobe After Effects Classroom in a Book (2024 Release)*.

While this book is intended to give you a good foundation for working with After Effects, it can't cover everything. To continue learning about After Effects, check out the resources described in the Getting Started section at the beginning of the book.

Review questions

1 What is compression, and what are some things you should consider when compressing files?

2 How can you output a movie using Adobe Media Encoder?

3 Name two types of templates you can create for use in the Render Queue panel, and explain when and why to use them.

Review answers

1 Compression is essential to reduce the size of movies so that they can be stored, transmitted, and played back effectively. When exporting or rendering a movie file for playback on a specific type of device at a certain bandwidth, you choose a compressor/ decompressor, or codec, to compress the information and generate a file readable by that type of device at that bandwidth. A wide range of codecs is available; no single codec is the best for all situations. For example, the best codec for compressing cartoon animation is generally not efficient for compressing live-action video. When compressing a movie file, you can fine-tune it for the best quality playback on a computer, a video playback device, the web, or from a DVD player. Depending on which encoder you use, you may be able to reduce the size of compressed files by removing artifacts that interfere with compression, such as random camera motion and excessive film grain.

2 To output a movie using Adobe Media Encoder, select the composition in the Project panel in After Effects, and then choose Composition > Add To Adobe Media Encoder Queue. In Adobe Media Encoder, select an encoding preset and any other settings, name the output file, and click the Start Queue button.

3 In After Effects, you can create templates for both render settings and output-module settings. These templates are presets that you can use to streamline the setup process when you render items for the same type of delivery format. After you define these templates, they appear in the Render Queue panel on the appropriate pop-up menu (Render Settings or Output Module). Then, when you're ready to render a job, you can simply select the template that is appropriate for the delivery format that your job requires, and the template applies all the settings.

APPENDIX: Tools for Troubleshooting

Startup Repair Options

If After Effects crashes, freezes, or returns an error when you attempt to start the application, press Ctrl+Alt+Shift (Windows) or Command+Option+Shift (macOS) as you restart. In the Startup Repair Options dialog box, click Start In Safe Mode. If you suspect a third-party effect is causing a conflict, disable third-party effects in the Starting in Safe Mode dialog box.

If a damaged preferences file is the problem, reset preferences. If a third-party effect is the issue, choose Effects > Manage Effects to systematically enable effects until you identify the issue. If starting in Safe Mode and disabling effects doesn't solve the problem, see After Effects Help for more options.

Locating missing assets

If After Effects can't find an imported file, a font, or an effect, it will report that the item is missing. If you can't tell which files are missing in a complex composition, choose File > Dependencies > Find Missing Footage to display the missing assets in the Project panel. Then right-click or Control-click the file name, choose Replace Footage, and nagivate to the file. If other missing assets are in the same location as the first one you re-link, After Effects will automatically locate and link them, too. (Choose File > Dependencies > Find Missing Fonts or Find Missing Effects to identify them as well.)

Identifying the source of long render times

Render times depend on the complexity of a composition, effects and their settings, and the resources available on your system. To identify which components of a project require more resources, click the snail icon at the bottom of the Timeline panel. After Effects adds a column to the Timeline panel, displaying the render time of each component—layers, effects, layer styles—in seconds. To see more detail in nested compositions, view the render times in their timelines.

Once you know which effects are causing delays, you can disable them while you work on other aspects of the project, adjust settings so that they are less resource-intensive, or adjust the RAM allocation for After Effects and other applications. (To adjust RAM allocation, choose Edit > Settings > Memory Performance in Windows or After Effects > Settings > Memory Performance in macOS.)

INDEX

B

background,
replacing 235, 257–260

background strokes,
creating with the
Roto Brush tool 226–227

Bad TV 3 - weak animation
preset 286

base frames, creating with the
Roto Brush tool 224–225

Bend pins

about 208

animating 214

placing 210

Bezier curves

in a motion path 130

in masks 186

Bezier masks, creating 188

bicubic scaling 349

bilinear sampling 349

Black Clip 261

blending modes

about 196

applying 196

for masks 185, 258

blur, adding.
See motion blur, adding

Bridge. *See* Adobe Bridge

Brightness and Contrast
effect 268–269

brightness, changing
in the user interface 35

Browse Presets command 68

Bullet Train animation
preset 48

C

cached frames, using
Roto Brush tool 229

Cache Frames When Idle 32

cameras

adding to a 3D scene
316–317

animating 320

CC Light Sweep effect 21–22

CC Particle Systems II
effect 367–378

Center Anchor Point In New
Shape Layers 92

Channel Blur effect 28–29

Character Animator 218

Character panel 25, 44, 63

child layers 110

Cinema 4D Lite 322

circles, drawing 197

cloning objects 261–265

codecs 395

collaboration tools 36

color

animating 105

changing for a shape 92

correcting 248–276

correcting using Auto
Contrast 261

grading 248

keying 222

previewing accurately 250

Color Emboss effect 47

Colorizing an image 255–257

Composition Navigator bar 23

Composition panel

about 15

typing in 63

Composition Profiler 167

compositions

about 15

adding footage to 16, 42

creating 15, 40–41, 59, 281

creating from footage 90

defined 12

duration of 41

fitting layers to 42

importing 13

nesting 16

rendering 52

retiming 168–177

Composition Settings
dialog box 16–17, 41

About the Authors

Lisa Fridsma has long loved the process of teaching others to use Adobe products. She has been an illustrator, compositor, and lesson designer for over thirty books in the Classroom in a Book series (including books for Photoshop, After Effects, and Acrobat). Lisa also authored and illustrated the 2022 version of *Visual QuickStart Guide: Adobe Illustrator*.

Brie Gyncild aims to make technical information accessible to those who need it. Over the past two decades, Brie has written or co-written numerous editions of the Classroom in a Book series on Photoshop, After Effects, Flash, and Acrobat; several editions of the How to Wow series; and various other books about Adobe applications.

Production Notes

Adobe After Effects Classroom in a Book 2024 Release was created electronically using Adobe InDesign. Art was produced using Adobe InDesign, Adobe Illustrator, and Adobe Photoshop.

References to company names in the lessons are for demonstration purposes only and are not intended to refer to any actual organization or person.

Typefaces used

Adobe Myriad Pro and Adobe Warnock Pro as well as other Adobe typefaces are used throughout the lessons.

Team credits

The following individuals contributed to the development of this book:

- **Writer:** Brie Gyncild
- **Illustrator and Compositor:** Lisa Fridsma
- **Indexer:** Brie Gyncild
- **Keystroker:** Megan Ahearn
- **Interior design:** Mimi Heft
- **Lesson Designers:** Lisa Fridsma, Brie Gyncild
- **Adobe Press Executive Editor:** Laura Norman
- **Adobe Press Production Editor:** Tracey Croom
- **Associate Sponsoring Editor:** Anshul Sharma
- **Adobe After Effects product team liaison:** Victoria Nece

Project contributors

The following artists contributed creative assets for lessons in this book:

- **Lee Daniels** is a freelance animator, illustrator, and motion graphics artist working from his home studio in South London. See more of his work at leedanielsart.com.
- **Stephen Schleicher** has worked as an editor, graphic designer, videographer, director, and producer on a variety of small and large video productions. Stephen is a regular contributor to Digital Media Net (www.digitalmedianet.com).

Pearson's Commitment to Diversity, Equity, and Inclusion

Pearson is dedicated to creating bias-free content that reflects the diversity of all learners. We embrace the many dimensions of diversity, including but not limited to race, ethnicity, gender, socioeconomic status, ability, age, sexual orientation, and religious or political beliefs.

Education is a powerful force for equity and change in our world. It has the potential to deliver opportunities that improve lives and enable economic mobility. As we work with authors to create content for every product and service, we acknowledge our responsibility to demonstrate inclusivity and incorporate diverse scholarship so that everyone can achieve their potential through learning. As the world's leading learning company, we have a duty to help drive change and live up to our purpose to help more people create a better life for themselves and to create a better world.

Our ambition is to purposefully contribute to a world where:

- Everyone has an equitable and lifelong opportunity to succeed through learning.

- Our educational products and services are inclusive and represent the rich diversity of learners.

- Our educational content accurately reflects the histories and experiences of the learners we serve.

- Our educational content prompts deeper discussions with learners and motivates them to expand their own learning (and worldview).

While we work hard to present unbiased content, we want to hear from you about any concerns or needs with this Pearson product so that we can investigate and address them.

- Please contact us with concerns about any potential bias at https://www.pearson.com/report-bias.html.

Notes

Notes

Notes

Notes

The fastest, easiest, most comprehensive way to learn
Adobe Creative Cloud

Classroom in a Book®, the best-selling series of hands-on software training books, helps you learn the features of Adobe software quickly and easily.

The **Classroom in a Book** series offers what no other book or training program does—an official training series from Adobe Systems, developed with the support of Adobe product experts.

To see a complete list of our Classroom in a Book titles covering the 2024 release of Adobe Creative Cloud go to: peachpit.com/CC2024

Adobe Photoshop Classroom in a Book 2024 Release
ISBN: 9780138262525

Adobe Illustrator Classroom in a Book 2024 Release
ISBN: 9780138263829

Adobe InDesign Classroom in a Book 2024 Release
ISBN: 9780138263911

Adobe After Effects Classroom in a Book 2024 Release
ISBN: 9780138316488

Adobe Animate Classroom in a Book 2024 Release
ISBN: 9780138317713

Adobe Photoshop Lightroom Classic Classroom in a Book 2024 Release
ISBN: 9780138318147

Adobe Premiere Pro Classroom in a Book 2024 Release
ISBN: 9780138318567

Adobe Photoshop, Illustrator, and InDesign Collaboration and Workflow Classroom in a Book
ISBN: 9780137908462

Adobe Creative Cloud Classroom in a Book
ISBN: 9780137914708

Adobe Acrobat Classroom in a Book, 4th edition
ISBN: 9780137983636